Cacas

EVERGREEN is an imprint of TASCHEN GmbH

© for this edition: 2000 TASCHEN GmbH
Hohenzollernring 53, D–50672 Köln

© 1998 COLORS Magazine S.r.l.
Villa Minelli, 31050 Ponzano Veneto (TV)
All rights reserved.

Idea: Oliviero Toscani
Photos: Marirosa Toscani Ballo
Design: Thomas Hilland
Editors: Rose George, Carlos Mustienes
Researchers: Paola Boncompagni, Oliver Chanarin,
Negar Esfandiary, Giuliana Rando, Benjamin Sutherland
Cover design: Angelika Taschen

German translation by Wolfgang Himmelberg
French translation by Isabelle Baraton

Printed in Spain
ISBN 3–8228–5775–0 (edition with German cover)
ISBN 3–8228–5877–3 (edition with English cover)
ISBN 3–8228–5742–4 (edition with French cover)

Die Enzyklopädie der Kacke

Cacas

Oliviero Toscani

The Encyclopedia of Poo
L'encyclopédie

COLORS

EVERGREEN

Wir produzieren sie von unserer Geburt bis zu unserem Tod. Der Vorgang ist genauso natürlich wie das Atmen. Doch viele Menschen können ihren Anblick, ihren Geruch, den Kontakt mit ihr nicht ertragen. Wir entledigen uns ihrer hinter geschlossenen Türen, lassen sie in sauberen, weißen Toiletten verschwinden und erwähnen sie im gepflegten Gespräch mit keinem Wort. Sie ist eines der letzten Tabus der »zivilisierten« Gesellschaft. Schluß damit! Sie ist die am meisten unterschätzte Ressource der Welt. Wir können damit kochen und bauen, wir können sie bewundern und uns darin kleiden. Sie ist immer einzigartig (kein Exemplar gleicht dem anderen). Sie ist so alt wie die Schöpfung. Es wird nie Mangel an ihr sein. Es ist an der Zeit, der Scheiße ein Loblied zu singen.

From the moment we're born to the moment we die, we produce it. It's as natural as breathing. But many of us can't bear to look at it, touch it or smell it. We dispose of it behind closed doors, flush it down clean white toilets, don't mention it in polite company. It's one of "civilized" society's last taboos. Enough! It's the world's most underrated resource. We can cook with it, build with it, admire it, wear it. It's unique (no two examples are alike). It's as old as creation. It will never run out. It's time to celebrate shit.

Elle nous est tout aussi naturelle que de respirer. Et pourtant, combien d'entre nous vacillent à l'idée même de la regarder, de la toucher, de la sentir ? Nous nous en déchargeons derrière des portes closes, nous la noyons sous des cataractes d'eau dans des toilettes immaculées ; gare à qui la mentionne en bonne compagnie. Voilà bien l'un des derniers tabous de la société dite « civilisée ». Assez ! Car nous avons affaire à la ressource mondiale la plus injustement sous-estimée : carburant, matériau de construction, œuvre d'art, vêtement, toujours différente et toujours unique (vous n'en trouverez pas deux semblables). Née avec notre monde. Inépuisable. Il est grand temps de rendre hommage à la merde.

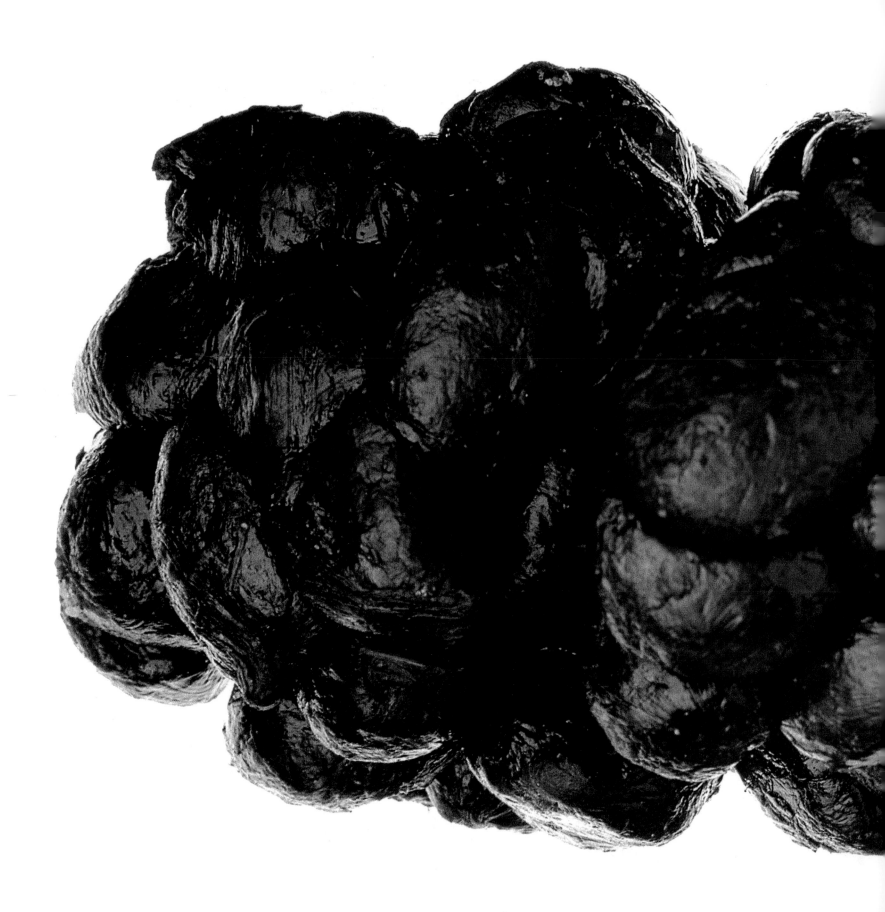

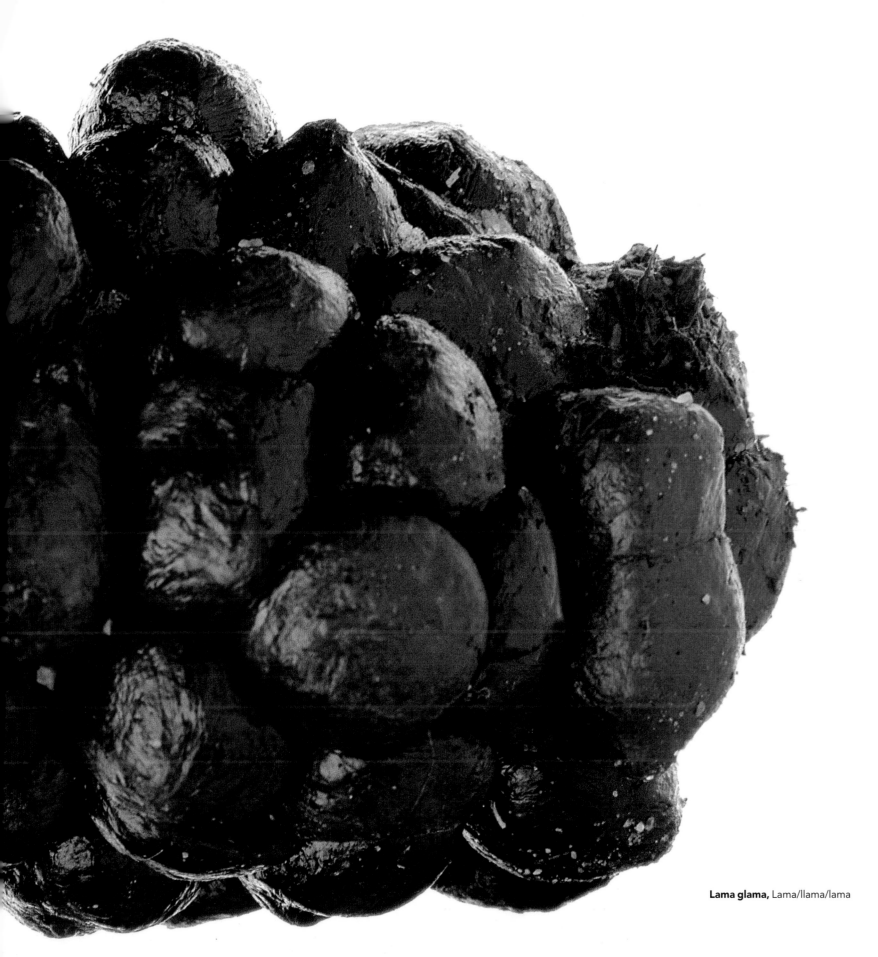

Lama glama, Lama/llama/lama

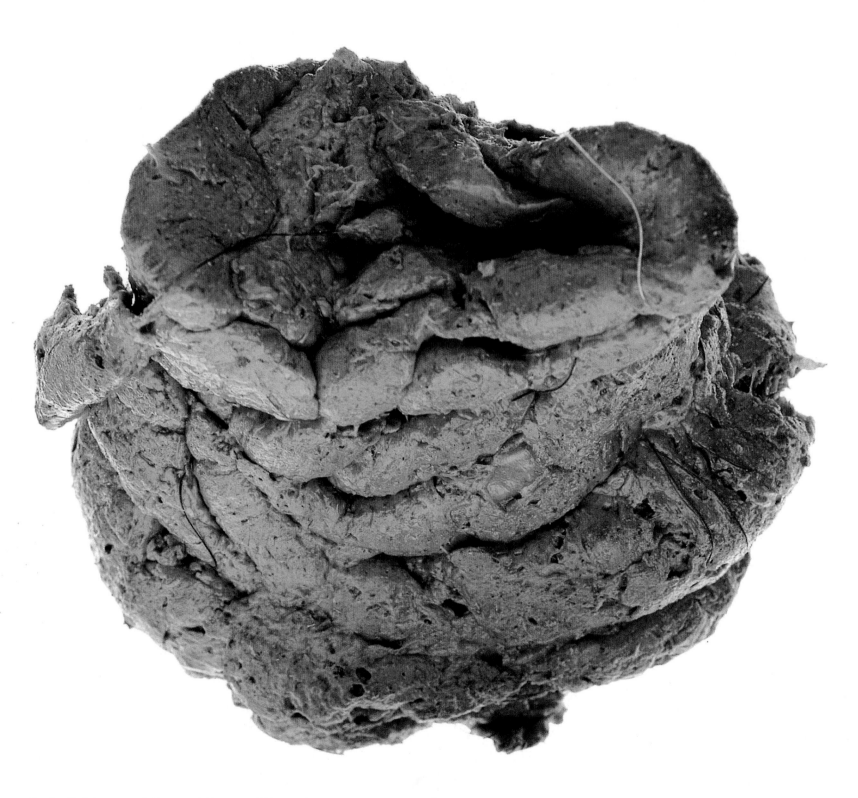

Pan troglodytes verus, Schimpanse/chimpanzee/chimpanzé
Rechts/Right/A droite: **Okapia johnstoni,** Okapi/okapi/okapi

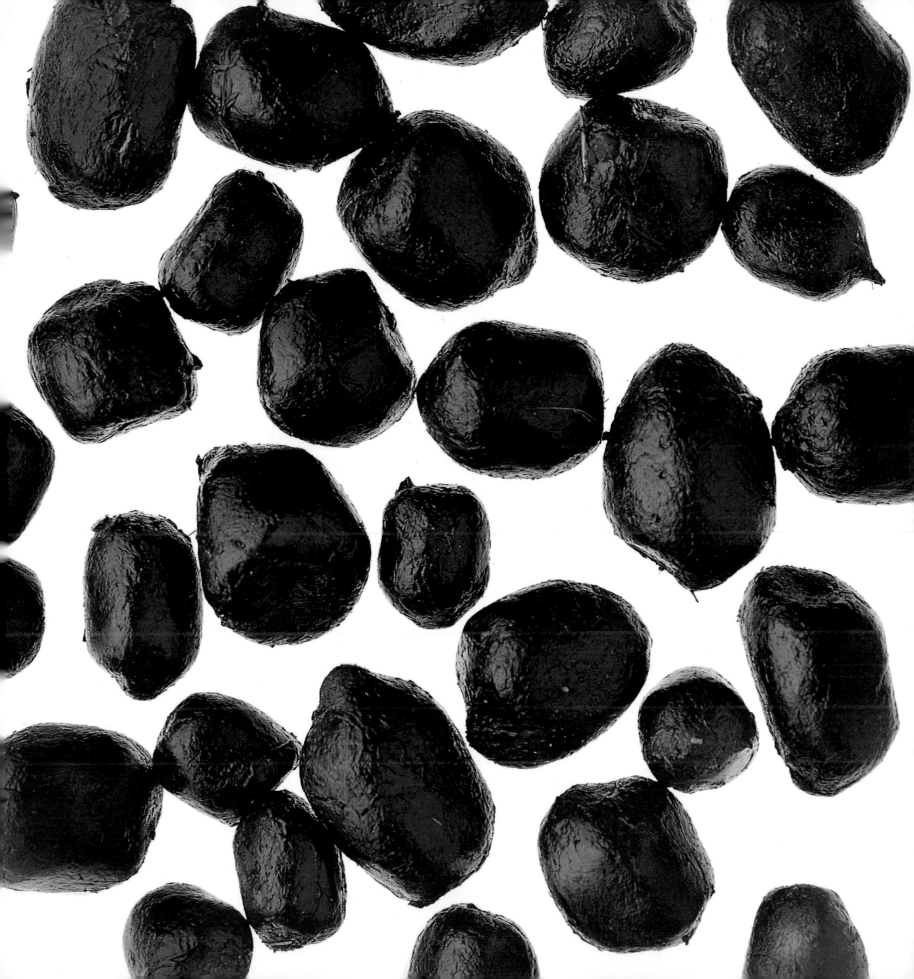

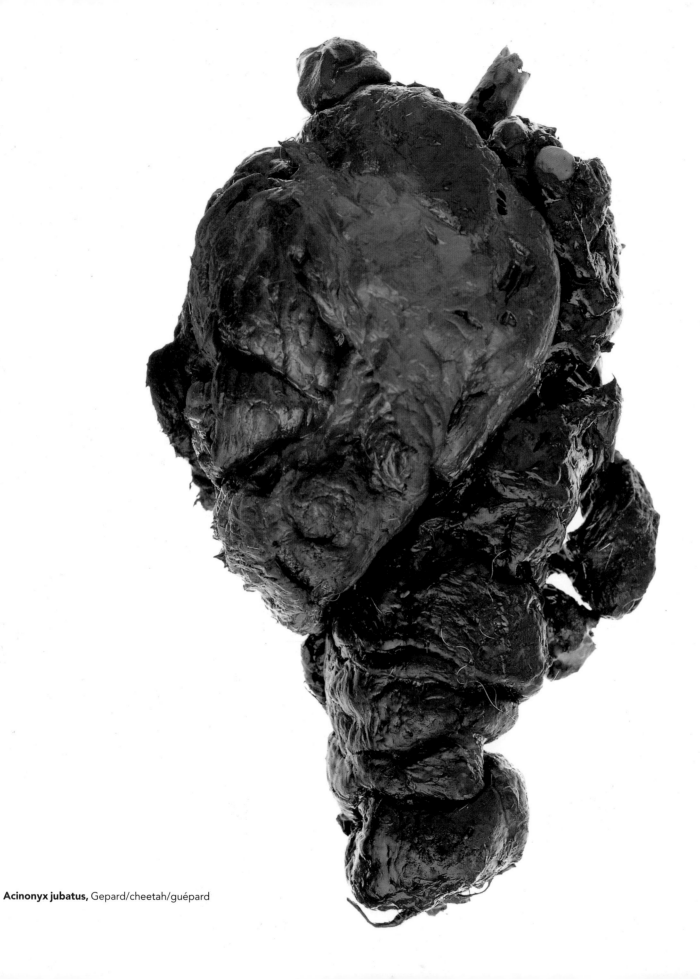

Acinonyx jubatus, Gepard/cheetah/guépard

Der Stuhlgang Etwa 50.000 mal vollziehen Sie in Ihrem Leben die folgende Prozedur: 1. Sie verdauen 95 Prozent der Nahrung, die Sie zu sich genommen haben. 2. Sie lassen die Schlacke durch die Eingeweide wandern, bis sie den Sigmoid erreicht (den Abschnitt des Dickdarms, in dem sich der Kot sammelt). 3. Während der Sigmoid sich füllt, senden Sie Nervensignale aus, um den Analkanal auf einen bevorstehenden Stuhlgang aufmerksam zu machen. 4. Sie suchen eine Toilette auf. 5. Sie ziehen Ihre Beckenmuskel zusammen, um die Wände Ihres Analkanals auszudehnen und damit den Kot durch den Dickdarm zum Anus hin zu drücken. 6. Indem Sie die kreisförmigen Muskeln Ihres Rektums zusammenziehen, lösen Sie einige peristaltische Wellen aus, um den Kot das letzte Stück des Wegs passieren zu lassen. (Stellen Sie sich vor, Sie drückten einen Ball durch einen Schlauch, aus dem die Luft herausgelassen wurde). 7. Sie halten den Atem an, so daß Ihr Zwerchfell (ein Muskel unterhalb der Lungen) Druck auf Ihre Eingeweide ausübt, um die Darmentleerung einzuleiten. 8. Bevor es jetzt zur Sache geht, verlangsamen Sie Ihren Herzrhythmus und erhöhen den Blutdruck. 9. Mit Hilfe Ihres inneren Schließmuskels pressen Sie Ihren Dickdarm zusammen, um den Kot – wie bei der Wurstherstellung – in kürzere Stücke zu unterteilen, die leichter auszuscheiden sind. 10. Sie scheiden den Kot aus. 11. Sie wischen sich ab. (Der britischen Tierschutzgesellschaft Royal Society for Prevention of Cruelty to Animals [RSPCA] zufolge ist der letztgenannte Punkt ausschließlich dem Menschen vorbehalten).

The Movement *About 50,000 times during your life, you'll perform the following procedure: 1. Digest 95 percent of your food. 2. Shunt the debris down your intestine until it arrives in your sigmoid colon (the part of the intestine where feces accumulate). 3. As the colon fills, send nerve signals to warn the anal canal of an imminent bowel movement. 4. Find a toilet. 5. Contract your pelvic muscles to expand the walls of your anal canal – this pushes the feces through the colon toward the anus. 6. Now initiate some peristaltic waves by contracting the circular muscles of your rectum (think of it as pushing a ball through a collapsed inner tube). 7. Stop breathing so your diaphragm (a muscle below the lungs) can help push out the feces by exerting pressure on your intestine. 8. Slow down your heart and increase your blood pressure as you prepare to defecate. 9. Use your puborectal sling to squeeze the colon – rather like sausage making, this breaks the feces into shorter lengths that are easier to expel. 10. Release. 11. Wipe. (According to the UK's Royal Society for Prevention of Cruelty to Animals [RSPCA], the final stage applies exclusively to human beings.)*

L'expulsion des selles Près de 50 000 fois au cours de votre vie, vous vous plierez à la procédure suivante : 1. Digérer 95 % de votre nourriture. 2. Expédier les résidus vers votre intestin, jusqu'au côlon sigmoïde (le segment où s'accumulent les selles). 3. Tandis que le côlon s'emplit, envoyer des impulsions nerveuses au rectum pour l'avertir d'une vidange intestinale imminente. 4. Trouver des toilettes. 5. Contracter les muscles du périnée afin de dilater le rectum – ce qui aura pour effet de faire glisser les selles du côlon vers l'anus. 6. Envoyer le long du rectum une série d'ondes péristaltiques en contractant ses muscles circulaires (imaginez que vous poussez une balle à travers une chambre à air dégonflée). 7. Suspendre votre souffle pour permettre au diaphragme (muscle situé sous les poumons) de contribuer à expulser les selles en exerçant une pression sur vos intestins. 8. Ralentir votre pouls et laisser monter votre tension artérielle afin de vous préparer à déféquer. 9. Utiliser votre sangle rectalo-pubienne pour contracter le côlon – comme dans la fabrication de la saucisse, l'opération aura pour effet de diviser les selles en morceaux plus petits, donc plus faciles à expulser. 10. Relâcher. 11. Essuyer (comme le rappelle la Société royale pour la prévention de la cruauté contre les animaux [RSPCA] du Royaume-Uni, cette étape finale concerne exclusivement les êtres humains).

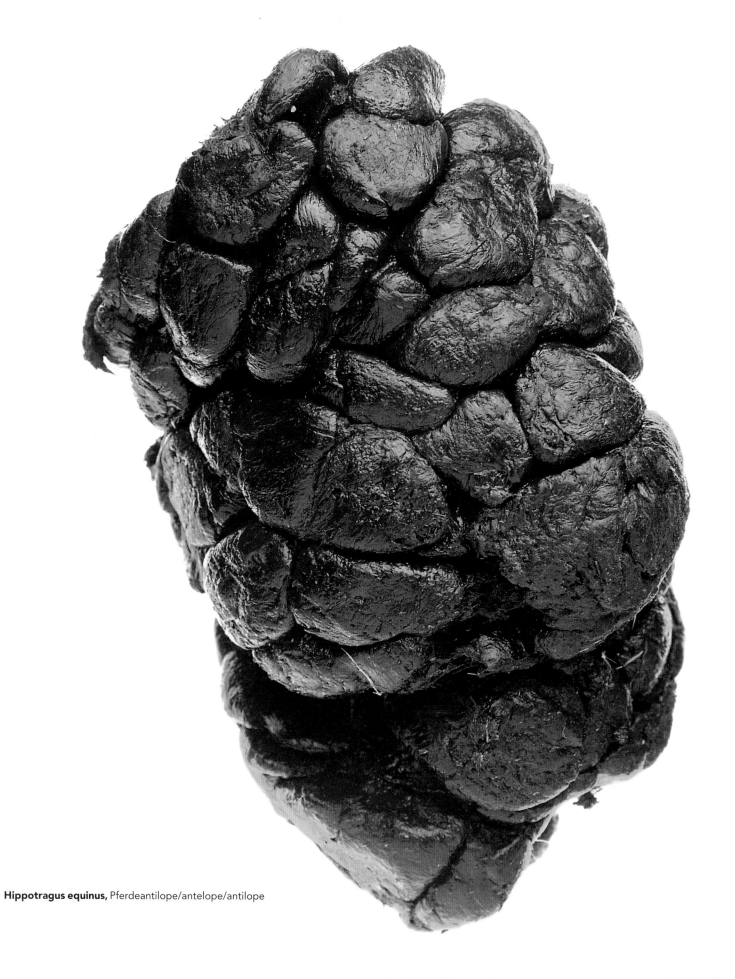

Hippotragus equinus, Pferdeantilope/antelope/antilope

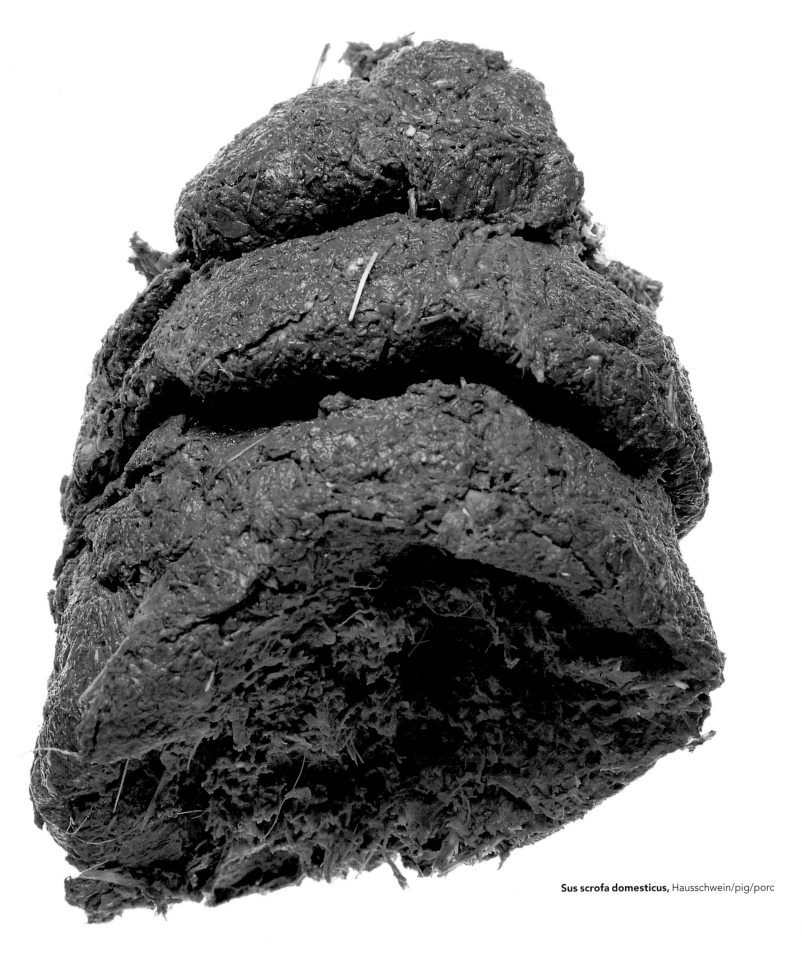

Sus scrofa domesticus, Hausschwein/pig/porc

Nach dem Stuhlgang

Viele Menschen kennen kein Toilettenpapier. Weltweit ist Zeitungspapier das gebräuchlichste Abwischmaterial. In Sambia ziehen die Menschen, die keine Zeitnot kennen, jedoch ein normales Blatt Papier vor: Reibt man es 15 Minuten lang zwischen geschlossenen Fäusten, wird es zu einem weicheren, anusfreundlicheren Material, wie ein Experte auf diesem Gebiet versichert. Im ländlichen China heben die meisten Männer ihre leeren Zigarettenschachteln (mitsamt des Zellophans) für den Besuch der Latrine auf. In Mosambik tut's ein glatter Kieselstein. Die meisten Inder halten Toilettenpapier für unhygienisch und benutzen statt dessen Wasser aus einem als *lota* bekannten Gefäß. Die gute Sitte schreibt vor, daß man sich mit der linken Hand wäscht (wie es auch die Moslems tun), und das Lota in der rechten Hand hält, so daß es für den nächsten Benutzer rein bleibt. Was man beachten sollte: Die Fingernägel der linken Hand immer kurz halten, damit man sich nicht kratzt, und wenn man sich auf einer Straße entleert, immer auf der Seite, die aus der Stadt hinausführt, nie auf der, die in sie hineinführt.

After the Movement

Lots of people can't get hold of toilet paper. Worldwide, newspapers are the most common wiping material, although Zambians with time on their hands prefer plain sheets of paper: Scrunching it between closed fists for 15 minutes softens it into a more anus-friendly material, reports one user. In China's countryside, men commonly save their cardboard cigarette packs (and cellophane wrapping) for latrine trips. A smooth pebble does the trick in Mozambique. In India, toilet paper is considered unhygienic by most people, and water from a container known as a lota *is used instead. Custom dictates that you wash with your left hand (as Muslims do), and handle the* lota *with your right, so as not to contaminate it for the next user. Tips to remember: Keep nails on the left hand short to avoid scratches, and if defecating on a road, always do it on the side leading out of town, never the one coming in.*

Fluch und Segen des Guano

Prähistorischer Vogeldreck ist reich an Phosphat, einem wertvollen Düngemittelgrundstoff. Nauru, die winzigste Inselrepublik der Welt, lebt einzig und allein vom Export dieses Materials, dem der Inselstaat eines der weltweit höchsten Pro-Kopf-Einkommen verdankt. Der Abbau, der vor 90 Jahren begann, hat die Insel jedoch zu 80 Prozent in eine öde Mondlandschaft aus Korallenbänken verwandelt. Und mit einem garantierten Jahreseinkommen von 20.000 US-Dollar haben sich die Inselbewohner auf eine verwestlichte, fettreiche Ernährung umgestellt, die die Zahl der Fettleibigen und der Zuckerkranken in die Höhe schnellen und die durchschnittliche Lebenserwartung auf 50 Jahre fallen ließ. Zwar werden die Dungreserven nach der Jahrtausendwende versiegen, doch die Nauruer haben beträchtliche Geldreserven anhäufen können. Und die brauchen sie auch: Das einstige tropische Paradies ist ökologisch derart verwüstet, daß die 10.000 Insulaner den Erwerb einer neuen Inselheimat von ihren pazifischen Nachbarn in Erwägung ziehen.

Cost-Benefit Analysis: Guano

Prehistoric bird dung is rich in phosphate, a valuable ingredient in fertilizer. Nauru, the world's tiniest island republic, has based its entire economy on exporting the stuff, making it one of the richest countries per capita in the world. But 90 years of mining has stripped the island bare: 80 percent of Nauru now resembles a bleak lunar landscape of coral pinnacles. And with a guaranteed annual income of US$20,000, islanders adopted a westernized fatty diet that has brought soaring rates of diabetes and obesity and slashed average life expectancy to 50 years. Although the droppings are expected to run out by the end of the 20th century, Naurans still have plenty of cash in the bank. Just as well: The former tropical paradise is so ecologically devastated that the 10,000 residents are considering buying a new island home from their Pacific neighbors.

Hosenscheißer

»Es ist ein weltweit bekanntes Phänomen, daß Angst eine unwillkürliche Exkretion auslösen kann«, sagt Professor Jeffrey Gray vom britischen Institute of Psychiatry. Mit anderen Worten: Es ist wissenschaftlich erwiesen, daß man sich vor Angst in die Hose scheißen kann. In extremen Streßsituationen setzt der Körper Histamin, Prostaglandine und andere Hormone frei, die die Auskleidung der Eingeweide entzünden, um sie vor Verletzungen zu schützen. (Sollte sie brechen, könnten gefährliche Bakterien enthaltende Abbauprodukte austreten und den Körper infizieren.) Eben diese Stoffe überreizen jedoch auch den mit Kot angefüllten Teil des Darms und lösen damit eine unvorhergesehene Defäkation aus. Im Zweiten Weltkrieg machten 21 Prozent der Soldaten unter den Belastungen des Fronteinsatzes ihre Hosen schmutzig. Um nähere Einsichten in dieses Phänomen zu gewinnen, haben Forscher über einen Zeitraum von mehr als 60 Jahren Tieren (darunter Füchsen, Nerzen, Katzen, Stachelschweinen und Hähnen) mit Blitzlichtern und Lautsprechern eine »Scheißangst« eingejagt. Ihre Schlußfolgerung: In Streßsituationen scheißen Männchen eher als Weibchen.

Shit-Scared

"It is a matter of universal experience that fear causes involuntary excretion," says Professor Jeffrey Gray at the UK's Institute of Psychiatry. In other words, shitting your pants is a scientifically recognized phenomenon. In cases of extreme stress, the body secretes histamine, prostaglandin and other hormones that inflame the intestine's lining, protecting it against injury. (If it were to break, waste material containing dangerous bacteria could leak and infect the body.) The same chemicals, though, also overstimulate the part of the intestine that's packed with feces, bringing on unexpected bowel movements: 21 percent of World War II soldiers soiled their pants under the strain of battle. Seeking further insight into the phenomenon, researchers have been using flashlights and loudspeakers to "scare the shit" out of animals (including foxes, mink, cats, porcupines and cockerels) for over 60 years. Their conclusion: When terrorized, males defecate more readily than females.

Mille façons de s'essuyer Bien des gens n'ayant pas accès au papier toilette, c'est aux vieux journaux que l'humanité confie le plus couramment son arrière-train. Cependant, les Zambiens disposant de quelque loisir préfèrent les feuilles de papier ordinaires, qu'ils froissent entre leurs poings fermés durant un bon quart d'heure pour les assouplir et les rendre plus clémentes à leur anus, rapporte un utilisateur. Dans les campagnes chinoises, les hommes conservent fréquemment leurs paquets de cigarettes vides (et les emballages cellophane) pour leurs voyages aux latrines. Un galet lisse fait l'affaire au Mozambique. En Inde, le papier toilette a mauvaise presse sur le plan de l'hygiène, aussi lui préfère-t-on l'eau, que l'on puise à un récipient appelé le *lota*. La coutume exige que l'on s'essuie de la main gauche (comme le font les musulmans), en tenant le *lota* de la main droite, de façon à ne pas le contaminer pour l'utilisateur suivant. Quelques conseils utiles : rognez-vous les ongles de la main gauche, pour éviter les écorchures, et si vous êtes pris d'un besoin urgent en pleine route, déféquez du côté de la chaussée qui mène hors de la ville, non de celui qui y conduit.

Le guano ou des déjections valant leur pesant d'or La fiente d'oiseau est riche en phosphates, ingrédients fondamentaux dans la fabrication d'engrais. Nauru, la plus petite république insulaire au monde, a bâti toute son économie sur l'exportation de cette substance, grâce à laquelle elle est devenue l'une des nations les plus riches au monde en termes de revenu par habitant. Hélas, quatre-vingt-dix ans de cette exploitation ont fait de cet atoll un caillou dénudé : sur 80 % de son territoire, Nauru déroule désormais un paysage lunaire et désolé de pics coralliens. En outre, un revenu annuel garanti de 20 000 $US a fortement incité les îliens à adopter le régime alimentaire occidental, saturé en graisses, d'où un taux record de diabète et d'obésité et une réduction de l'espérance de vie à 50 ans à peine. On estime que les gisements de fientes s'épuiseront sous peu, mais les Nauruans disposent encore de comptes en banque confortables. Bien leur en prend : ce qui fut un jour un paradis tropical s'avère aujourd'hui si dévasté que les 10 000 habitants de l'atoll envisagent de déplacer leurs pénates vers une autre île, qu'ils achèteraient à un archipel voisin du Pacifique.

Faire dans sa culotte « Le monde entier connaît cela – la peur provoque une défécation involontaire », rappelle le Pr Jeffrey Gray, de l'Institut britannique de psychiatrie. En d'autres termes, chier dans son froc est un phénomène scientifiquement reconnu. Dans les situations de stress extrême, notre corps sécrète diverses hormones, telles l'histamine et la prostaglandine, qui enflamment la paroi de l'intestin afin de le protéger des blessures éventuelles (s'il venait à se perforer, des déchets grouillant de dangereuses bactéries pourraient s'en évacuer et contaminer l'organisme). Ces mêmes substances chimiques ont cependant un effet corollaire : elles opèrent une stimulation excessive du segment d'intestin qui se trouve précisément chargé de selles – d'où des vidanges intempestives. Ainsi, pendant la Seconde Guerre mondiale, 21 % des soldats souillaient leur fond de culotte dans le feu de la bataille. Espérant mieux cerner le phénomène, les chercheurs ont terrorisé durant plus de soixante ans des animaux divers (dont renards, visons, chats, porcs-épics et coquelets), à grand renfort de lampes torches et de porte-voix, dans le but de les faire « chier sous eux ». Telle fut leur conclusion : sous l'emprise de la peur, les mâles défèquent plus facilement que les femelles.

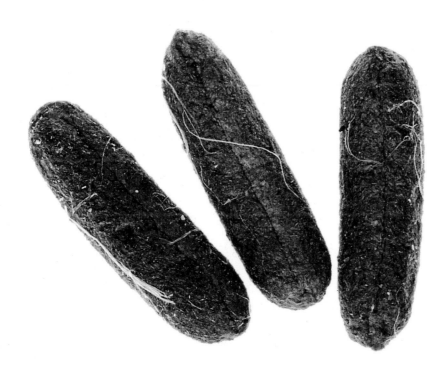

Cavia cobaya, Meerschweinchen/guinea pig/cochon d'Inde

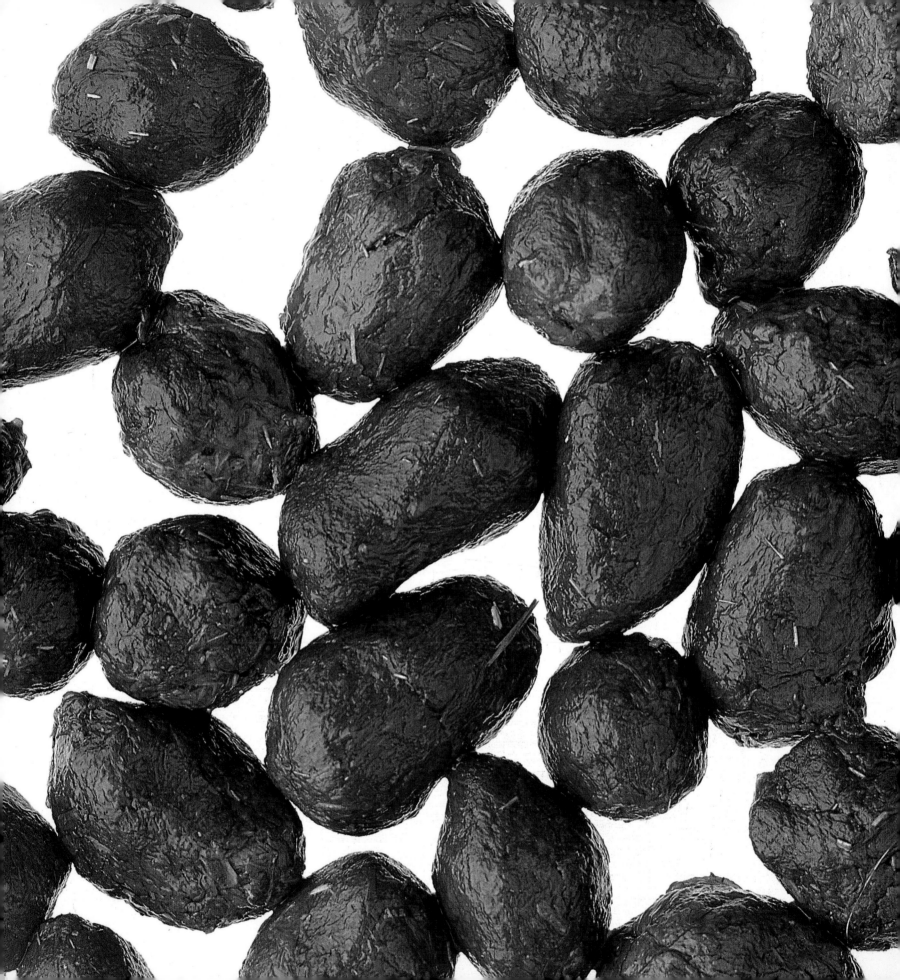

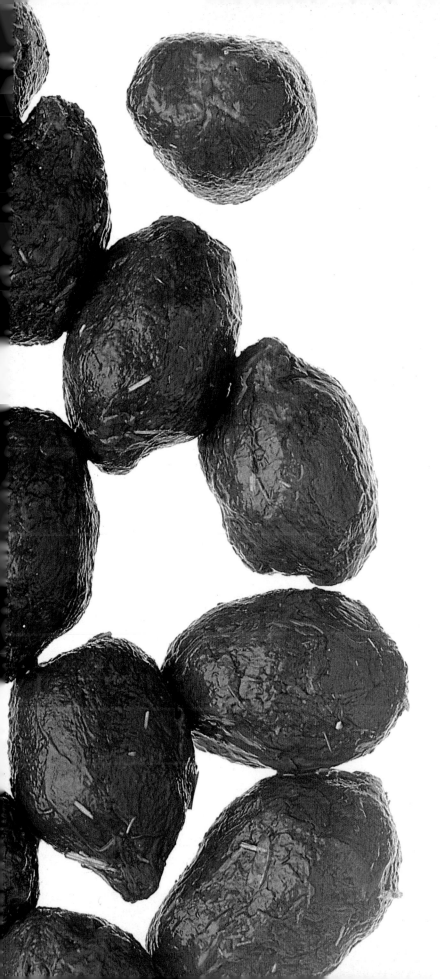

Verstopfung Der Bibel zufolge hatten Adam und Eva (die ersten Menschen auf der Erde) während ihres Aufenthalts im Garten Eden kein einziges Mal Stuhlgang. Die Gelehrten schreiben dies der makellosen Verdauung zu (sie konnten sich von schlackenfreier Kost ernähren). Vielleicht litten Adam und Eva aber auch an der Beschwerde, die in Amerika an erster Stelle steht – Verstopfung. Die Verstopfung wird durch eine Verhärtung der Schlacke im Dickdarm verursacht und macht den Stuhlgang schmerzhaft und manchmal unmöglich. Ein Mensch kann den Stuhl drei Wochen lang zurückhalten, sagt Dr. John Popp vom American College of Gastroenterology. Dann wird der Kot so kompakt, daß der Körper ihn nicht mehr ausscheiden kann. »Normalerweise können wir den Stuhl mit unseren Fingern lösen oder mit einem Einlauf weich machen«, so Dr. Popp. Wenn das nichts hilft, greift die Schulmedizin zu einer Operation, damit der Dickdarm nicht bersten und potentiell tödliche Schlacke in den Körper eindringen kann.

Tough Shit *According to the Bible, Adam and Eve (the earth's first humans) didn't defecate once during their stay in the Garden of Eden, an earthly paradise. Scholars attribute this to immaculate digestion (the perfect food available produced no waste). But perhaps Adam and Eve were suffering from America's No.1 medical complaint – constipation. Caused by the hardening of food waste in the intestine, constipation makes defecating painful, and sometimes impossible. A human can go three weeks without excreting, says Dr. John Popp of the American College of Gastroenterology. By then, the feces become so compacted that the body can't get rid of them. "Usually we can loosen the stool with our fingers, or soften it with an enema," explains Dr. Popp. If this fails, conventional medicine then proposes an operation to keep the colon from exploding and polluting the body with potentially deadly waste.*

Des ancêtres constipés D'après la Bible, Adam et Eve (premiers hommes sur terre) ne déféquèrent pas une seule fois durant leur séjour dans le Jardin d'Eden ou paradis terrestre. Les théologiens attribuent cette faculté à une digestion immaculée (à aliments parfaits, déchets inexistants). Cependant, qui nous dit qu'Adam et Eve ne souffraient pas du mal numéro un aux Etats-Unis : la constipation? Causée par le durcissement des résidus digestifs dans l'intestin, celle-ci rend la défécation douloureuse, voire impossible. Un être humain peut survivre trois semaines sans évacuer ses selles, indique le Dr John Popp, de l'Institut américain de gastro-entérologie. A ce stade, elles sont devenues si compactes que le corps ne parvient plus à les expulser. « Nous réussissons généralement à morceler les selles au doigt ou à les assouplir à l'aide d'un clystère », explique le Dr Popp. Si ces procédés échouent, la médecine conventionnelle prescrit une intervention, pour éviter que le côlon n'explose et que des déchets potentiellement mortels ne viennent souiller le corps.

Giraffa camelopardalis peralta, Giraffe/giraffe/girafe

Dünger nach Geheimrezept »Die Leute fragten immer, warum wir so herrliche Rosen haben«, sagt Pat Cade vom Zoo im englischen Chester, »die Antwort: Weil wir aus Tierkot gefertigte Düngemittel verwenden.« Pflanzen gedeihen prächtig auf dem kalium- und stickstoffreichen Dung pflanzenfressender Tiere. (Der Kot fleischfressender Tiere enthält mehr Giftstoffe und riecht strenger.) Der Zoo treibt inzwischen einen schwunghaften Handel mit Elefantendung (ca. 10 DM für einen Müllsack voll), doch die Rosen in den Gärten der Kunden werden wohl nie so prächtig gedeihen wie die im Zoo. »Der Obergärtner hat im Laufe der letzten 31 Jahre ein Geheimrezept entwickelt«, sagt Pat, »und dieses Rezept wird den Zoo nicht verlassen.« Sie will nur verraten, daß es Exkremente von Nashörnern, Elefanten und anderen pflanzenfressenden Tieren enthält. Wer von diesem Superdung etwas haben will, muß sich nach Chester aufmachen. »Wir verkaufen nur an Leute, die sich hierher begeben«, sagt Pat. »Die Post weigert sich, Dung zu befördern.«

An Elephant on Your Flower-Bed *"People wanted to know how we got our beautiful roses," says Pat Cade of the UK's Chester Zoo. "It's because we use fertilizers made from animal dung." In fact, plants thrive on the potassium- and nitrogen-rich manure of vegetarian animals (carnivore feces are smellier and more toxic). Chester now does a roaring trade in elephant dung (UK£3, or US$5, for a garbage-bag full), but Zoo Poo customers will probably never have gardens as splendid as the zoo's: "The head gardener has been developing a secret recipe over the last 31 years," says Pat. "And the recipe's not leaving the zoo." All she'll reveal is that it contains excrement from rhinos, elephants and other vegetarian animals. For your personal supply of super manure, head for Chester. "We only sell to personal shoppers," says Pat. "The Post Office won't let dung through the mail."*

Un engrais miracle « Les gens voulaient savoir comment nous faisions pour avoir de si belles roses, raconte Pat Cade, du zoo de Chester, au Royaume-Uni. C'est bien simple : comme engrais, nous utilisons les excréments de nos bêtes. » De fait, les plantes croissent et prospèrent sur le fumier riche en potassium et en azote que produisent les animaux végétariens (les selles des carnivores sont plus nauséabondes et plus toxiques). Fort de ce constat, le zoo s'est lancé dans le fructueux commerce des bouses d'éléphant (au prix de 30 francs le sac-poubelle). Cela dit, les clients du zoo n'auront probablement jamais de jardins aussi somptueux que leur fournisseur. « Le jardinier en chef a mis au point une recette secrète – il travaille là dessus depuis trente et un ans, souffle Pat. Et, croyez-moi, elle ne sortira pas d'ici. » Tout ce qu'elle consent à révéler, c'est qu'il entre dans ce cocktail magique des bouses de rhinocéros et d'éléphant – entre autres cacas végétariens. Pour vous approvisionner en superfumier, il vous faudra faire le voyage jusqu'à Chester. « Nous ne vendons qu'aux clients qui se déplacent, indique Pat. La Poste n'autorise pas l'envoi de crottin par colis. »

Kot als Medizin Seit alters haben Ärzte Kot zu schätzen gewußt. Viele alte Heilmittel zum Beispiel für Tuberkulose, Ruhr, Taubheit oder Brustschmerzen enthielten Dachs-, Krokodil-, Lämmer- oder menschlichen Kot. Noch heute wischen die Beduinen von Katar ihren Babies den Po mit getrockneten Kamelfladen. Und im ländlichen Indien und Pakistan werden die Fußböden mit Kuhdung bedeckt, dem antiseptische Eigenschaften zugeschrieben werden: Er soll Fußpilz und bakterielle Infektionen verhindern und Insekten vertreiben. Wer Kühe besitzt, trägt den Dung täglich neu auf (mit dem Trocknen der Fladen verschwindet der Geruch), wer nicht, nur zweimal pro Woche.

Crap Medicine *Throughout history, doctors have been fond of feces: Many old remedies for tuberculosis, dysentery, deafness or sore breasts, for example, included badger dung, crocodile dung, the droppings of milk-fed lambs, and human feces. Today, the Bedouins of Qatar still use dried camel pats to wipe babies' bottoms. And rural Indians and Pakistanis coat their floors with dung in the belief that it has antiseptic properties, staving off athlete's foot and bacterial infections, and repelling insects. Cow-owning households apply excrement daily (the odor fades as the dung dries), otherwise twice weekly is considered sufficient.*

Des matières fécales aux vertus curatives De tous temps, les médecins ont fait montre d'une prédilection particulière pour les selles. Crottes de blaireau, de crocodile, d'agneau de lait ou d'homme entraient dans la composition de bien des antiques remèdes, censés guérir par exemple la tuberculose, la dysenterie, la surdité ou les seins douloureux. De nos jours, les Bédouins du Qatar utilisent toujours des bouses séchées de chameau pour essuyer les derrières de leurs bébés. Dans les zones rurales de l'Inde et du Pakistan, on recouvre les planchers de bouse, à laquelle on prête des vertus antiseptiques : non contente de repousser les insectes, elle protégerait des mycoses du pied et des infections bactériennes. Les heureux foyers possédant du bétail changent leur bouse quotidiennement (l'odeur se dissipe au séchage). A défaut, deux fois par semaine sont estimées suffisantes.

Knast-Cocktail In amerikanischen Gefängnissen können die Insassen bei ihren Mitgefangenen Punkte sammeln, indem sie die Wärter mit Scheiße bewerfen. Ein voller Erfolg wird dann erreicht, wenn ein solcher »Knast-Cocktail« den Wärter ins Krankenhaus befördert: In frischem Kot finden sich Krankheitserreger, die durch die Schleimhäute in die Augen, die Nase und den Mund eindringen und Tuberkulose und Hepatitis auslösen können. In den USA wird seit langem darüber debattiert, ob es rechtlich zulässig ist, alle Gefangenen auf ansteckende Krankheiten zu untersuchen. Das beste wäre es, so sagen Gefängnisbeamte, die Zellen erkrankter Insassen mit dichtem Fliegendraht abzuschirmen.

Shit-Shot *In US prisons, hurling feces at guards (known as a "correctional cocktail") usually wins prisoners prestige among fellow inmates. More points are scored if the guard ends up in hospital: Pathogens causing tuberculosis and hepatitis, found in fresh feces, can penetrate mucous membranes in the eyes, nose and mouth. US legislators are still debating the legality of testing all prisoners for communicable diseases. Ideally, say prison officials, cells of diseased inmates should be sealed with fine mesh screens.*

Le cocktail correctionnel Dans les prisons américaines, il est de bon ton de jeter des étrons à la face des surveillants. Cette délicatesse attire au lanceur un prestige certain aux yeux de ses codétenus. On marque bien sûr plus de points si l'on envoie le maton à l'hôpital : les selles fraîches contiennent des agents pathogènes de la tuberculose et de l'hépatite, susceptibles de pénétrer l'organisme à travers les membranes des muqueuses oculaires, nasales et buccales. Il a été envisagé de pratiquer sur les prisonniers un dépistage systématique de maladies transmissibles, mais les législateurs américains débattent encore de la légalité de telles procédures. Dans l'idéal, préconisent les administrations pénitentiaires, les cellules des détenus malades devraient être isolées par de fins grillages métalliques.

Conuropsis carolinensis
Sittich/parakeet/perruche

Durchfall Gegen Durchfall (der Kot wird ausgeschwemmt, ohne dem Organismus die Möglichkeit zu geben, Flüssigkeiten oder Nährstoffe aufzunehmen, was eine massive Entwässerung zur Folge hat) hilft ein Päckchen ORT (Orale Rehydratationstherapie) für 20 Pfennig. Oder man löst einen halben Teelöffel Salz und drei Teelöffel Zucker in einem Liter Wasser auf. Vergessen Sie nicht zu essen, am besten sind magenschonende Nahrungsmittel wie Reis oder Brot. Vermeiden Sie unreifes Obst oder rohes Gemüse, zu viel Alkohol oder verunreinigtes Wasser. So trivial der Durchfall auch zu sein scheint – weltweit ist er die häufigste Todesursache bei Kindern.

Diarrhea *To cure diarrhea, spend US$0.08 on a packet of Oral Rehydration Therapy (ORT). Or mix half a teaspoon of salt and three teaspoons of sugar in a liter of water. Remember to eat (bland foods like rice or bread are ideal). Avoid unripe fruit or raw vegetables, too much alcohol, or contaminated water. It sounds simple – yet diarrhea (caused by the intestines sweeping out feces without giving you time to absorb fluids or nutrients, leading to massive dehydration) is the biggest killer of children worldwide.*

Le flux de ventre Pour soigner votre diarrhée, investissez 60 centimes dans un paquet de TRO (thérapie de réhydratation orale). Ou mélangez tout simplement une demi-cuillerée à café de sel et trois de sucre à un litre d'eau. N'oubliez pas de vous alimenter (choisissez des aliments neutres, tels le riz blanc ou le pain sec). Evitez les fruits encore verts et les légumes crus, l'abus d'alcool et l'eau contaminée. Voilà qui semble simple. Pourtant, la diarrhée (provoquée par un dérèglement des intestins, qui évacuent les selles sans laisser à l'organisme le temps d'absorber liquides et nutriments, entraînant ainsi une importante déshydratation) reste la cause de mortalité infantile la plus fréquente dans le monde.

Fennecus zerda, Wüstenfuchs/fennec/fennec

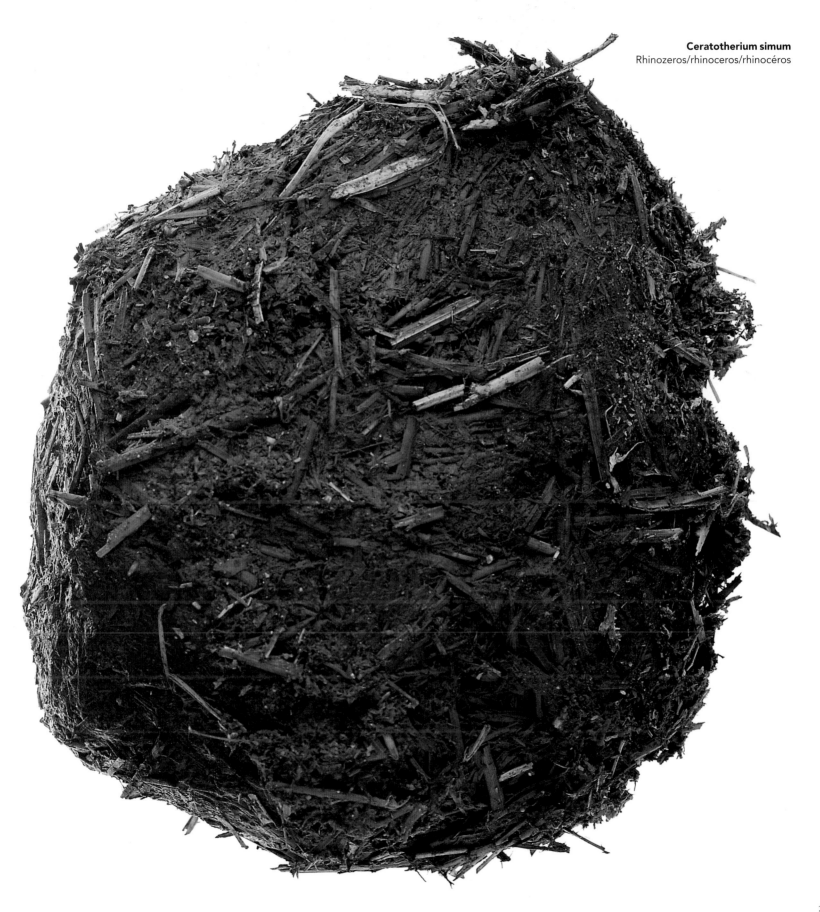

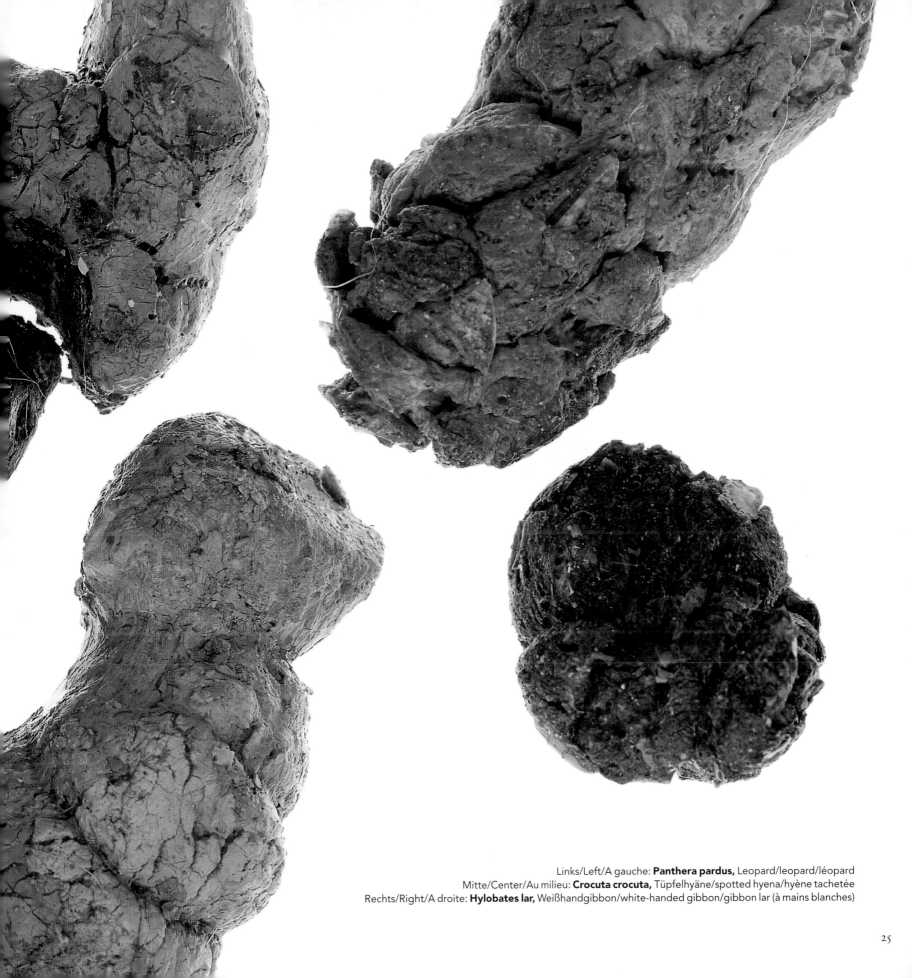

Links/Left/A gauche: **Panthera pardus,** Leopard/leopard/léopard
Mitte/Center/Au milieu: **Crocuta crocuta,** Tüpfelhyäne/spotted hyena/hyène tachetée
Rechts/Right/A droite: **Hylobates lar,** Weißhandgibbon/white-handed gibbon/gibbon lar (à mains blanches)

Das Bidet Es wurde von den Franzosen erfunden, sein Name bedeutet »kleines Pferd«, man sitzt darauf wie auf einem Sattel, und es wird auch als »Beichtvater der Frauen« und »unaussprechliche Geige« bezeichnet. Es wurde in den 1730er Jahren erfunden und fand zuerst unter Prostituierten Verbreitung, die sich in der Hoffnung, Geschlechtskrankheiten verhindern zu können, nach dem Verkehr darin wuschen. Schon bald wurde es von den Italienern übernommen, und der faschistische Diktator Benito Mussolini war derart davon beeindruckt, daß er seinen Offizieren die regelmäßige Benutzung befahl. Die Briten jedoch schauen immer noch auf das Bidet – ein niedriges Becken zur bequemen Reinigung des Anus und der Genitalien – herab und nennen es abfällig »French bidet«. In Italien werden jährlich 1,5 Millionen Bidets produziert, und in Japan gilt es als Luxusobjekt, doch in seiner Heimat hat das »kleine Pferd« in den letzten Jahren schnell an Gunst verloren: Während in den 1970er Jahren noch 90 Prozent aller Badezimmer in französischen Haushalten ein Bidet hatten, sind es heute nur noch 40 Prozent.

The Bidet *It was invented by the French, named after a small horse and designed to be straddled. Known variously as the "woman's confessor," and "the unspeakable violin," it was first popularized by prostitutes, who used it to wash after intercourse in the hope of avoiding venereal diseases. The Italians adopted it soon after its invention in the 1730s, and Fascist dictator Benito Mussolini was so impressed with it that he imposed its use on his army officers. Yet the bidet – a low basin that allows users to wash the anus easily – is still spurned by the British, who refer to it dismissively as the "French bidet." And although Italy produces 1.5 million bidets a year, and the Japanese consider it a luxury object, the "little horse" is fast losing favor in its home country: Only 40 percent of French household bathrooms have one today, compared to 90 percent in the 1970s.*

Le bidet D'invention française, il reçut un nom désignant jusqu'alors un petit cheval de selle, et fut conçu pour être chevauché. Autrement connu sous les titres de « confesseur des dames » et de « violon innommable », il fut à l'origine popularisé par les prostituées qui, guettées par les maladies vénériennes, prenaient après les rapports des bains de siège à vocation censément prophylactique. Les Italiens l'adoptèrent sitôt après son invention, dans les années 1730, et le dictateur fasciste Benito Mussolini en conçut une si bonne opinion qu'il en imposa l'usage aux officiers de ses armées. Pourtant, le bidet – une vasque basse facilitant le lavage de l'anus – est toujours boudé sur les îles Britanniques, où il est qualifié avec mépris de « bidet français ». Et l'Italie a beau en produire chaque année 1,5 million, les Japonais ont beau l'avoir haussé au rang d'objet de luxe, le « petit cheval » perd rapidement la faveur de sa mère patrie. Aujourd'hui, 40 % seulement des salles de bains françaises en sont équipées, contre 90 % dans les années 1970.

Serinus canarius, Kanarienvogel/canary/canari

Wundermittel Tigerkot Tigerkot kann Alkoholismus heilen: Man löse etwas pulverisierten Dung in Wein auf, verabreiche ihn dem Betroffenen, und sein Verlangen nach Alkohol wird schwinden. Bei einem Alkoholiker aus Taiwan, dem das Exkrement gratis vom Zoo in Taipeh überlassen wurde, hat es gewirkt. »Wir wollten kein Geld dafür nehmen, weil der Zoo eine Bildungseinrichtung ist«, sagt der Zoodirektor Ming-chieh Chao. In Großbritannien ist Tigerkot noch nicht als Heilmittel anerkannt, doch die Zoowärter schwören auf seine Schutzwirkung vor ungebetenen Gästen: Der Kot enthält starke chemische Wirkstoffe, Pheromone, die Katzen, Füchse und das Wild aus der Nachbarschaft glauben lassen, daß ein 180 kg schwerer Kater auf der Lauer liegt. »Ich lege ihn auch um mein Vogelhaus aus, um die Katzen fernzuhalten«, sagt Robin Godbeer vom Dartmoor Wildlife Park. Tigerkot (ca. 3 DM für 3,2 kg) sollte in einem Netz vor dem Garten aufgehängt oder um ihn herum verstreut und alle vier bis fünf Wochen ausgetauscht werden.

Tiger-Poo Miracle Cure! *Tiger poo can cure alcoholism: Dissolve some powdered dung in wine, give it to the afflicted, and their craving for alcohol will subside. It worked for one Taiwanese alcoholic, who was given the excrement free by Taipei Zoo. "We decided not to sell it because the zoo is an educational institution," says general curator Ming-chieh Chao. In the UK, tiger dung hasn't yet been accepted as a medical remedy, but zookeepers swear by it as a garden pest repellent: The excrement contains powerful chemical substances, or pheromones, that make unwanted visitors (like neighborhood cats, deer and foxes) think there's a 180kg tomcat in the vicinity. "I use it myself around the edges of my aviary to keep the cats away from the birds," confided Robin Godbeer from the UK's Dartmoor Wildlife Park. For best results hang the dung (UK£1, or US$1.50, for 3.2kg) in a mesh bag off the ground or sprinkle it around the perimeter of the garden. Reapply every four to five weeks.*

Un remède souverain Le caca de tigre peut guérir de l'alcoolisme. Faites dissoudre un peu d'excréments en poudre dans du vin et administrez le mélange au malade : le besoin d'alcool décroîtra graduellement. La méthode a fonctionné en tout cas chez un alcoolique taïwanais, à qui le zoo de Taipeh a gracieusement offert la matière première. « Nous avons décidé de ne pas la vendre parce que notre zoo est une institution à vocation éducative », déclare Ming-chieh Chao, le conservateur général du parc. En Grande-Bretagne, la médecine n'a pas encore reconnu les vertus thérapeutiques des crottes de tigre, mais les gardiens de zoos ne jurent que par elles pour éloigner les animaux nuisibles des jardins. Elles dégagent en effet de puissantes substances chimiques, appelées phéromones, laissant croire aux visiteurs indésirables (tels les chats du voisinage, les chevreuils et autres renards) qu'un matou de 180 kg rôde dans les parages. Résultats optimaux garantis en suspendant les crottes (achetées au prix de 10 francs le sac de 3,2kg) au-dessus du sol, dans un filet, ou en les dispersant autour du périmètre de votre jardin. A renouveler toutes les quatre à cinq semaines.

Heilige Scheiße! Als vor hundert Jahren das Gerücht aufkam, der Kot des Dalai Lama – des geistlichen Oberhaupts der tibetanischen Buddhisten – habe heilende Eigenschaften, ließ der britische Stabsarzt Proben dieses Kots im Interesse der Wissenschaft analysieren. Etwas Bemerkenswertes konnte nicht gefunden werden. Das scheint sich herumgesprochen zu haben. Einem Sprecher der in Großbritannien ansässigen Tibet Foundation zufolge gibt es heute nicht einmal mehr getragene Kleidung des Dalai Lama zu kaufen, geschweige denn seine Exkremente. Jahrhundertelang haben Exkremente in vielen Religionen eine wichtige Rolle gespielt, und in manchen Kulturen haben sie heute noch eine zeremonielle Bedeutung. Die Azteken stellten ihren Gott der Fleischeslust als menschliche Exkremente verzehrendes Wesen dar, manche Hindus essen Kuhdung als Buße für ihre Sünden, und Aborigines im Süden Australiens bestreichen sich zum Zeichen der Trauer mit Tierkot. Nicht alle religiösen Gruppen teilen jedoch diese Vorliebe für Kot. Fromme Juden zum Beispiel dürfen weder beten noch die Schriften studieren, wenn sie Stuhldrang verspüren.

Holy Shit! *A hundred years ago, rumors that the feces of the Dalai Lama – the spiritual leader of Tibetan Buddhists – had beneficial properties prompted the UK's Surgeon General to analyze them in the interests of science. They contained nothing remarkable, he concluded. Just as well: According to a spokesperson at the UK-based Tibet Foundation, "These days you can't even buy the Dalai Lama's used clothes, never mind his excrement." Elsewhere, though, feces have played central roles in religious ceremonies for centuries. The Aztec god of carnal pleasure is traditionally depicted eating human excrement, some Hindus atone for their sins by eating cow dung, and Aboriginals in southern Australia cover themselves with animal feces during mourning. However, not all religious groups share the same enthusiasm. Pious Jews, for example, are forbidden to pray or study the Scriptures while feeling the urge to defecate.*

Des selles divines ! Il y a cent ans, la rumeur courut que les selles du Dalaï-Lama – chef spirituel des bouddhistes tibétains – avaient des propriétés bénéfiques, ce qui incita le médecin-général britannique à les analyser dans l'intérêt de la science. Elles ne contenaient rien de remarquable, conclut-il. Autant s'en féliciter. Car, déplore un porte-parole de la Fondation du Tibet, basée au Royaume-Uni, « ces derniers temps, on ne parvient même plus à acheter les vêtements usagés du Dalaï-Lama – alors, ses excréments, vous pensez! » Il est pourtant d'autres contrées où les déjections jouent depuis des siècles un rôle tout à fait central dans bien des célébrations cultuelles. Le dieu aztèque des plaisirs charnels est traditionnellement représenté en train de dévorer des excréments humains ; certains hindous expient leurs péchés en mangeant de la bouse de vache ; les Aborigènes d'Australie méridionale se couvrent de crottes d'animaux en période de deuil. Cependant, toutes les communautés religieuses ne partagent pas le même enthousiasme. Pour un juif très pieux, par exemple, il est interdit de prier ou d'étudier les Ecritures en cas d'envie pressante.

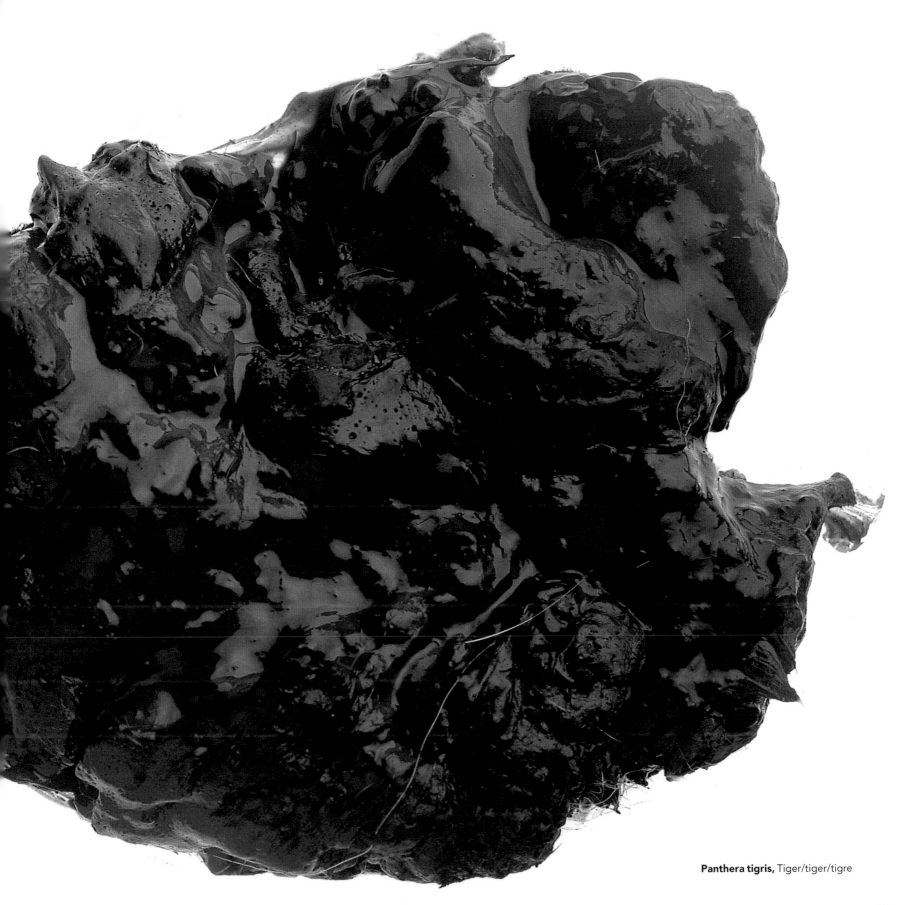

Panthera tigris, Tiger/tiger/tigre

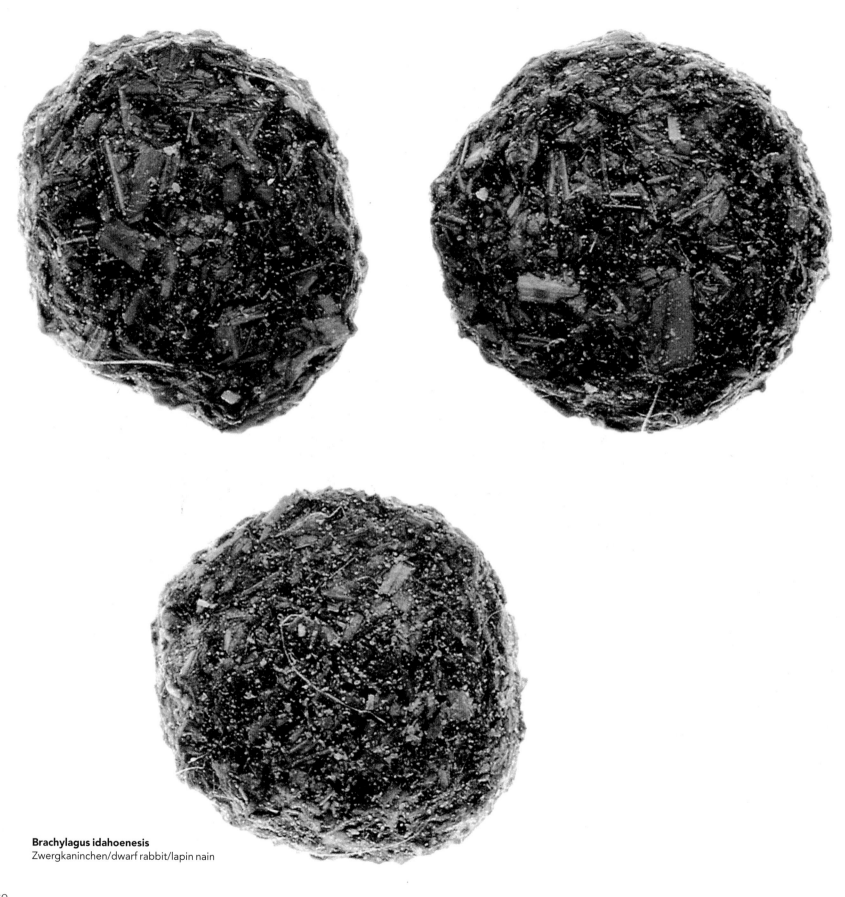

Brachylagus idahoenesis
Zwergkaninchen/dwarf rabbit/lapin nain

Guten Appetit! Die Koprophagie (das Kotessen) ist weiter verbreitet als man glauben möchte: Die meisten Kleinkinder unter zweieinhalb Jahren kosten ihren Kot, und Geruchsforscher fanden zu ihrer Überraschung heraus, daß Babys Kot genausogern riechen wie den Geruch von Bananen. Glücklicherweise hält diese Vorliebe nicht allzu lange an: Durch Speichel, ein natürliches Antiseptikum, und Magensäuren werden die sich in kleinen Mengen Kot befindenden Krankheitserreger normalerweise abgetötet, doch größere Happen können Kopfschmerzen, Erbrechen, Gelbsucht, Hepatitis, Gastroenteritis und Cholera verursachen. Bei Erwachsenen ist die Koprophagie nicht sehr häufig anzutreffen, doch gelegentlich frönen ihr einige Fetischisten und geistig Zurückgebliebene. Unfreiwillig wahrscheinlich auch Sie: Ungeklärte Abwässer sind weltweit die häufigste Ursache für verschmutztes Trinkwasser, und allein in Indien gehen 80 Prozent aller Erkrankungen darauf zurück.

No Shit! *Coprophagy (eating excrement) is more common than people think: Most toddlers taste their feces before the age of two and a half, and researchers studying smells were surprised to learn that the odor of feces was as popular with infants as that of bananas. The fecal fascination doesn't last long, fortunately: Saliva, a natural antiseptic, and stomach acids can usually kill pathogens present in trace amounts of excrement, but mouthfuls can cause headaches, vomiting, jaundice, hepatitis, gastroenteritis and cholera. In adults, coprophagy is less common, but some fetishists and the mentally retarded indulge occasionally. As do you, probably: Raw sewage is the most common pollutant in drinking water worldwide, and causes 80 percent of all diseases in India alone.*

Bon appétit! La coprophagie (consommation d'excréments) est une pratique plus répandue que l'on ne croit: la plupart des enfants goûtent à leurs selles avant l'âge de 30 mois. Les chercheurs spécialistes des odeurs ont d'ailleurs découvert, non sans surprise, que le fumet des excréments est aussi voluptueux aux narines des nourrissons que le parfum de la banane. Cette fascination fécale n'est que passagère, fort heureusement du reste: en quantité minime, les excréments restent assimilables – antiseptique naturel, la salive tue généralement une bonne part des agents pathogènes, et les acides gastriques ont raison du reste. En revanche, qu'on s'avise d'avaler du caca à grosses bouchées, et l'on encourt maux de tête, nausées, jaunisses, hépatites, gastro-entérites et choléra. Chez l'adulte, la coprophagie est moins courante, bien que certains fétichistes et les attardés mentaux s'y adonnent à l'occasion. Tout comme vous, probablement, sans le vouloir: les eaux usées non traitées sont la première cause de pollution de l'eau potable dans le monde; on leur attribue d'ailleurs 80% des maladies dans le sous-continent indien.

Die Kreml-Pille Wenn Sie davor zurückschrecken, in Ihren eigenen Exkrementen zu stochern, ist die Kreml-Pille wohl nicht das Richtige für Sie. Diese Metallkapsel setzt sich aus zwei Elektroden, einem Mikroprozessor und einem Batterietester zusammen und verdankt ihren Namen dem früheren sowjetischen Präsidenten Leonid Breschnew, der sie zu seiner Lieblingsmedizin erkor. Über die Details können wir keine Auskunft geben, doch die Kreml-Pille scheint ungefähr so zu funktionieren: Hat man sie verschluckt, durchwandert sie den Verdauungstrakt und sendet elektrische Impulse aus, die zu Muskelkontraktionen führen. Diese zwingen »untätige Bereiche« der Eingeweide, hartnäckig dort verharrende Abbauprodukte auszustoßen. Das Ergebnis sind sauberere, gesündere Innereien. Die Pille verläßt den Verdauungstrakt auf natürlichem Wege. Einer Moskauer Quelle zufolge gehört die Kreml-Pille im heutigen Rußland zu den populärsten »alternativen« Behandlungsmethoden. Zwar ist sie mit ca. 100 DM für die meisten Russen kaum erschwinglich, doch kann sie wieder und wieder verwendet werden.

The Kremlin Tablet *If you have qualms about picking through your own excrement, the Kremlin Tablet is not for you. The favorite medicine of former Soviet president Leonid Brezhnev, the metal tablet is composed of two electrodes, a microprocessor and a battery checker. We're not too clear on the details but the Kremlin Tablet seems to work something like this: Once swallowed, it settles in your digestive system and starts emitting electrical impulses that cause your digestive muscles to contract. These contractions force "non-functioning areas" of the intestine to expel stubborn waste matter, leaving you with cleaner, healthier insides. Either way, the pill passes directly out of your system. The Kremlin Tablet is one of the most popular "alternative" medical treatments now sweeping Russia, according to one Moscow source. Though its cost is prohibitive for most Russians (US$50), the tablet can be used again and again. And that's where the part about the excrement comes in.*

La pastille de Brejnev Si vous ressentez quelque scrupule à fouiller dans vos selles, alors le comprimé du Kremlin n'est pas pour vous. Ainsi nommée parce qu'elle était le remède favori de l'ancien président soviétique Leonid Brejnev, cette pastille métallique se compose de deux électrodes, d'un microprocesseur et d'un circuit de contrôle des batteries. Le système nous échappe quelque peu dans le détail (et, en la matière, la notice n'aide guère), mais le comprimé du Kremlin semble fonctionner ainsi: une fois avalé, il s'installe dans vos boyaux et commence à émettre des impulsions électriques qui induiront la contraction des muscles digestifs. Par ce biais, vous forcerez les « portions inopérantes » de l'intestin à expulser les résidus fécaux récalcitrants, ce qui vous laissera la tripe fraîche, purifiée et assainie. Et, quoi qu'il advienne, le cachet est évacué de votre système par les voies naturelles. Selon une source moscovite, le comprimé du Kremlin fait un véritable malheur en Russie; il compte parmi les traitements médicaux « alternatifs » vedettes du pays malgré son coût qui reste prohibitif pour une vaste majorité de Russes (350 FF).

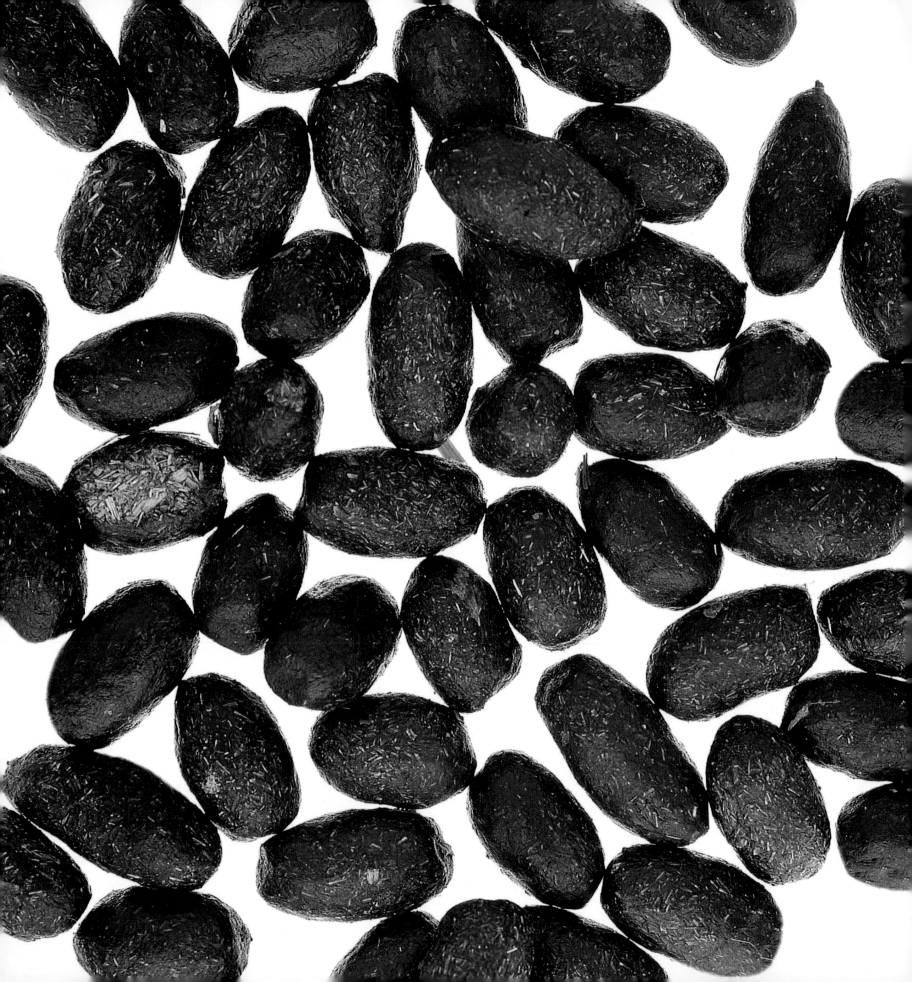

Der Einlauf Seit Jahrtausenden reinigen die Menschen ihre Gedärme. Einläufe (die Einführung von Flüssigkeit in das Rektum, um Verstopfungen zu lösen) werden schon in alten ägyptischen Schriften erwähnt, und den Griechen – die dafür eine Kochsalzlösung bevorzugten – verdanken wir das Wort »Klistier« (das »Spülung« bedeutet). Auch bei den Indianern, den Chinesen und den Hindus war diese Behandlungsmethode sehr beliebt. Die Maya, die Exkremente für etwas Göttliches hielten, würzten ihre Einläufe mit Halluzinogenen und spritzten sich in der Hoffnung, mit den Göttern in Verbindung zu treten, eine Mischung aus fermentiertem Honig, Tabaksaft, pulverisierten Pilzen und Samen ins Rektum. Der französische König Ludwig XIV. ließ sich während seiner Herrschaft mehr als 2.000 Einläufe verpassen, oft im Beisein ausländischer Würdenträger. Aus hygienischen Gründen ist heutzutage vor einem operativen Eingriff ein Einlauf obligatorisch (unter der Narkose entspannt sich der Schließmuskel). Die Patienten dürften jedoch keinen so großen Genuß dabei verspüren wie die alten Römer, deren Lieblingsrezept für Einläufe sich wie folgt zusammensetzte: ein Liter Rotwein, fünf Eidotter, zwei Eßlöffel Olivenöl und ein Spritzer Trüffelsaft.

The Enema *Humans have been purging their intestines for millenia. References to enemas (the injection of liquid into the rectum to flush out stubborn feces) are found in ancient Egyptian writings, and the Greeks – who favored a saline solution – gave us the word itself (it means "send in"). Other fans of the treatment have included Native Americans, Chinese and Hindus. The Mayans, believing excrement was divine, spiced up their enemas with hallucinogens, squirting up a mixture of fermented honey, tobacco juice, powdered mushrooms and seeds in an attempt to communicate with the gods. At his 17th century French court, King Louis XIV was given over 2,000 enemas during his reign, often meeting foreign dignitaries during the procedure. These days, enemas are obligatory before surgery, to keep things from getting messy (anesthetic relaxes the sphincter). But patients are unlikely to get as much fun out of it as ancient Romans: Their favorite purging recipe was one liter of red wine, five egg yolks, two tablespoons of olive oil and a dash of truffle juice.*

Le purgatif L'homme se purge les intestins depuis des millénaires. On a ainsi trouvé des références aux clystères (injections de liquide dans le rectum afin d'évacuer les selles rétives) dans d'antiques écrits égyptiens, et c'est aux Grecs – partisans des solutions salines – que nous devons le nom du procédé (il signifie « laver »). Parmi les adeptes historiques du traitement, citons également les Amérindiens, les Chinois et les hindous. Quant aux Mayas, qui voyaient dans les excréments une matière divine, ils épiçaient leurs lavements de substances hallucinogènes, s'injectant par voie anale un mélange de miel fermenté, de jus de tabac, de champignons en poudre et de graines dans l'espoir de communiquer avec les dieux. A la cour de France, au XVII^e siècle, le roi Louis XIV se vit administrer plus de 2000 clystères durant son règne, recevant souvent des dignitaires étrangers pendant l'opération. De nos jours, les lavements sont obligatoires avant une intervention chirurgicale, pour éviter quelques fâcheux désordres (les anesthésiants relâchent les sphincters). Toutefois, gageons que les patients n'en tireront pas autant d'amusement que la Rome antique. Le purgatif préféré des Romains se préparait comme suit : un litre de vin rouge, cinq jaunes d'œufs, deux cuillerées à soupe d'huile d'olive et un soupçon de jus de truffe.

Rechts/Right/A droite:
Lampropeltis getula californiae, Königsnatter/king snake/serpent royal
Gegenüberliegende Seite/Opposite/Page de gauche:
Orix gazella, Oryxantilope/oryx/oryx

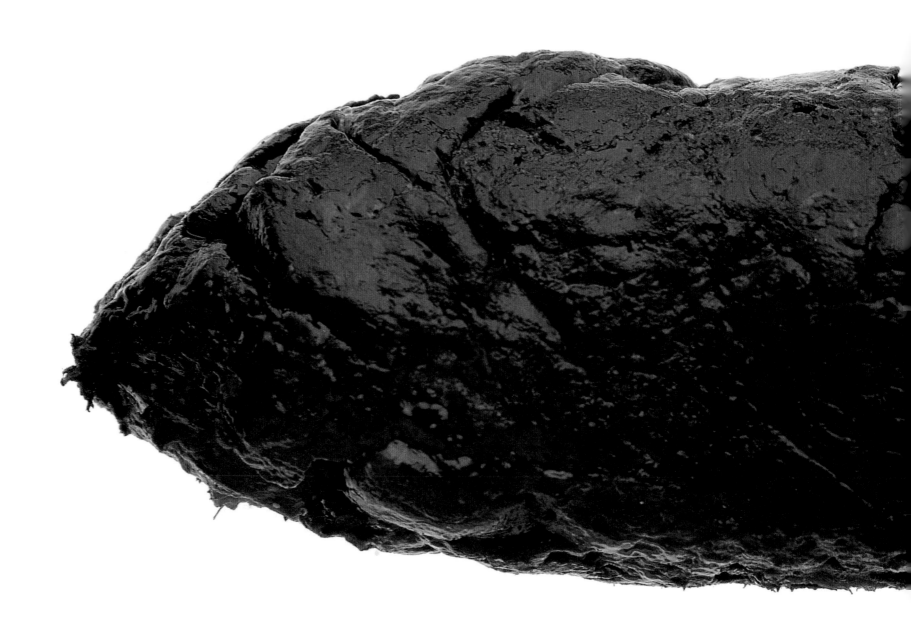

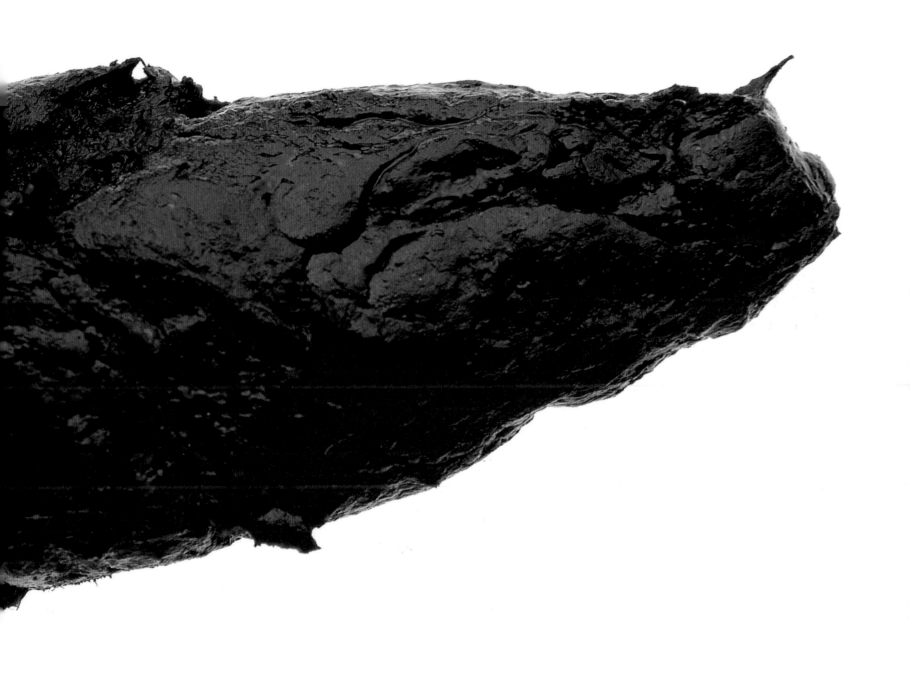

Homo sapiens, Mensch/human/homme

Koprolithen Versteinerte Exkremente – »Koprolithen« – sind bei einigen Kuriositätensammlern heiß begehrt. Man findet sie in allen erdenklichen Größen, von den von wirbellosen Tieren abgelegten Kügelchen bis hin zu den riesigen Haufen der Dinosaurier. Gute Exemplare sind jedoch nur selten zu finden, sagt Allie Garrahan von Montana Fossils in den USA. »Koprolithen gibt es jede Menge, aber den meisten fehlt die Farbe, an der man sie als solche erkennen kann.« Für braune Koprolithen und solche mit »persönlicher Note« muß man deshalb tiefer in die Tasche greifen; die größten Exemplare kosten ca. 930 DM. Anders als menschliche Paläofäkalien – getrocknete menschliche Exkremente sind gelegentlich in Höhlen zu finden – riechen Koprolithen nicht, und sie brauchen auch keine Pflege. Allie präsentiert uns ein paar: »Die hier sind 55.000 Jahre alt, da ändert sich nichts mehr. Aber um sie richtig frisch aussehen zu lassen, genügt ein bißchen Olivenöl.«

Coprolites *Fossilized droppings are highly prized by some curio collectors. Known as coprolites, mineralized dung comes in a wide range of sizes, from pellet-size invertebrate feces to huge dinosaur deposits. But good ones are hard to find, says Allie Garrahan of US-based Montana Fossils. "There are coprolites all over," she says. "But they're not the color that they should be to resemble what they are." Consequently, brown ones and those with personality ("squiggly ones") are more expensive, with the biggest specimens selling for US$450. Unlike human paleofeces (dried human droppings sometimes found in caves), coprolites don't smell, and are low-maintenance. "These things are 55,000 years old," Allie points out. "They're not going to change. But if you want to make one look really fresh, put a little olive oil on it."*

Les coprolithes Les excréments fossiles sont hautement prisés de certains collectionneurs de curiosités. Connues sous le nom de coprolithes, les crottes minéralisées se présentent dans une grande variété de tailles, depuis les petites boulettes semées par les invertébrés jusqu'aux énormes monticules laissés par les dinosaures. Néanmoins, difficile d'en dénicher de bonnes, avertit Allie Garrahan, de la société Fossiles du Montana, basée aux Etats-Unis. « Il y a des coprolithes partout, dit-elle, mais aujourd'hui ils n'ont plus la couleur qu'ils devraient pour ressembler à ce qu'ils sont. » En conséquence, les spécimens d'une belle teinte brune ou dotés d'une certaine personnalité (les « beaux tortillons ») sont les plus chers à la vente, les grosses pièces atteignant 3 100 francs. Contrairement aux paléo-excréments humains (les crottes desséchées de nos lointains ancêtres, que l'on trouve parfois dans les cavernes), les coprolithes sont inodores et d'entretien facile. « Ces petites choses-là ont 55 000 ans, souligne Allie. Ce n'est pas maintenant qu'elles vont changer. Mais si vous tenez à leur donner l'aspect du frais, enduisez-les d'huile d'olive. »

Carassius auratus, Goldfisch/goldfish/poisson rouge

Die Qual der Wahl Die Hälfte der Weltbevölkerung hat keinen Zugang zu Toiletten oder sanitären Anlagen, die diesen Namen verdienen. Die andere Hälfte hat die Qual der Wahl. Für Leute mit ökologischem Bewußtsein gibt es das australische Rota-Klo, das mit Hilfe von Bakterien Fäkalien und Wasser kompostiert: Aus acht Tonnen Scheiße (der jährlichen Durchschnittsmenge einer Person) können 20 kg organischer Dünger gewonnen werden. Der »Peacekeeper« aus den USA beugt Familienstreitigkeiten vor (die Spülung läßt sich nur bei heruntergeklapptem Sitz betätigen). Für gesundheitsbewußte Technologiefans entwickelt die japanische Firma Toto das Modell »Medical Queen«, das den Urin analysieren, den Blutdruck messen und die Daten über das eingebaute Modem an den Arzt des Besitzers weiterleiten wird. Das klassische deutsche Flachspülklosett ist eine Low-Tech-Alternative: Die Exkremente landen auf dem flachen Beckenboden, so daß sie bequem inspiziert werden können. 70 Prozent der Deutschen ziehen jedoch Tiefspülklosetts vor, bei denen die Exkremente direkt ins Wasser fallen. Warum? Aus ästhetischen Gründen, sagt Jorge Kramer vom deutschen Toilettenhersteller Villeroy & Boch. »Bei diesen Klosetts gibt's keinen Geruch und keine Streifen.«

Agonizing over the Toilet *Half the world's population doesn't have access to toilets or adequate sanitation. The rest are spoiled for choice. For the ecology-minded, there's the Australian Rota-loo. It uses bacteria to compost feces and water: Eight tons of waste (the average person's yearly output) can produce 20kg of organic fertilizer. The US-made Peacekeeper was designed to resolve family arguments (it flushes only when the seat is lowered). For health-conscious technology fans, the Japanese company Toto is developing the Medical Queen, which will analyze urine and measure blood pressure, then fax the data to your doctor with its built-in modem. The classic German washout toilet is a lower-tech alternative: The feces land on a ledge in the bowl, making them easy to inspect for disease. Despite this, 70 percent of Germans prefer to use washdowns (where waste hits the water directly). Why? It's cosmetic, says Jorge Kramer of German toilet manufacturers Villeroy & Boch. "With washdowns, there's no smell and no stripes."*

L'embarras du choix La moitié de la population mondiale n'a pas accès à des toilettes ni à des installations sanitaires dignes de ce nom. L'autre moitié n'a que l'embarras du choix. Pour les écolos, voici le Rota-loo (W. C.-recyclage) australien qui, au moyen de bactéries, transforme en compost le mélange des selles et de l'eau. Huit tonnes de matière évacuée, solide et liquide (soit la production annuelle de l'individu moyen) peuvent ainsi produire 20 kg d'engrais bio. De fabrication américaine, le Peacekeeper (casque bleu) a été conçu quant à lui pour mettre fin aux litiges familiaux (la chasse d'eau ne se déclenche que lorsque la lunette est abaissée). Pour les passionnés de technologie à tendance hypocondriaque, la société japonaise Toto met actuellement la dernière main à sa Reine médicale, des toilettes qui analyseront vos urines et mesureront votre tension artérielle, puis faxeront les résultats à votre médecin traitant grâce à leur modem intégré. Notons que le grand classique allemand dit à «évacuation par balayage» rend des services similaires dans une version moins hi-tech: les selles atterrissent sur une plate-forme à mi-cuvette avant de toucher l'eau, ce qui facilite leur inspection pour rechercher d'éventuelles maladies. Cependant, 70 % des Allemands préfèrent les toilettes à «évacuation directe» (où les selles partent directement dans l'eau). Pourquoi? Question d'esthétique, estime Jorge Kramer, qui travaille pour le fabricant de toilettes allemand Villeroy & Boch. «Avec l'évacuation directe, pas d'odeurs, pas de traces.»

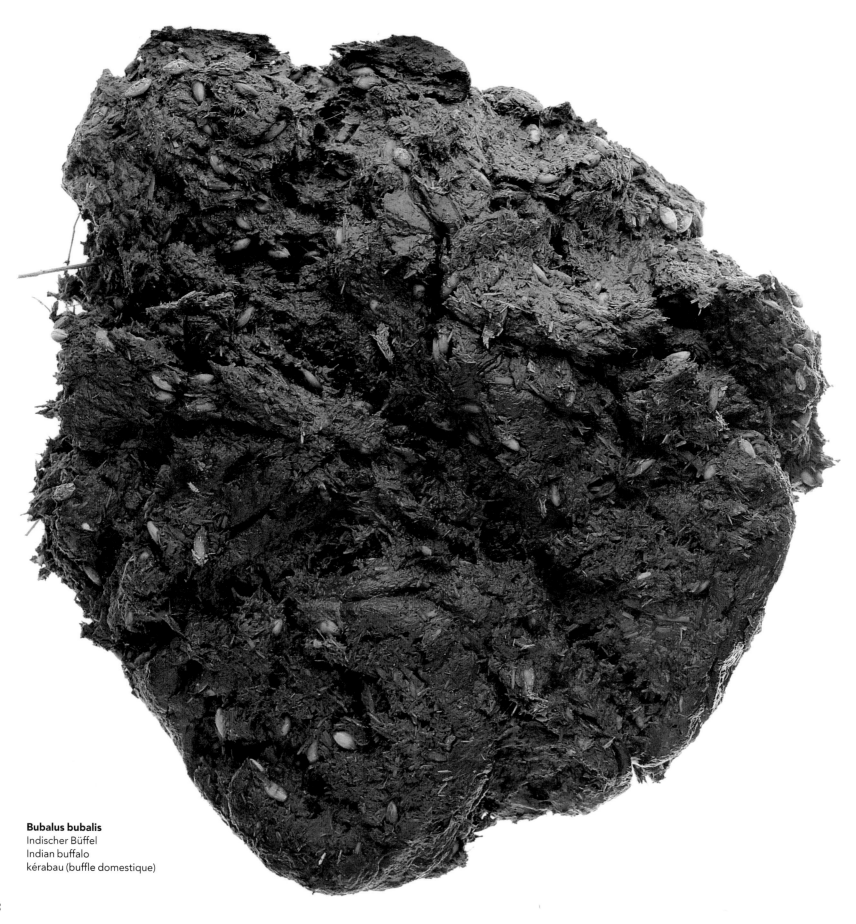

Bubalus bubalis
Indischer Büffel
Indian buffalo
kérabau (buffle domestique)

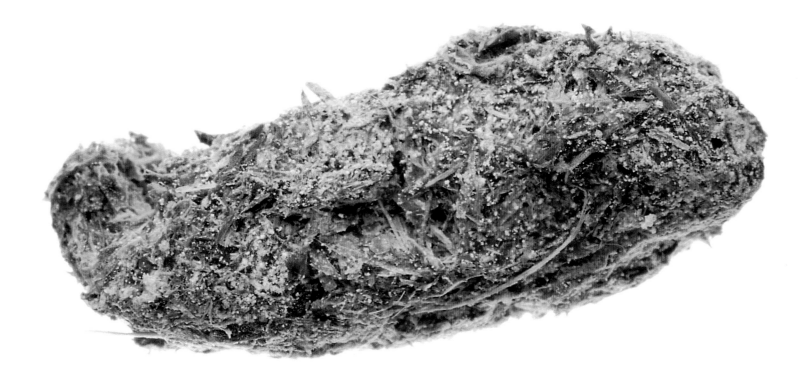

Synthetische Scheiße Um die Saugfähigkeit von Windeln zu testen, wurden sie früher mit Kartoffelbrei, Erdnußbutter oder Kürbiskompott bestrichen. Da sich diese Substanzen jedoch schneller verflüssigten als Babykot, stellten sie keinen vollwertigen Ersatz dar. Dann ließ der amerikanische Windelfabrikant Kimberley-Clark einen synthetischen, geruchlosen Babykot patentieren, ein Gemisch aus pulverisierter Zellulose, Weizenkleie, Harz, Farbstoffen und Wasser. Damit können heute dünnflüssige Ausscheidungen und geschmeidige oder härtere, kleinere oder größere Häufchen simuliert werden. Der japanische Toilettenhersteller Toto testet seine Produkte mit Hilfe künstlicher Haufen aus Miso-Paste – einer Mischung aus fermentierten Sojabohnen, Reis und Salz.

Faking a Poo *To test diapers, designers used to pump mashed potatoes, peanut butter or pumpkin pie mix into diapers worn by live babies. But because these mixtures separated into liquids faster than human feces, nothing could compare with the real thing. Then US manufacturer Kimberley-Clark patented its own synthetic, odorless feces. Mixing powdered cellulose, wheat bran, resin and colorants with water, diaper designers can now prepare batches of runny stools, smooth paste or dense pellets. In Japan, toilet manufacturer Toto tests its products using fake turds made from miso paste – a mixture of fermented soybeans, rice and salt. "Chunks of miso are soft, and we can change their shape and density," says company engineer Takashi Higo. "That allows us to simulate floating and sinking situations."*

Le caca synthétique Pour tester leurs produits, les concepteurs de couches bébé usaient jusqu'à ce jour d'ingrédients popote: purée de pommes de terre, beurre d'arachide ou potiron écrasé. Hélas, rien n'égalait la substance originale, ces mixtures se liquéfiant plus vite que les selles humaines. Ce fut alors que le fabricant américain Kimberley-Clark patenta son propre caca synthétique, garanti sans odeur. En mélangeant de la poudre de cellulose, du son de blé, de la résine et des colorants à une certaine quantité d'eau, les bureaux d'étude sont désormais en mesure de concocter des lots de caca mou, de caca pâteux ou de petites crottes bien dures. Au Japon, le fabricant de toilettes Toto teste ses produits grâce à de faux étrons confectionnés à partir de *miso* – une pâte à base de haricots de soja fermentés, de riz et de sel.

Stuhlgang im All Die Schwerelosigkeit stellt dem Stuhlgang beträchtliche Hindernisse in den Weg. Da es im All keine Schwerkraft gibt, die den Kot aus den Gedärmen zieht und im Klosettbecken ruhen läßt, mußten sich die sowjetischen und amerikanischen Raumfahrtingenieure etwas Neues einfallen lassen. Sie entwickelten den Orbiter (Spitzname: Dry John), ein Vakuumsystem mit rotierenden Schaufelblättern, die die Fäkalien einsaugen und in einer dünnen Schicht auf die Wand des Behälters verteilen. Der Orbiter verfügt zwar über Griffe, damit die Astronauten ihn in der richtigen Stellung halten können, aber trotzdem bleibt es eine Herausforderung, sich im Raum schwebend sauber in eine 8 cm breite Vakuumröhre zu entleeren. »Das Zielen will gelernt sein«, sagt der französische Astronaut Jean-François Clervoy, der, als wir mit ihm sprachen, an einem Trainingsprogramm der amerikanischen Raumfahrtbehörde NASA teilnahm. »Wir üben mit Hilfe einer Videokamera, die auf den After gerichtet ist. Auf einem Monitor können wir uns beim Scheißen beobachten, um die richtige Sitzhaltung einzustudieren.« Sollte der Orbiter seinen Geist aufgeben, greifen die Astronauten auf primitivere Methoden zurück: Sie befestigen mit Klebeband einen Plastikbeutel an ihrem Hintern, erledigen ihr Geschäft und versiegeln den Beutel.

Shitting in Space *Weightless environments seriously hinder your toilet activities. For travel in space, where there's no gravity to pull feces out of your intestine or keep them in the toilet, Soviet and US space engineers had to redesign traditional lavatories. They came up with the Orbiter (nicknamed the Dry John), a vacuum system with rotating blades that suck in feces and scatter them in a thin layer on the reservoir wall. It has handholds for astronauts to grab to help them stay in place, but defecating neatly into an 8cm-wide vacuum tube while floating in space still remains a challenge. "It's not easy to aim," says French astronaut Jean-François Clervoy, currently training with US space agency NASA. "We practice with a video camera underneath that films your anus excreting. You watch on a TV monitor to learn just how to sit." If the toilet breaks down, astronauts resort to pre-Orbiter disposal methods: They tape a plastic bag to their butt, defecate and seal.*

Comment déféquer dans l'espace L'apesanteur complique sérieusement vos activités excrétoires. Lors d'un voyage dans l'espace, on ne peut plus compter sur la force de gravité pour tirer les selles hors du corps et les maintenir dans la cuvette des toilettes. Pour résoudre ce problème, les ingénieurs de l'aérospatiale soviétique et américaine ont dû repenser le système des toilettes traditionnelles. C'est ainsi qu'ils mirent au point l'Orbiter (surnommé « chiottes-à-sec ») , un système à lames rotatives qui aspire les selles et les répand en une fine couche homogène dans les parois du réservoir. L'installation est équipée de poignées pour permettre aux astronautes de rester en place, mais déféquer proprement dans un tube d'aspiration large de 8 cm, tout en flottant dans l'espace, tient toujours de l'exploit sportif. « Ce n'est pas facile de viser, avoue l'astronaute français Jean-François Clervoy, qui s'entraîne actuellement sous les auspices de la NASA, l'agence spatiale américaine. On s'entraîne à l'aide d'une caméra vidéo placée juste en dessous, qui filme votre anus en train d'excréter. On suit l'opération sur un écran télé, pour apprendre à s'asseoir correctement. » En cas de panne du système, les astronautes ont recours aux bonnes vieilles méthodes pré-Orbiter : se scotcher un sac plastique au derrière, faire caca et sceller hermétiquement.

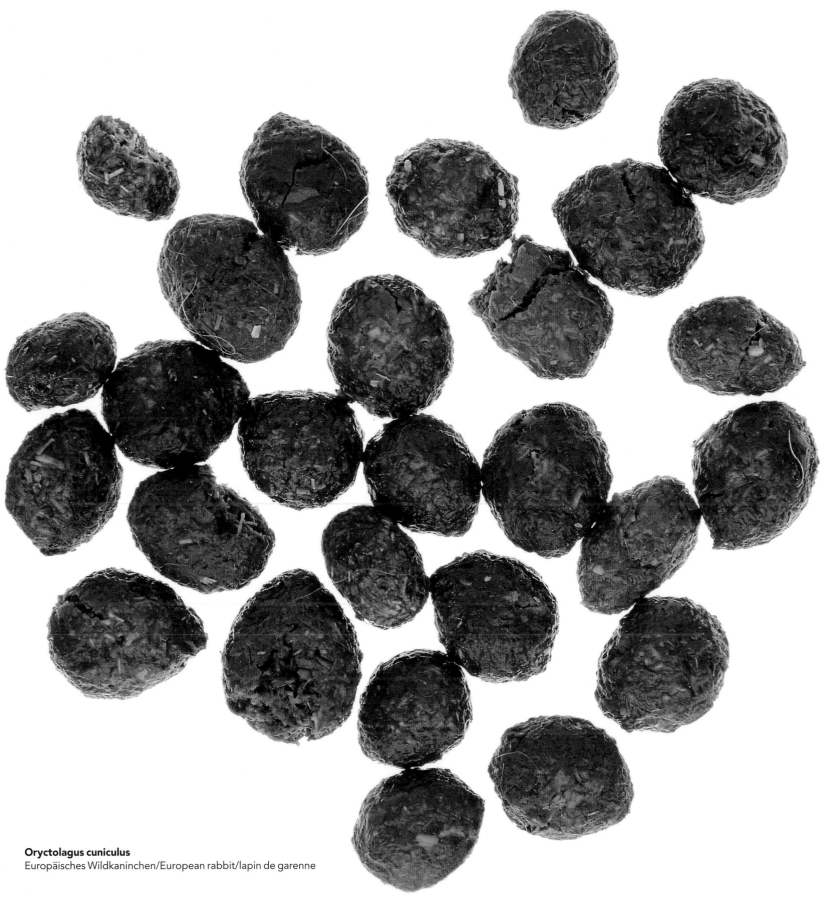

Oryctolagus cuniculus
Europäisches Wildkaninchen/European rabbit/lapin de garenne

Der beste Kaffee Das Luwak, ein in Indonesien beheimatetes tropisches Wiesel, mampft für sein Leben gern die Früchte der Kaffeepflanze. Doch die Plantagenbesitzer betrachten es nicht als einen Schädling. Da das Luwak nur die reifsten und besten Früchte zu sich nimmt, braucht man nur seine Hinterlassenschaften einzusammeln, um an die besten Bohnen zu kommen: Es verdaut das saftige Fruchtfleisch und scheidet die Bohnen unversehrt mit den übrigen Exkrementen aus. Die Bohnen werden dem Kot entnommen, gewaschen und bei 200 °C geröstet. Kennern zufolge macht der einzigartige Fermentierungsprozeß, den die Bohnen im Magen des Luwak durchlaufen, diese Bohnen zu den besten der Welt. Und zu den teuersten: Kopi-Luwak-Kaffee kostet ca. 1.350 DM pro Kilogramm (zwölfmal soviel wie grüner Kaffee, der nicht ausgeschieden wurde).

Processing Coffee *The luwak – a tropical weasel found in Indonesia – loves to munch coffee berries. But plantation owners don't consider the animal a pest: As it picks only the ripest and best berries, gathering the luwak's leftovers is the quickest way to select the finest beans. After carefully choosing its berry, the luwak digests the juicy outer pulp and passes the whole bean with the rest of its excrement. All the workers have to do is harvest the beans from the droppings, wash and roast at 200 ºC. Aficionados say the unique fermenting process the beans undergo in the luwak's stomach makes this the best-tasting coffee in the world. And the most expensive: Kopi Luwak coffee sells for US$660 per kg (or 12 times the price of non-excreted green coffee).*

Un café de premier choix Le luwak – une belette tropicale que l'on trouve en Indonésie – adore croquer des baies de caféier. Pourtant, les planteurs ne le considèrent pas comme un animal nuisible. En effet, ce fin gourmet ne s'intéresse qu'aux fruits les plus mûrs et les meilleurs, aussi suivre ses traces est-il le plus sûr moyen de sélectionner les grains de première qualité. Après avoir soigneusement choisi sa baie, le luwak digère la pulpe juteuse qui protège le grain. Ce dernier est ensuite éliminé par les selles de l'animal. Il ne reste plus aux ouvriers des plantations qu'à récolter les grains épars à l'intérieur de ses fientes, à les laver et à les torréfier à 200 °C. Aux dires des connaisseurs, le processus unique de fermentation auquel sont soumis les grains dans le système digestif du luwak produit le café le plus savoureux au monde. C'est aussi le plus cher : le kopi luwak ne se vend pas à moins de 4 500 francs le kilo (soit 12 fois le prix d'un café vert non excrété).

Toilettenpapier Die durchschnittliche japanische Frau verbraucht 4 km Toilettenpapier pro Jahr (entrollt entspräche das der 86fachen Höhe der New Yorker Freiheitsstatue). Andere Spitzenreiter im Toilettenpapierverbrauch sind die Norweger (2 km jährlich) und die Amerikaner, die mit 1,2 km auskommen. »Die Amerikaner haben eine besondere Beziehung zu ihrem Toilettenpapier«, so die James River Co. in den USA. »Es soll sich angenehm anfühlen und stets bei der Hand sein.« Der Umsatz der amerikanischen Toilettenpapierindustrie beträgt jährlich drei Milliarden Dollar. Der Markt ist heiß umkämpft: Das Unternehmen Scott Paper investierte allein 13 Millionen Dollar in die Werbung für ein garantiert geruchsabsorbierendes Papier mit Natronzusatz. Potentielle Gesundheitsrisiken werden jedoch stillschweigend in Kauf genommen: Da für die meisten Toilettenpapiersorten mit Chlor behandelter Zellstoff verwendet wird, können sie Dioxinrückstände enthalten – ein toxisches Nebenprodukt des Bleichungsprozesses, das sich in Tierversuchen als eine stark krebserregende Substanz erwiesen hat.

Toilet Paper *The average Japanese woman uses 4km of toilet paper a year (unfurled, that's 86 times the height of New York's Statue of Liberty). Other paper-happy nationalities include Norwegians (2km a year) and Americans, who get by on 1.2km. "Americans have a special relationship with their toilet paper," says the James River Co. of the USA. "They expect it to be comfortable and they want it always close at hand." Competition to dominate the US$3-billion toilet paper market is fierce: US-based Scott Paper spent $13 million to advertise a baking soda paper guaranteed to absorb nasty odors. No company has yet shown the same generosity in making toilet paper completely safe, though: Chlorine-treated tissue used in most types may contain traces of dioxin – a toxic by-product of the bleaching process that is the most potent cancer-causing agent in laboratory animals.*

Le papier toilette La Japonaise moyenne utilise 4 km de papier toilette par an (soit, une fois dévidé, 86 fois la hauteur de la statue de la Liberté). Parmi les autres peuples amis du papier, citons les Norvégiens (2 km par an) et les Américains, qui s'accommodent d'un modeste 1,2 km. « Les Américains ont un rapport particulier à leur papier toilette, indique la James River Co., une société américaine. Ils le veulent confortable et toujours à portée de main. » La compétition est féroce pour dominer un marché représentant, il est vrai, la bagatelle de 3 milliards de dollars US. Ainsi, la firme Scott Paper, basée aux Etats-Unis, a dépensé 13 millions de dollars sur la promotion d'un papier au bicarbonate de soude – plus d'odeurs fétides, absorption totale garantie, disait-elle. Aucun fabricant n'a encore eu la main aussi large pour mettre au point un produit totalement inoffensif : la plupart des papiers subissant des traitements chlorés, ils peuvent contenir des traces de dioxine, un résidu toxique du blanchissement au chlore qui s'avère sans pareil pour générer des cancers chez les animaux de laboratoire.

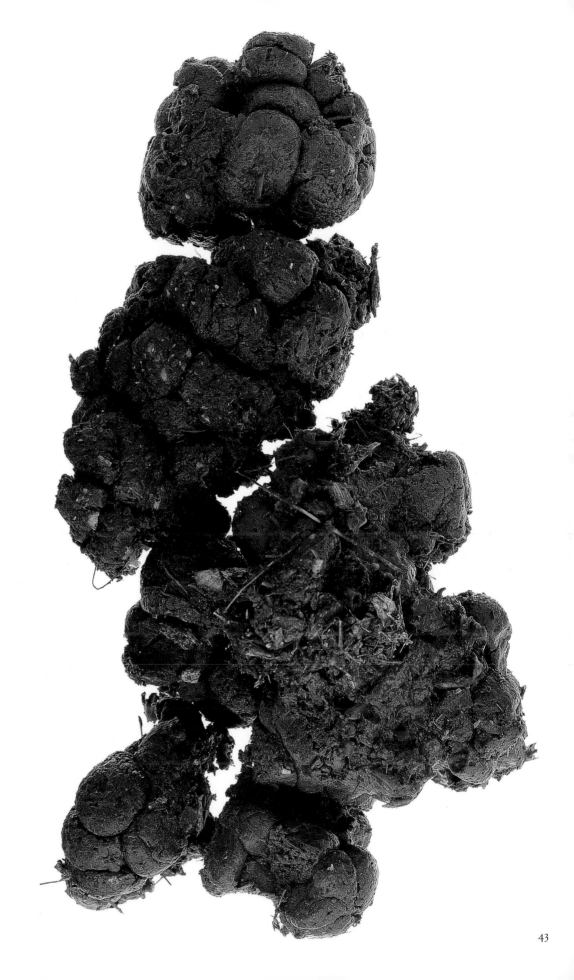

Tayassu angulatus
Halsbandpekari/collared peccary/pécari à collier

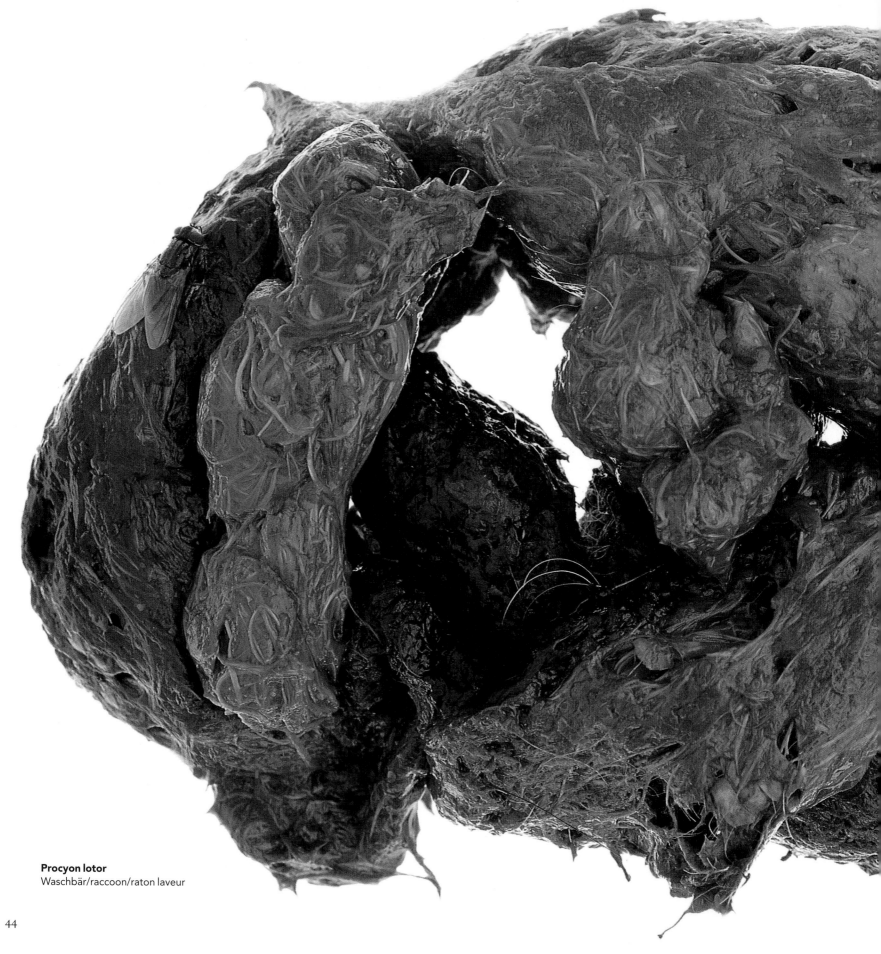

Procyon lotor
Waschbär/raccoon/raton laveur

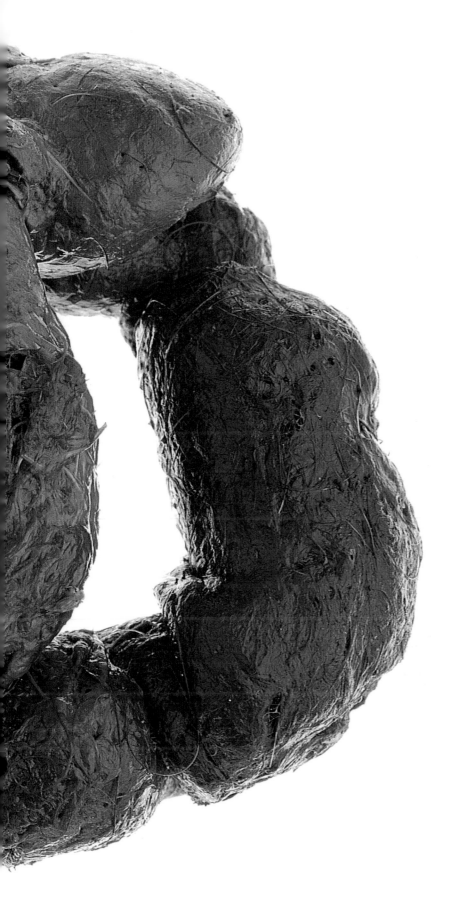

Eine Klofrau erzählt Donatella Pelliccioli reinigt die Toiletten in einer Autobahnraststätte in Norditalien. Täglich gehen 3.000 Leute an ihr vorbei, um die Toiletten aufzusuchen. »Nachts arbeitet hier niemand, und wenn ich morgens hierher komme, sind alle Toiletten sehr schmutzig, und es stinkt erbärmlich. Zuerst putze ich alles mit einem sehr starken Reinigungsmittel, um den Gestank wegzukriegen. Am schlimmsten ist es sonntags morgens, wenn Hunderte von Menschen aus den Diskos der Umgebung die Toiletten aufgesucht haben. Überall liegt Scheiße und Erbrochenes herum – in den Urinalen, auf dem Boden, in den Waschbecken. Mehr als einmal in der Woche finden wir Scheiße auf dem Boden. Wir kriegen auch alle Geräusche mit, da kann man nichts machen. Inzwischen habe ich mich daran gewöhnt, aber als ich mit dieser Arbeit anfing, dachte ich, das hältst du nicht aus. Manchmal kommen Leute, die sich vorstellen können, was wir hier auszuhalten haben, und die uns Komplimente machen, weil wir alles so sauber halten. Ich freue mich über solche Komplimente. Jede Arbeit hat ihre Nachteile, aber für diese braucht man einen starken Magen.«

Loo-Attendant Tells All *Donatella Pelliccioli cleans toilets at a highway service station in northern Italy. She sees about 3,000 people pass through her rest rooms every day. "No one works here overnight, so when I get here in the morning, all the toilets are very dirty and smelly. First, I clean everything with a very strong bleach, otherwise the stink would never go away. The worst is Sunday morning, when hundreds of people use these toilets, going and coming from discos around here. There's shit all over the place, and a lot of vomit, too – in the urinals, on the floor, in the sinks. More than once a week we find turds on the floor. We hear all the noises too, we can't avoid it. I'm used to it now, but when I started this job I thought I'd never make it. Sometimes, people understand what kind of work we do, and they compliment us because we keep everything so clean. I like it when that happens. All jobs have their defects, but for this one you need a strong stomach."*

Les confidences d'une dame pipi Dame pipi de profession, Donatella Pelliccioli entretient les toilettes d'une station-service, dans le Nord de l'Italie. Elle y voit défiler près de 3 000 usagers par jour. « Il n'y a personne qui travaille la nuit ici, alors quand j'arrive le matin, les toilettes sont toutes dégoûtantes et ça pue. Je commence par tout nettoyer à la javel, sinon l'odeur ne partirait pas. Le pire, c'est le dimanche matin – il y a des centaines de gens qui s'arrêtent dans ces toilettes, sur la route des boîtes du coin ou bien au retour, et ils laissent de la merde partout, plein de vomi aussi, dans les urinoirs, sur le carrelage, dans les lavabos. Plus d'une fois dans la semaine, on trouve du caca par terre. On entend les bruits aussi – ça, on ne peut pas l'éviter. Maintenant, je suis habituée, mais quand j'ai commencé ce boulot, j'ai cru que je n'y arriverais jamais. Il y a quelquefois des gens qui comprennent ce que c'est, et qui nous font des compliments parce que tout est bien propre. Quand ça arrive, ça me fait plaisir. Tous les métiers ont leurs défauts, mais pour celui-ci, il faut avoir l'estomac bien accroché. »

Das Kuhfladenwerfen Die Siedler, die sich vor hundert Jahren in Oklahoma in den USA niederließen, verwendeten getrocknete Kuhfladen (»cow chips«) als Brennstoff. Sie sammelten die Fladen auf Karren, und daraus entwickelte sich ein Wettkampf, bei dem der als Sieger hervorging, der die meisten Fladen auf den Karren werfen konnte, ohne sie in Brüche gehen zu lassen. Im »Annual Cow Chip Throw« in Beaver City, Oklahoma, lebt dieses Spiel bis heute fort. Die Teilnehmer können in fünf Kategorien antreten. Jeder erhält zwei Kuhfladen, und der, der am weitesten wirft, gewinnt. Das ist gar nicht so einfach, wie es sich anhören mag: Der Weltrekord – ein Wurf über 5,56 m von Leland Searcy – ist seit 1979 ungebrochen. Um ein gutes Ergebnis zu erzielen, nimmt man einen flachen Fladen und wirft ihn mit gestrecktem Arm oder im Frisbee-Stil. Aerodynamische Manipulationen sind strikt verboten, warnt der Organisator des Wettkampfs, Michael Barnett. »Wer sich an der Form des Fladens zu schaffen macht, dem werden zur Strafe 25 Fuß [7,6 m] abgezogen, und die Entscheidung des Schiedsrichters ist unanfechtbar.«

Slinging the Pat *A hundred years ago, pioneers who settled in Oklahoma, USA, used cow chips (dried cowpats) for fuel. Used to throwing them into wagons, they developed a contest to see who could toss the most chips into the wagon without breaking any. A version of the game lives on today in the Annual Cow Chip Throw, held in Beaver City, Oklahoma. Contestants can enter in five categories (including VIP men and VIP women, especially for government officials): Each gets two cow chips, and the one who throws the farthest wins. It's not as easy as it sounds: The world record – a throw of 5.56m by Leland Searcy – hasn't been broken since 1979. For a good shot at the record, choose a flat chip, and toss overarm or Frisbee style. Aerodynamic modifications are strictly forbidden, warns organizer Michael Barnett. "To alter or shape chips in any way subjects the contestant to a 25 foot [7.6m] penalty. The decision of the Chip Judge is final."*

Le meilleur lanceur de bouses séchées Il y a cent ans, les pionniers américains de l'Oklahoma utilisaient comme combustible des « pâtés de vaches » – comprenez, des bouses séchées. Habitués à les jeter dans leurs chariots, ils finirent par instituer un concours du meilleur lanceur : c'était à qui parviendrait à lancer le plus de bouses dans un chariot sans en briser aucune. Une version simplifiée de ce sport se pratique toujours dans le cadre du « Annual Cow Chip Throw », grand concours du lancer de pâtés de vaches, qui se tient chaque année à Beaver City, en Oklahoma. Les candidats peuvent s'inscrire dans cinq catégories. Chacun reçoit deux bouses séchées – l'emportera celui qui lancera le plus loin. La tâche n'est pas si facile qu'il y paraît. A preuve, le record mondial (un lancer de 5,56 m réalisé par Leland Searcy) n'a pas été battu depuis 1979. Pour avoir toutes vos chances, choisissez une bouse bien plate, et tirez-la par-dessus votre bras ou comme un Frisbee. Toutefois, il est strictement interdit de modifier l'aérodynamique des projectiles, avertit Michael Barnett, l'organisateur du concours. « Pour toute altération ou remodelage des bouses, le candidat encourt une pénalité de 7,6 m. La décision du juge ne peut être contestée. »

Jauche und Gülle Laut einer Empfehlung der Umweltschutzorganisation Greenpeace sollten menschliche Fäkalien sachgemäß kompostiert und dann als Dünger verwendet werden. In China werden die Felder seit Tausenden von Jahren mit kompostierten Exkrementen gedüngt. Wie ein Korrespondent in Kunming berichtet, ist die heutige Realität jedoch »gar nicht besonders schön oder wohlriechend.« Die Fäkalien kommen unmittelbar aus den öffentlichen Latrinen auf die Felder. »Das ist einer der Gründe dafür«, so unsere Quelle, »warum die Chinesen keine frischen Salate essen. Mit ganz wenigen Ausnahmen wird alles gekocht.«

Lettuce and Shit *Properly composted excrement used as fertilizer is one of the best ways to deal with human waste, according to environmental group Greenpeace. In China, composted waste has been used for thousands of years on the country's fields. But the reality today, reports a correspondent in Kunming, "is not so pretty or sweet-smelling." Feces are taken directly to fields from public latrines. "This is one reason why the Chinese don't eat any fresh salads," continues our source. "Everything is cooked, with very few exceptions."*

Le meilleur engrais du monde Le mouvement écologiste Greenpeace est formel sur ce point : correctement réalisé et utilisé comme engrais, le compost à base d'excréments reste l'un des meilleurs modes de traitement des déjections humaines. Les Chinois l'ont bien compris, qui l'emploient depuis des millénaires pour fertiliser leurs cultures. Cependant, un de nos correspondants à Kunming fait état d'une réalité contemporaine « ni aussi rose, ni aussi parfumée ». La matière fécale est transportée directement des latrines jusqu'aux champs. « C'est l'une des raisons pour lesquelles les Chinois ne mangent jamais de salade fraîche, poursuit notre source. Tout est cuit, à quelques rares exceptions. »

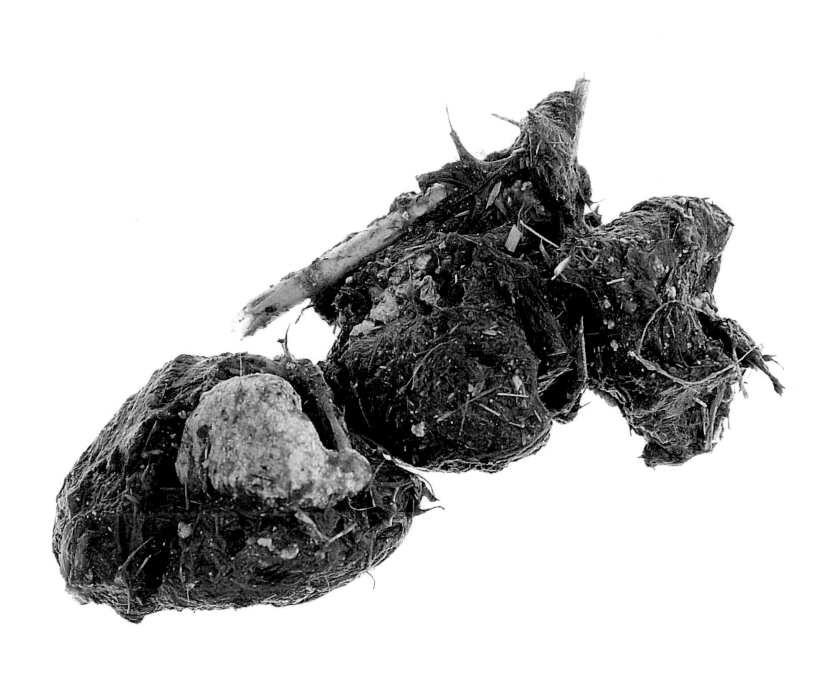

Python reticulatus
Netzpython/reticulated python/python réticulé

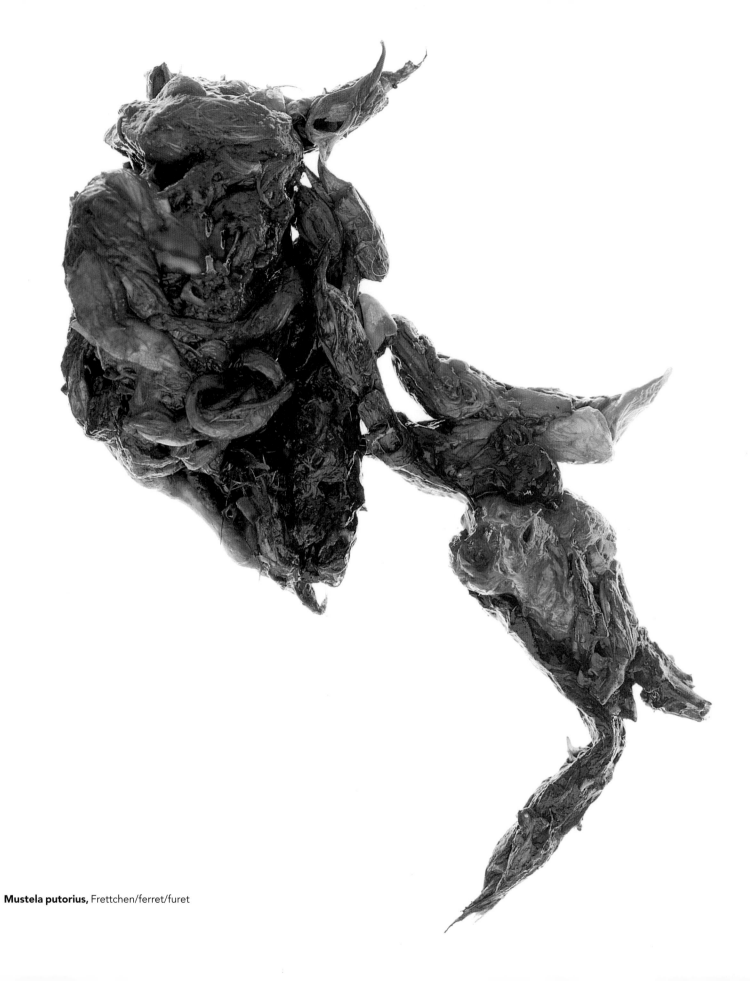

Mustela putorius, Frettchen/ferret/furet

Hämorrhoiden Mehr als die Hälfte der über 50jährigen in den USA leiden an Hämorrhoiden – knotenförmig erweiterten Blutgefäßen im Rektum, die sich während des Stuhlgangs entzünden und Blut austreten lassen können. Sie werden oft durch zu harten Kot verursacht, der das Ergebnis einer falschen, ballaststoffarmen Ernährung ist. Auch Bewegungsmangel begünstigt die Entstehung von Hämorrhoiden – nicht umsonst ist das Leiden auch als »Sitzkrankheit« bekannt. Wer stundenlang sitzen muß und von Hämorrhoiden geplagt wird, kann sich mit Hilfe eines speziellen Kissens Erleichterung verschaffen. Es hat die Form eines Krapfens mit einem Loch in der Mitte, um den Druck auf das Rektum und damit den Juckreiz und die Blutungen zu lindern. Auch die Priester in der La-Salette-Kapelle im US-Bundesstaat Massachusetts (die 49 Stunden in der Woche auf harten Holzstühlen verbringen müssen) wissen solche Kissen zu schätzen. Die Langeweile lindern helfen können sie allerdings nicht. »Es ist schon ermüdend«, gibt einer der Priester zu, der in den Spitzenzeiten – der Advents- und der Fastenzeit – pro Stunde 16 Gläubigen mit jeweils im Schnitt vier Sünden die Beichte abnehmen muß. »Nach einer Weile geht's zum einen Ohr herein und zum anderen wieder heraus.«

Hemorroids *Often called "the sitter's disease," hemorrhoids afflict more than half of over-50-year-olds in the USA. The condition – blood vessels in the rectum inflamed by straining during bowel movements – is often caused by the wrong diet (lack of fiber hardens feces and makes them painful to excrete). Sedentary lifestyles don't help, either. Long-term sitters like priests at LaSalette shrine in Massachusetts, USA, (who spend 49 hours a week on hard wooden chairs) may get relief from a hemorrhoid cushion. Shaped like a doughnut, the cushion has a hole to relieve pressure on the rectum, reducing itching and bleeding. It won't alleviate the boredom, though. "It's tiring," admitted one priest, who during the Christian peak seasons of Christmas and Lent hears 16 believers an hour confess an average of four sins each. "After a while you just don't hear anything."*

Le mal des assis Souvent appelées « le mal des assis », les hémorroïdes affectent plus de la moitié des Américains après 50 ans. Il s'agit d'une inflammation des vaisseaux sanguins dans le rectum, causée par une pression trop intense durant la défécation, et souvent attribuable à une mauvaise alimentation (une carence en fibres durcit les selles et les rend difficiles à expulser). Une trop grande sédentarité n'aide guère non plus. Aussi ceux qui par profession doivent pratiquer la posture assise prolongée, tels les prêtres du sanctuaire américain de La Salette, dans le Massachusetts, (qui passent quarante-neuf heures par semaine sur de dures chaises de bois) trouveront-ils un certain soulagement en adoptant le coussin à hémorroïdes. De forme circulaire, il est troué en son milieu pour éviter toute pression sur le rectum, ce qui permet d'atténuer démangeaisons et saignements. Toutefois, il ne réduira pas l'ennui. « C'est très lassant, avoue un prêtre qui, durant les périodes de pointe du culte chrétien, soit Noël et le Carême, entend 16 croyants par heure lui confesser une moyenne de quatre péchés chacun. Après un moment, on n'entend plus rien. »

Kotfresser Kotfressende Insekten wie Schmetterlinge, Käfer und Maden ernähren sich ausschließlich von in Fäkalien enthaltenen Nährstoffen. Schweine, Kühe, Schafe und Hunde fressen Kot, wenn anderes Futter Mangelware ist. Exkremente sind reich an Spurenelementen und Hefe, sie bestehen zu 15 Prozent aus Protein und stillen den Durst (der Wasseranteil beträgt 65 Prozent). Die meisten Tiere, die Scheiße fressen, tun das jedoch der Bakterien wegen. Indem sie Kot verzehren, überziehen Elefanten, Hunde, Biber, Kaninchen und Leguane ihren Verdauungstrakt mit einer Flora, die die Nahrungszersetzung unterstützt und Infektionen abwehrt. Wird die Kotaufnahme unterbunden, können Gesundheitsprobleme auftreten. Laborratten, denen ihr eigener Kot vorenthalten wird, zeigen Symptome von Unterernährung, und Truthähne und Hühner, die in Käfigen aufgezogen werden (und den Kot ihrer Mutter nicht fressen können), sind häufiger von Infektionen befallen als freilaufendes Geflügel. Um Salmonellen in Schranken zu halten, geben die Betreiber von Geflügelfarmen dem Trinkwasser der Hühner heute künstlich produzierte Fäkalbakterien bei.

Eat Shit *Coprophagous insects like butterflies, beetles and maggots live entirely off nutrients in feces. And pigs, cows, sheep and dogs sometimes eat feces if other food is scarce. Excrement is rich in trace minerals and yeast, is 15 percent protein, and quenches thirst (it's 65 percent water). Most animals that eat shit, however, do it for the bacteria. By ingesting feces, elephants, dogs, beavers, rabbits and iguanas coat their digestive tract with flora that help break down food and fight infections. Feces-deficient diets can cause health problems. Laboratory rats deprived of their own feces become malnourished, and turkeys and chickens raised in cages (and unable to eat their mother's droppings) develop more infections than free-range fowl. To curb salmonella outbreaks, battery farmers now pour commercially produced fecal bacteria into chickens' drinking troughs.*

Les bienfaits d'une petite crotte Les insectes coprophages, tels que papillons, scarabées et asticots, se sustentent exclusivement de nutriments tirés de la matière fécale. Porcs, vaches, moutons et chiens ne crachent pas non plus sur une petite crotte occasionnelle. Riches en oligo-éléments et en levures, les déjections contiennent en outre 15 % de protéines. En outre, elles étanchent la soif, étant composées d'eau à 65 %. C'est néanmoins à un autre ingrédient que s'intéressent la majorité des animaux consommateurs de merde : ses bactéries. En ingérant des selles, les éléphants, les chiens, les castors, les lapins et autres iguanes tapissent leurs voies digestives d'une flore intestinale qui facilite leur digestion et prévient les infections. Au reste, un régime pauvre en caca peut nuire gravement à leur santé. Un rat de laboratoire privé de ses propres selles manifestera tôt ou tard des symptômes de malnutrition ; les dindes et les poulets élevés en batterie (et dans l'incapacité de manger les fientes de leurs mères) développent plus d'infections que ceux grandis à l'air libre. Pour minimiser la prolifération de la salmonelle, les éleveurs industriels versent désormais dans les abreuvoirs de leurs volailles des bactéries fécales de production commerciale.

Im Wald und auf dem Meer Sie sind im Wald und müssen dringend. Mit einer Schaufel bewaffnet verziehen Sie sich hinter einen Busch. Stop! Ein in der Erde vergrabener Kothaufen durchschnittlicher Größe kann über ein Jahr lang eine toxische Wirkung ausüben und mit seinen bösen Bakterien viele Male das Grundwasser verschmutzen. Die ökologisch sinnvollere Option ist das Verschmieren: Umweltschützer empfehlen, den Kot mit einem Stock über einen Stein zu verteilen. Das stinkt zwar zunächst, weil bakterielle Gase freigesetzt werden, aber nicht lange: Die Kotschicht wird durch die ultraviolette Strahlung der Sonne in harmlose Flocken zersetzt und ist nach etwa zwei Wochen ganz verschwunden. Verspüren Sie Stuhldrang auf offener See, sollten sie ihn zurückhalten: Zwar wird der Kot durch die Mineralien im Meerwasser und durch die Wellenbewegung schnell zersetzt, doch Haie können die Exkremente einer Beute noch aus einer Entfernung von 2 km riechen. Die US-Navy gibt Leuten, die sich in Booten oder auf Flößen in haiverseuchten Gewässern befinden, den Rat, ihre Exkremente an Bord aufzubewahren.

In the Woods/All at Sea *You're in the woods, desperate to go. You head for a bush, armed with a shovel. Stop! An average-size pile of feces buried in earth can remain toxic for more than a year, giving its nasty bacteria plenty of time to pollute the water table. The greener option is to smear: Ecologists recommend using a stick to spread feces thinly across a stone. It'll stink at first, because bacterial gases are exposed to the air, but not for long: The sun's ultraviolet radiation cooks the sheet of feces into harmless flakes that blow away in about two weeks. If you're caught out at sea, hold it in: Although saltwater minerals and wave action decompose feces quickly, sharks can smell a prey's feces as far as 2km downcurrent. The US Navy cautions people in boats or rafts susceptible to shark attack to store their feces aboard.*

Dans les bois et en mer Une envie pressante vous saisit en plein bois. Vous vous ruez sur un buisson, la pelle à la main. Stop ! Une fois ensevelie, une pile d'étrons de taille moyenne préserve sa toxicité parfois plus d'une année, ce qui laisse à ses bactéries nuisibles amplement le temps de polluer les nappes phréatiques. La solution verte : étaler. Les écologistes recommandent en effet de répartir vos selles en une fine couche sur une pierre, à l'aide d'un bâton. Certes, cela commencera par sentir très mauvais, les gaz bactériens se trouvant brusquement exposés à l'air, mais l'incommodité sera de courte durée. Les rayons ultraviolets du soleil auront tôt fait de cuire cette pellicule, qui se morcellera en flocons inoffensifs. En deux semaines environ, tout aura été dispersé par le vent. En revanche, si le besoin vous prend en mer, gardez tout. Bien sûr, les sels minéraux contenus dans l'eau salée, combinés à l'action des vagues, décomposeront rapidement vos selles ; mais gare aux requins si les courants leur apportent vos effluves – leur odorat perçoit les déjections de leurs proies jusqu'à 2 km de distance. C'est pourquoi la marine militaire américaine conseille aux passagers de rafiots ou radeaux susceptibles d'essuyer des assauts de squales de stocker leurs excréments à bord.

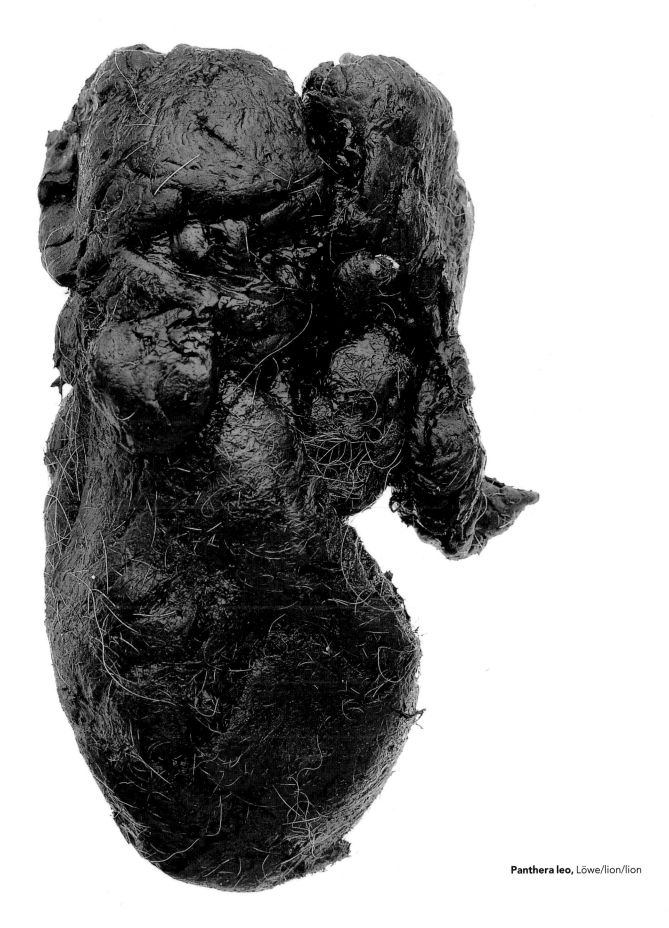

Panthera leo, Löwe/lion/lion

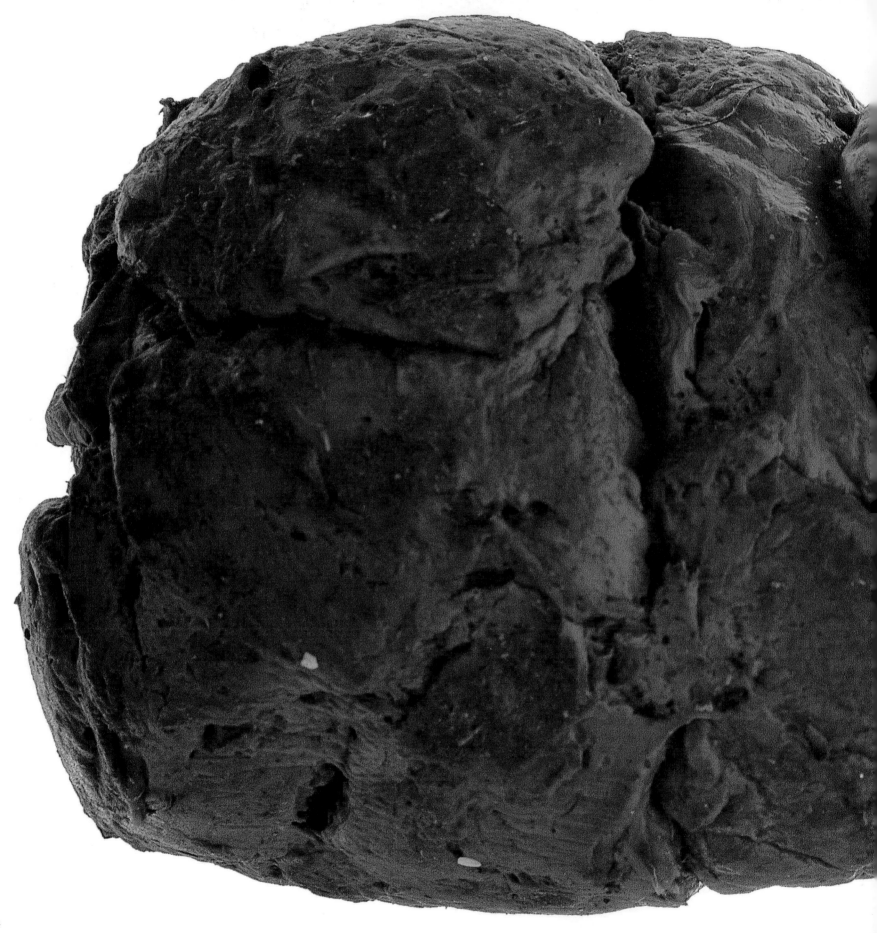

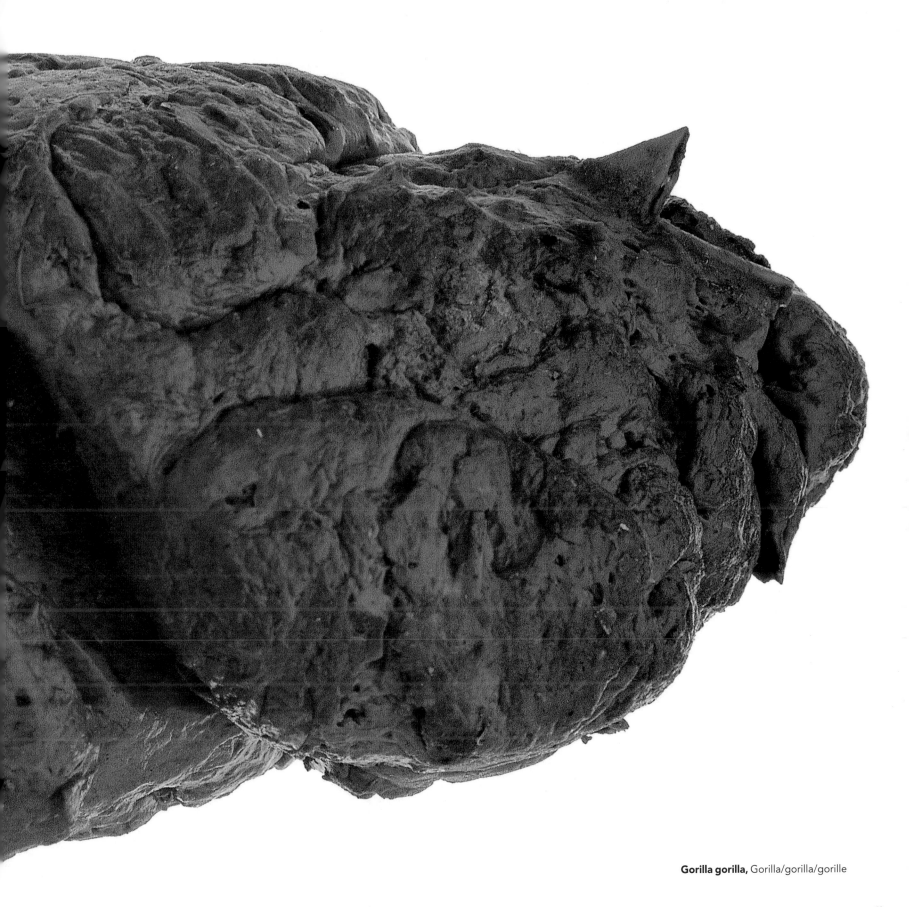

Gorilla gorilla, Gorilla/gorilla/gorille

»Goose Poop Art« 30.000 kanadische Gänse besuchen Jahr für Jahr den US-Bundesstaat Minnesota und hinterlassen dort 30 Tonnen Exkremente. Einiges davon wird seit 1983 von Gary Blum im Namen der Kunst verwendet. »Ich sammle den Kot, trockne ihn in einem Toaster und zerstoße ihn dann zu Pulver. Bei der Herstellung der Bilder darf man nicht zimperlich sein: Ich greife jedesmal im wörtlichen Sinne voll in die Scheiße, aber nachdem sie im Toaster war, stinkt sie wirklich nicht mehr. Jedes Bild hat Kot in vier verschiedenen Farben; die Farbe hängt davon ab, was die Gänse fressen. Dunkelbraun kriegt man von Oktober bis Dezember, wenn die Gänse die zarten Pflanzenwurzeln fressen, nachdem die Farmer die Felder umgepflügt haben. Die helleren Farben gehen für gewöhnlich auf Getreidekörner zurück.« 1994 stellte Gary seine »Goose Poop Art« zum ersten Mal aus, und seitdem hat er Tausende von Bildern verkauft. »Angefangen hat es als Jux. Wir nahmen an einer Ausstellung teil, und die Scheiße (»the poop«) war der Hit. Und seitdem steh ich bis zum Hals in dieser Scheiße.«

'Goose Poop Art' *Thirty thousand Canada geese visit the state of Minnesota, USA, every year, leaving 30 tons of excrement. Since 1983, Gary Blum has been using some of it in the name of art. "I collect the droppings, dry them in a toaster, and then crush them into a powder. When making the pictures you can't be too timid, I do get my hands right in there, but after the poop has been baked, it really doesn't smell. Each picture has four different colors of poop, which vary depending on what the geese eat. Dark brown is usually available in October-December, and is the result of geese eating the tender roots of plants after the farmers have turned over the fields. The lighter colors are usually the result of eating grains." Since his "Goose Poop Art" became commercially available in 1994, Gary has sold thousands of pictures. "It started off as a practical joke," he says. "We participated in one show and the poop hit the fan. I've been up to my neck in the stuff ever since."*

Art caca d'oie Trente mille oies sauvages du Canada font un séjour annuel dans l'Etat du Minnesota, aux Etats-Unis, laissant derrière elles 30 tonnes d'excréments. Depuis 1983, Gary Blum utilise ce matériau pour l'amour de l'art. « Je récolte les fientes, je les fais sécher dans un grille-pain, puis je les réduis en poudre. Lorsqu'on se met à peindre, ce n'est pas le moment de faire le dégoûté – j'y vais à pleines mains, bien sûr. Mais une fois cuite, la fiente ne sent vraiment plus rien. Chaque tableau décline quatre couleurs de caca, qui varient en fonction de l'alimentation des oies. Le brun foncé se trouve généralement d'octobre à décembre – à cette saison, les oies mangent des racines tendres qui émergent une fois que les fermiers ont retourné la terre. Les couleurs plus claires dérivent le plus souvent d'un régime de graines. » Depuis l'introduction sur le marché de son « art caca d'oie », en 1994, Gary a vendu des milliers de toiles. « Tout cela a commencé comme une plaisanterie, raconte-t-il. Nous avons participé à une exposition, et le caca a fait mouche auprès du public. Depuis, j'y suis jusqu'au cou. »

Kot für Scotland Yard Jeder menschliche Körper enthält codierte genetische Informationen, die aneinandergereiht 27 Milliarden km ergeben würden. Der Träger dieser Informationen ist die DNS (Desoxyribonukleinsäure). Weil jeder Mensch über spezifische individuelle DNS-Muster verfügt, hat in der Kriminalistik die DNS-Analyse den Fingerabdruck als sicherstes Beweismittel abgelöst. Normalerweise werden Blut-, Speichel- oder Haarproben untersucht, aber seit 1996 ist es möglich, sogar Fäkalien ein DNS-Profil zu entlocken, das allerdings kein erschöpfendes Bild bieten kann (es gibt zwar Auskunft über das Geschlecht und den ethnischen Hintergrund, nicht jedoch über erbliche Details). Deshalb greift man nur dann auf Kot zurück, wenn keine anderen Substanzen zur Verfügung stehen. »In Großbritannien«, sagt Dr. Armando Mannucci vom Institut für Rechtsmedizin in Genua, »hinterlassen Diebe oft ihren Kot am Ort des Geschehens; deshalb werden dort oft Fäkalien untersucht. Fester Kot eignet sich für DNS-Analysen am besten, Durchfallproben sind weniger brauchbar.«

Excrement for Scotland Yard *Every human body contains 27 billion km of coded genetic information called DNA (deoxyribonucleic acid). Because each person's DNA is unique, DNA testing has taken over from fingerprinting as the ultimate investigative tool. Tests are usually performed on blood, saliva and hair, but since 1996, you can even tease a DNA profile out of feces. The information isn't exhaustive (it'll reveal gender and ethnic background, but not hereditary details), so testing excrement is usually performed only when feces are the only investigative resource available. "In the UK," says Dr. Armando Mannucci of the Institute of Legal Medicine in Genoa, Italy, "thieves often leave their feces in a place they've just robbed, and DNA testing is widely used. For best results, it should be performed on solid feces, not diarrhea."*

Des crottes traîtresses Chaque corps humain contient 27 milliards de kilomètres d'informations génétiques codées, appelées ADN (acide désoxyribonucléique). L'ADN de chaque individu étant unique, les tests d'identification génétique ont désormais supplanté les empreintes digitales pour devenir l'outil d'investigation suprême. Ils s'opèrent en général sur le sang, la salive ou les cheveux mais, depuis 1996, on peut même extirper un profil ADN d'une simple crotte. Hélas, les informations obtenues ne sont pas exhaustives (elles révéleront le sexe et les origines ethniques, mais pas les détails d'hérédité), aussi ne pratique-t-on l'expertise sur excréments qu'à défaut d'autre ressource analysable. « Au Royaume-Uni, indique le Dr Armando Mannucci, de l'Institut médico-légal de Gênes (Italie), les cambrioleurs laissent leurs excréments sur les lieux du crime – c'est un usage très répandu. Les tests ADN sont donc fréquemment utilisés. Pour optimiser les résultats, il faut travailler sur des selles solides, pas sur de la diarrhée. »

Acheta domestica, Hausgrille/cricket/grillon

Genetta genetta
Ginsterkatze/genet/genette commune

Die richtige Stellung Die meisten Menschen gehen in die Hocke, um sich zu entleeren. Medizinern zufolge ist das die natürlichste Stellung: Die Oberschenkel üben einen sanften Druck auf den Unterleib aus und mindern damit die Belastung der Bauchmuskeln. Die Muskeln im Becken richten sich auf natürliche Weise so aus, daß der Stuhlgang erleichtert und eine gefährliche Überanstrengung vermieden wird. Warum entleeren sich dann die meisten Menschen in den Industrieländern im Sitzen? Wie Mulk Raj vom Toilettenmuseum im indischen Delhi sagt, haben die Menschen im Westen »längere Beine als Inder«, was das Hinhocken schwieriger macht. Außerdem dauert der Stuhlgang bei Fleischessern länger, so daß es für diese Menschen bequemer ist, dabei zu sitzen. Trotzdem sollten vielleicht auch sie zur Hockstellung überwechseln: Wer sich sitzend entleert, muß fester drükken und geht zudem das Risiko ein, sich auf Toilettensitzen Parasiten wie Ringelflechte oder Bandwürmer einzufangen.

Taking the Position *Most humans squat to defecate. It's the most natural position, say doctors: The thighs apply gentle pressure to your abdomen, reducing the strain on your abdominal muscles. The muscles in the pelvis are naturally aligned, making evacuation easier and avoiding dangerous straining. So why do people sit? According to Mulk Raj at India's Museum of Toilets, "Westerners have longer legs than Indians," making squatting more difficult. And meat-eaters take longer to pass feces, making sitting a more comfortable option. Even so, perhaps everyone should start practicing the squat: Not only do sitters have to push harder, but they risk picking up parasites like ringworm and tapeworm from toilet seats.*

Quelle posture adopter? Dans sa grande majorité, l'humanité s'accroupit pour déféquer. C'est là la posture la plus naturelle, estiment les médecins, les cuisses exerçant une légère pression sur le ventre et réduisant d'autant l'effort à produire pour les abdominaux. D'autre part, les muscles du périnée se retrouvent ainsi alignés, ce qui facilite l'évacuation tout en évitant les tensions dangereuses. Mais alors, quel besoin ont donc certains d'entre nous de s'asseoir? Au musée indien des Toilettes, Mulk Raj a son idée sur la question: « Les Occidentaux ont les jambes plus longues que les Indiens », d'où une plus grande difficulté à s'accroupir. En outre, les mangeurs de viande mettent plus longtemps à expulser leurs selles, ce qui fait de la posture assise une option plus confortable. Qu'à cela ne tienne: peut-être faudrait-il nous convertir tous à la défécation accroupie. Non seulement les assis doivent pousser plus fort, mais ils sont menacés par les parasites tapis sur la cuvette, comme les vers ronds et le ténia.

Schluß mit der Wasserverschwendung! Der Durchschnittskanadier spült täglich 140 Liter Wasser die Toilette hinunter. Nach Expertenschätzungen brauchen wir täglich 30 Liter Wasser, um zu überleben und uns sauberzuhalten: Die meisten Menschen in den Entwicklungsländern müssen mit 10 Litern auskommen. In den Industrieländern, wo die Menschen im Schnitt täglich fünfmal die Toilette aufsuchen (einmal für feste, viermal für flüssige Ausscheidungen), bemühen sich jetzt die Regierungen um eine Drosselung des Wasserverbrauchs. »Australien ist der zweittrockenste Kontinent der Welt«, sagt Steve Cummings vom Toilettenhersteller Caroma Industries. »Wir werden ständig ermahnt, effiziente Wassersparmethoden zu entwickeln.« Die Lösung sind möglicherweise High-Tech-Komponenten wie die japanische Otohime (»Spülprinzessin«). Japanische Frauen betätigen pro Toilettenbesuch im Schnitt 2,5 mal die Spülung, um peinliche Geräusche zu übertönen. Auf einen Knopfdruck liefert die Spülprinzessin Spülgeräusche vom Band, ohne einen Tropfen Wasser zu verschwenden.

Why Waste Water on Waste? *The average Canadian flushes 140 liters of water down the toilet every day. Experts estimate that we need 30 liters of water a day to survive and keep clean: Most people in developing countries live on 10 liters. In industrialized countries, where people go to the toilet five times a day on average (one for solids, four for liquids), governments are starting to cut back on flushing volumes. "Australia is the second driest continent in the world," says Steve Cummings of toilet manufacturers Caroma Industries. "We're constantly being requested to be more efficient with the flushing volume." Maybe high-tech water-saving devices, like the Japanese Otohime (Flush Princess) are the answer. Aimed at Japanese women – who flush an average of 2.5 times per toilet visit to mask embarrassing "toilet sounds" – the Flush Princess provides tape-recorded flushing sounds at the touch of a button, with not a drop of water wasted.*

Arrêtons le gaspillage Le Canadien moyen dépense 140 litres d'eau par jour en tirant la chasse. Or, les experts estiment que nos besoins quotidiens, pour survivre et nous tenir propres, ne dépassent pas 30 litres. La grande majorité des populations du tiers monde doivent même se contenter de 10 litres. Dans les régions industrialisées du globe, où l'on visite le petit coin cinq fois par jour en moyenne (une fois pour s'exonérer du solide et quatre fois pour le liquide), les gouvernements ont entrepris de faire réduire le volume des chasses d'eau. « L'Australie est le second pays le plus sec au monde, rappelle Steve Cummings, employé chez le fabricant de toilettes Caroma Industries. On nous demande constamment une efficacité accrue en matière de débit de chasses d'eau. » Peut-être trouverons-nous le salut dans les systèmes d'économie d'eau hi-tech, telle la Otohime (princesse de la chasse d'eau) nippone. Destinée aux Japonaises – qui tirent la chasse en moyenne 2,5 fois par passage pour couvrir les « bruits de toilettes » embarrassants – la Princesse propose des bruitages de chasse d'eau préenregistrés, sans une goutte gaspillée: il suffit d'appuyer sur un bouton.

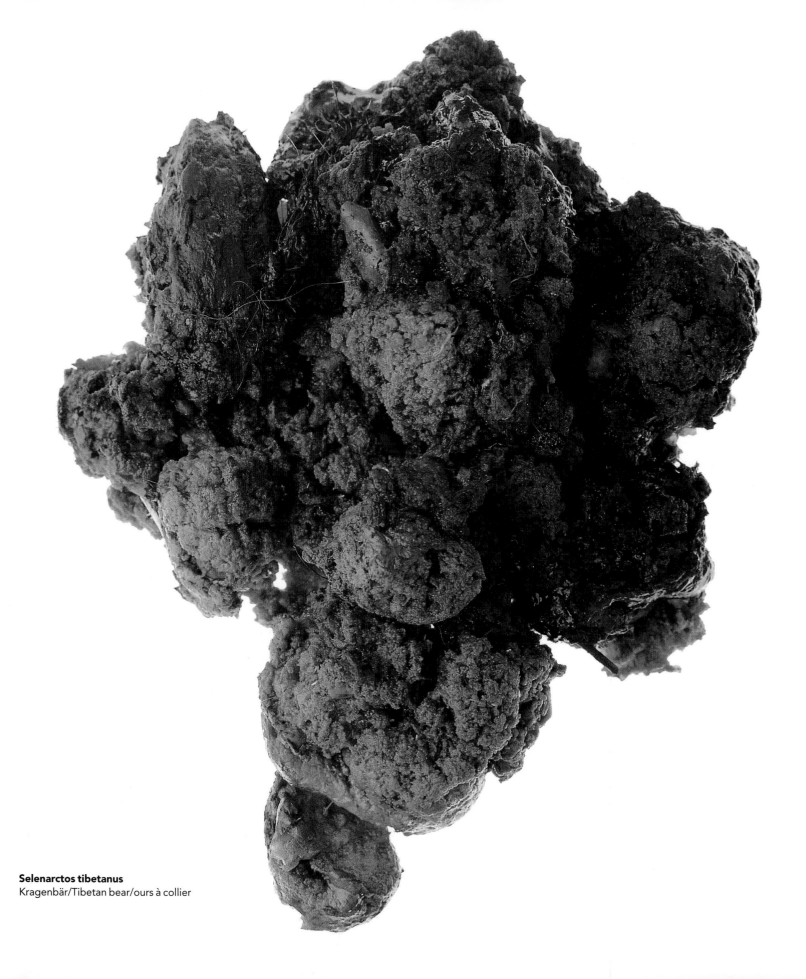

Selenarctos tibetanus
Kragenbär/Tibetan bear/ours à collier

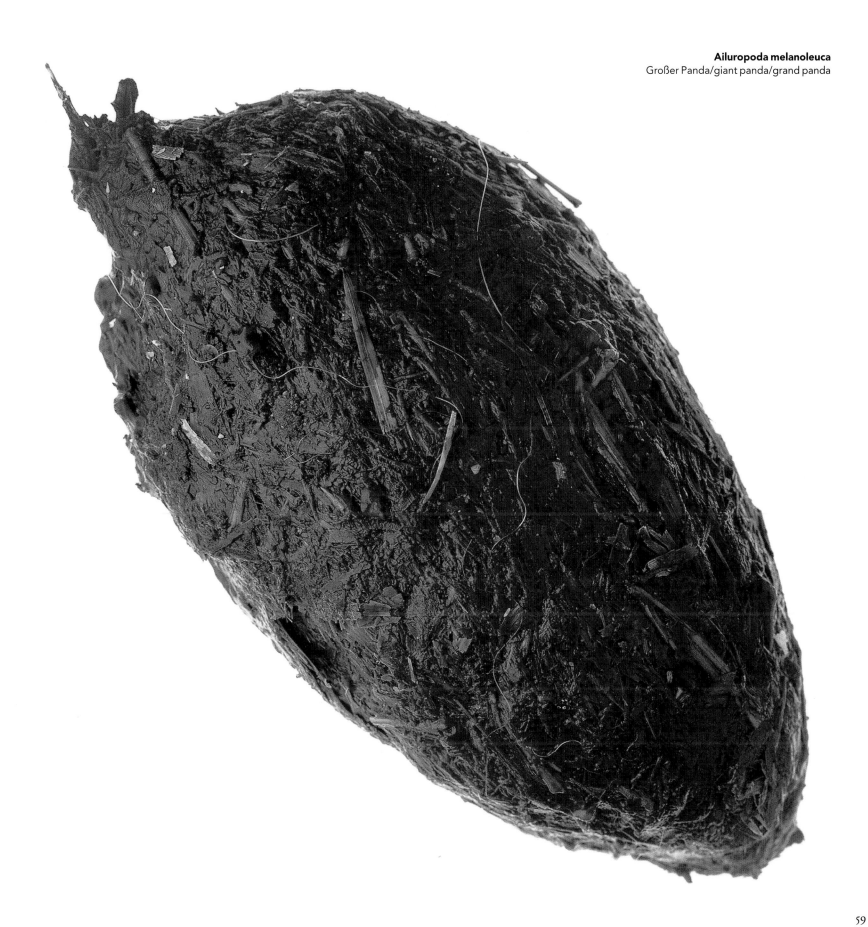

Szenen aus dem Arbeitsleben Der durchschnittliche Stuhlgang dauert 6,5 Minuten. Als Fabrikarbeiter muß man womöglich für jede Sekunde zahlen. Da eine Toilettenpause zu Lasten der Produktivität geht, greifen manche Arbeitgeber zu drastischen Maßnahmen: Sie geben Zeitkarten für den Besuch der Toilette aus, belegen die Beschäftigten, die die zugestandene Zeit überschreiten, mit einer Geldstrafe, und beschränken sogar die Flüssigkeitsaufnahme am Arbeitsplatz. Und das ist noch nicht alles. »Schikanen werden taktisch eingesetzt«, sagt Kathryn Hodden vom Internationalen Bund freier Gewerkschaften in Belgien. »Die Bosse haben völlig freie Hand. In einigen Fabriken müssen die Arbeiter die Hand heben und um Erlaubnis bitten. Und in einem Unternehmen war der Schlüssel zur Toilette an einem Autoreifen angebunden, und jeder, der zur Toilette wollte, mußte ihn mit sich herumschleppen.« Aber nicht nur »normale« Arbeitgeber interessieren sich für den Stuhlgang ihrer Untergebenen. Die Polizei in Los Angeles entdeckte kürzlich im Regelwerk einer Straßengang eine Vorschrift, die die Toilettenpause der Drogenhändler auf 15 Minuten beschränkte.

Crap Working Conditions *The average bowel movement lasts 6.5 minutes. If you're a factory worker, you might have to pay for every second. To boost productivity, some employers crack down on toilet breaks, issuing rest room time cards, fining people who take too long, and even restricting liquid intake on the job. And that's not all. "Humiliation is a tactic," says Kathryn Hodden of the International Confederation of Free Trade Unions in Belgium. "Bosses can do whatever they want, like make workers hold up their hand and ask permission. We've had complaints about a company making everyone carry the toilet key attached to a tire." Nor are legal employers the only ones interested in bowel movements. Police in Los Angeles, USA, recently discovered that one street-gang's rules booklet limited drug dealers' toilet breaks to 15 minutes.*

Le temps c'est de l'argent Une défécation dure en moyenne six minutes et demie. Si vous êtes ouvrier dans une usine, vous pourriez avoir à payer chaque seconde de cet intermède. En effet, pour doper la productivité, certains employeurs opèrent de sérieux tours de vis sur les pauses toilettes, en instituant des cartes de crédit-temps pour les visites au petit coin, en infligeant des amendes à ceux qui s'attardent, voire en réduisant les possibilités de boire durant le travail. Et ce n'est pas tout. « Une de leurs tactiques, c'est l'humiliation, accuse Kathryn Hodden, de la Confédération internationale des syndicats autonomes de Belgique. Les patrons peuvent faire tout ce qu'ils veulent, par exemple obliger les ouvriers à lever la main pour demander. Nous avons eu des plaintes en provenance d'une entreprise où tout le monde doit trimballer la clé des toilettes attachée à un pneu. » Au reste, les employeurs légaux ne sont pas seuls à s'intéresser aux vicissitudes du transit intestinal. La police de Los Angeles, aux Etats-Unis, a récemment mis la main sur le règlement intérieur d'un gang, exposé dans un livret : il autorisait les dealers à des pauses pipi de quinze minutes maximum.

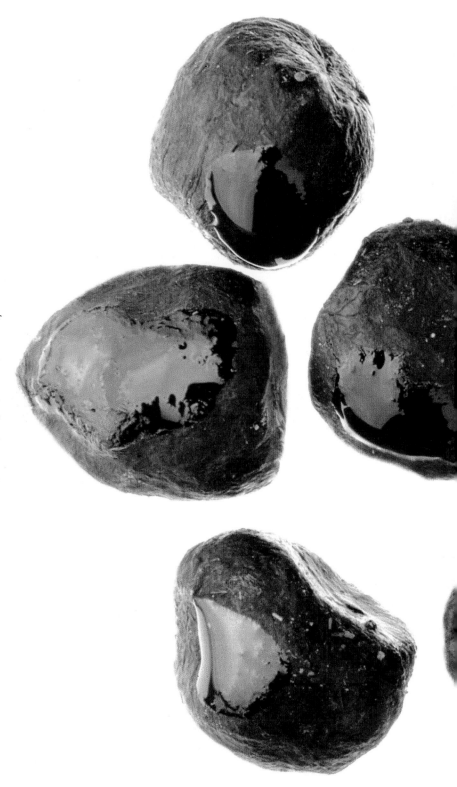

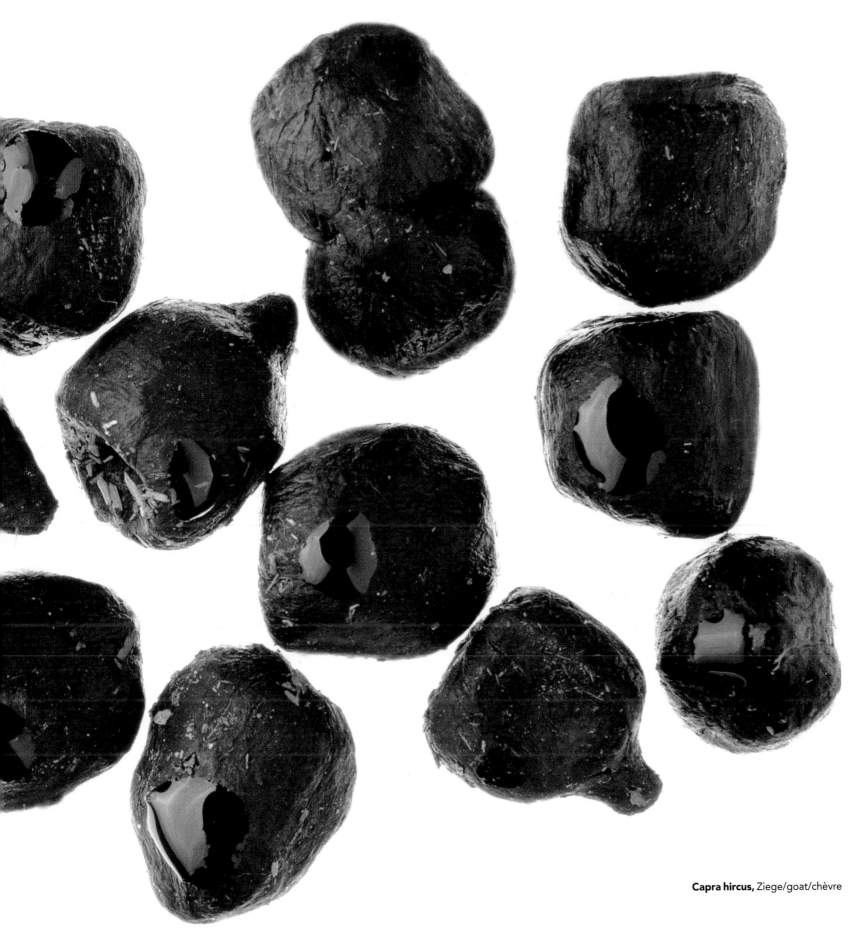

Capra hircus, Ziege/goat/chèvre

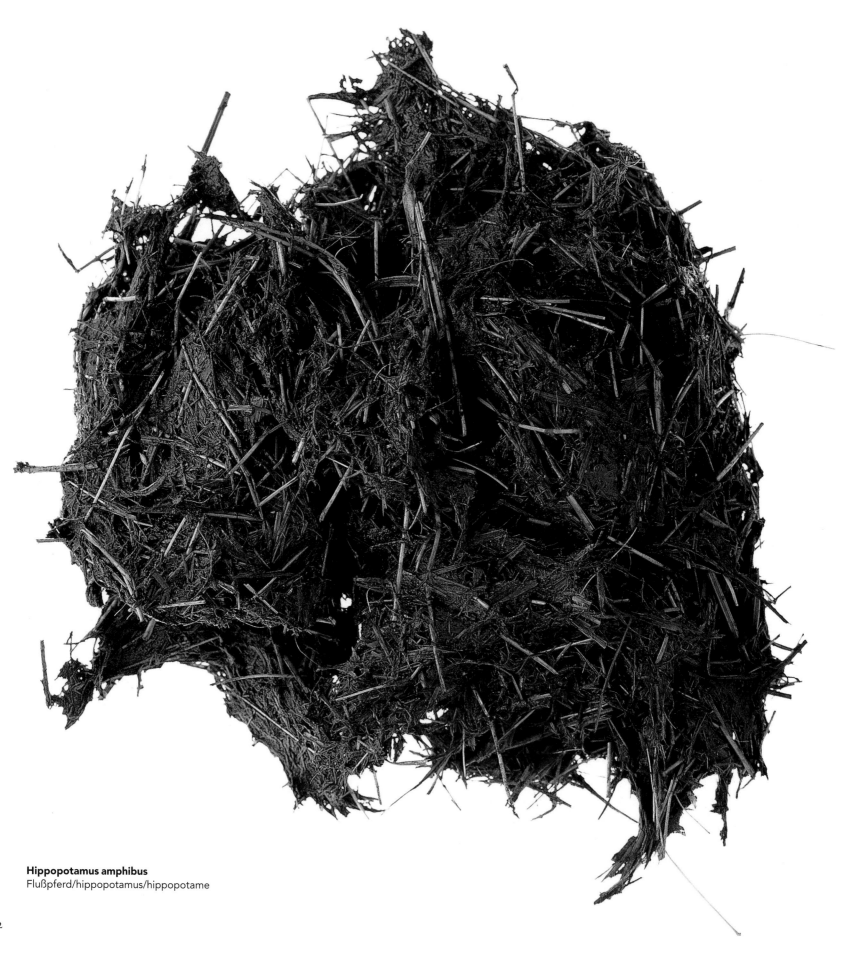

Hippopotamus amphibus
Flußpferd/hippopotamus/hippopotame

O wie peinlich! »Wir treten in eine Zeit ein, in der die Menschen die Verantwortung für ihre Gerüche übernehmen müssen«, behaupten die Hersteller von »Etiquette«, der japanischen Pille für Leute, »denen geruchsfreie Exkremente am Herzen liegen«. Mit mehr als 600.000 Flaschen, die in den ersten sechs Monaten verkauft wurden, hat Etiquette in Japan eine spezielle Marktnische gefunden. Nach Schätzungen des Unternehmens sind 40 Prozent des Umsatzes jungen Frauen zu verdanken. Eine Kundin, eine »Miss B«, behauptet, das Produkt habe ihr Leben verändert. »Wenn ich ein Hotelzimmer mit anderen teilen mußte, war mir der Geruch wirklich peinlich. Ich nahm lieber Verstopfungen in Kauf, als zur Toilette zu gehen.« Laut Auskunft des Herstellers setzt sich die Pille aus einer Spezialmixtur aus grünem Tee, Pilzen und Zucker zusammen, die den Fäkaliengeruch eliminiert, indem die »dafür verantwortlichen Elemente während der Verdauung ausgemerzt werden«. Wie sicher ist man sich der Wirkung des Produkts? »Nach drei oder vier Tagen«, so ist in der Broschüre der Firma zu lesen, »muß man schon die Nase in den Kot stecken, um ihn riechen zu können.«

The Shame of It! *"We are entering an era in which people must be responsible for their odors," say the manufacturers of Etiquette, the Japanese pill for "people minding excrement smell." With more than 600,000 bottles sold in its first six months, Etiquette has found a special niche in the Japanese market: The company estimates that young women account for 40 percent of Etiquette's business. One customer, referred to only as "Miss B," claims the pills have changed her life. "When I shared a hotel room," she says, "the odor was really embarrassing. I became constipated rather than go to the bathroom." According to the manufacturer, Etiquette's special mixture of green tea, mushrooms and sugar eliminates excrement odor by "eradicating the responsible elements during digestion." How confident is the company about its product? "After three or four days," its brochure says, "You'd have to put your nose in the excrement to smell it."*

Un parfum de thé vert « Nous entrons dans une ère où l'individu doit se sentir responsable de ses odeurs », décrète le fabricant japonais d'Etiquette, la pilule de « tous ceux qu'incommodent les relents d'excréments ». A voir son succès – 600 000 flacons et plus vendus en six mois de lancement – Etiquette semble avoir capturé un créneau bien spécifique du marché nippon : selon les estimations de la firme, 40 % des ventes reposent sur les jeunes femmes. Et de citer Mlle B., cliente satisfaite – ces pilules, proclame-t-elle, lui ont changé la vie : « Quand je partageais une chambre d'hôtel, l'odeur était vraiment embarrassante. Je devenais constipée plutôt que d'aller aux toilettes. » Aux dires du fabricant, la formule exclusive d'Etiquette, à base de thé vert, de champignons et de sucre, désodorise vos excréments en « éliminant radicalement les éléments générateurs d'odeurs durant la digestion ». Jusqu'où va la confiance que la compagnie accorde à son produit ? « Au bout de trois à quatre jours, nous apprend la brochure, il vous faudra mettre le nez dans vos déjections pour sentir quelque chose. »

Der letzte Weg Wenn Sie die Toilettenspülung betätigen, schicken Sie Ihre Exkremente auf eine Abenteuerreise. Die Exkremente aus dem Westen Londons legen zum Beispiel mit einer Geschwindigkeit von einem Meter pro Sekunde 32 km durch Tunnel zurück (von denen einige groß genug für einen Doppeldeckerbus wären), um zu einer Kläranlage auf der anderen Seite der Stadt zu gelangen. Auf dem Weg dorthin werden sie von Hundekadavern, Motorrädern, Brettern und Windeln begleitet. Dort angekommen werden sie gefiltert, und das Wasser wird aufbereitet und in das Flußsystem eingeleitet. 28 Stunden nach Antritt der Reise wird ein 100 g schwerer »Kuchen« entwässerten Klärschlamms verbrannt, und mit der Hitze wird eine Dampfturbine zur Stromerzeugung angetrieben. Das klingt gewiß sehr umweltfreundlich, aber die drei Millionen Liter Abwässer, die Tag für Tag in London anfallen, erzeugen lumpige 8 kW Elektrizität – gerade mal genug für 80 der 38.000 Glühbirnen, die die Tower Bridge beleuchten.

Where'd It Go? *When you flush a toilet, you're sending your excrement on an adventure. West London feces, for example, travel 32km through tunnels (some large enough to accommodate a double-decker bus) to a processing plant on the other side of the city. Cruising at 1m per second, they are joined by dead dogs, motorbikes, wooden planks and diapers. Once at the plant, they're filtered, and the excess water is treated and deposited in the river system. Twenty-eight hours after you flushed the toilet, a 100g "cake" of dehydrated sewage (the size of a Mars bar) is incinerated and the heat used to power a steam turbine to generate electricity. It certainly sounds environmentally friendly. But the three million liters of sewage that Londoners create every day generate a paltry 8kw of electricity – enough to power only 80 of the 38,000 light bulbs that illuminate the city's Tower Bridge.*

Un long voyage Tirez la chasse d'eau, et c'est une véritable aventure qui commence pour vos crottes. Les selles produites dans les quartiers Ouest de Londres, par exemple, parcourent 32 km de tunnels (certains si larges qu'un autobus à impériale y passerait aisément) jusqu'à une station d'épuration située à l'autre extrémité de la ville. Naviguant bon train, à la vitesse de 1 m par seconde, elles sont rejointes dans leur périple par des chiens crevés, des motos, des planches de bois et des couches-culottes. Une fois parvenues à bon port, elles sont filtrées, l'excédent d'eau recueilli, traité puis réinjecté dans le circuit fluvial. Vingt-huit heures après le déclenchement de votre chasse, un « gâteau » de 100 g de résidu d'égout déshydraté est incinéré. La chaleur dégagée est aussitôt recyclée pour actionner une turbine à vapeur produisant de l'électricité. Voilà qui semble fort respectueux de l'environnement. Hélas, les 3 millions de litres d'eaux usées que déversent chaque jour les Londoniens dans leurs égouts ne parviennent à générer qu'un pauvre 8 kW d'électricité – à peine assez pour illuminer 80 des 38 000 ampoules illuminant le Tower Bridge.

Die Unberührbaren 600.000 Inder schleppen Eimer voller Scheiße, weil ihre gesellschaftliche Stellung sie dazu verdammt. In Indien haben 7,5 Millionen Haushalte Eimerlatrinen, und die Aufgabe, sie zu leeren, fällt den *bhangi* zu – Angehörigen der niedrigsten Hindu-Kaste. Mit ihren Händen oder einem hölzernen Spachtel schöpfen sie die Scheiße nachts aus den Eimern und tragen sie in Kübeln auf nahegelegene Felder, die mit den Exkrementen gedüngt werden. Ihre Ausrüstung ist denkbar karg: Da sie sich von ihrem durchschnittlichen Monatslohn von 1.000 Rupien (ca. 46 DM) keine Schuhe, Handschuhe oder Arbeitskleidung leisten können, verrichten die meisten *bhangi* (80–90 Prozent sind Frauen) ihre Arbeit barfuß. Doch ihre miserablen Arbeitsbedingungen sind nichts gegen ihre gesellschaftliche Erniedrigung. Sie müssen die Häuser durch einen separaten Eingang für »Unberührbare« betreten und dürfen nicht mit anderen Indern an einem Tisch sitzen. Als sie einmal gefragt wurden, ob sie für einen noch geringeren Lohn eine angesehenere Arbeit annehmen würden, antwortete mehr als die Hälfte mit Ja.

Untouchables *Six hundred thousand Indians carry buckets of shit on their head because their social class forces them to. In India, 7.5 million households use bucket latrines, and the job of emptying them is assigned to the* bhangi *– the lowest caste of Hindu. Scavengers (as they're known in translation) scoop feces out of buckets with their hands or a wooden spatula. They carry the load in pails on their heads to nearby fields, then dump the excreta as night soil, or fertilizer. Equipment is minimal: The average monthly salary of Rs1,000 (US$22) doesn't allow for shoes, gloves or work clothes, so most night-soil workers (80 percent are women) work in bare feet. But what they suffer on the job, say scavengers, is nothing compared to their social humiliation. Scavengers must enter houses through a separate entrance for polluted beings, cannot be touched, and aren't allowed to eat with other Indians. When asked if they would accept lower wages for another job with more respect, more than half said yes.*

Les forçats de la fumure Ils sont 600 000 Indiens que leur naissance condamne à charrier sur leur tête des seaux de merde. En Inde, 7,5 millions de foyers utilisent des latrines où les excréments se déversent dans un seau, et le soin de vider ces derniers incombe exclusivement aux *bhangi* – caste inférieure de la structure sociale hindoue. Les ramasse-merde – ainsi les castes supérieures désignent-elles les bhangi – vident les seaux à la main ou à l'aide d'une spatule en bois. Ils transportent leur charge sur la tête, dans des baquets, jusqu'aux champs cultivés les plus proches et y déversent ce fumier humain qui fera office d'engrais. Leur équipement est minimal : un salaire mensuel de 1 000 roupies ne permettant guère l'achat de chaussures, de gants ou de vêtements adéquats, la plupart de ces forçats de la fumure (dont 80 à 90 % sont des femmes) travaillent pieds nus. Mais à leurs propres dires, ce qu'ils endurent dans ce métier n'est rien comparé à leur humiliation sociale. Les *bhangi* doivent entrer dans les maisons par des portes séparées, réservées aux êtres souillés. Il est interdit aux autres Indiens de les toucher ou de partager avec eux les repas. Accepteraient-ils un salaire plus bas pour un emploi plus respecté ? Plus de la moitié répondent par l'affirmative.

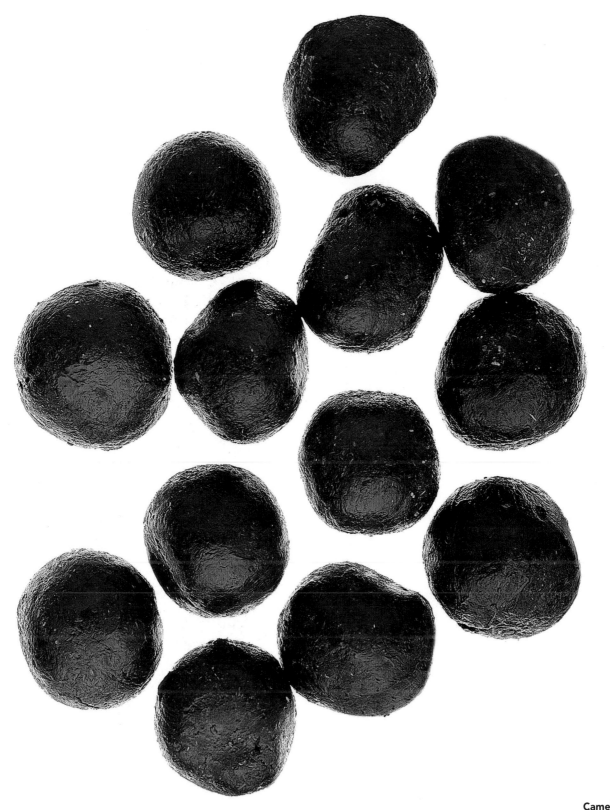

Camelus dromedarius
Dromedar/dromedary/dromadaire

Biologische Waffe Scheiße kann töten. Mit einer Milliarde Viren und Bakterien pro Gramm sind menschliche Exkremente die denkbar billigste biologische Waffe. *Pungi*-Stöcke – mit festem Kot überzogene und in den Boden eingeschlagene gespitzte Bambuspflöcke – durchdringen die Stiefelsohlen und infizieren die Füße mit Fäkalien. Im Vietnamkrieg gingen zwischen 1964 und 1973 die Hälfte aller amerikanischen Gefallenen auf von den kommunistischen Vietcong-Kämpfern eingegrabene Pungis zurück. In ganz Südostasien sind Pungis eine Lieblingswaffe der mittellosen Guerillabewegungen: In der üppigen Vegetation lassen sie sich leicht verstecken, und das tropische Klima erhöht die Wahrscheinlichkeit, daß ein infizierter Fuß amputiert werden muß. Pungis sind billiger als ein Stacheldrahtzaun und gewinnen als ein technisch anspruchsloses, aber effizientes Sicherheitssystem weltweit eine immer größere Beliebtheit. Dem Waffenexperten Charles Heyman von der Jane's Information Group in Großbritannien zufolge sind heute in Südostasien wie auch in Schwarzafrika sowohl Heroinlabors als auch Gemüsegärten von mit Kot überzogenen Pungis umgeben.

Crap Weapons Work *Shit can kill. With a billion viruses and bacteria per gram, human feces are the cheapest biological weapon around. Pungi sticks – sharpened bamboo spikes coated with caked excrement and planted in the ground – are designed to pierce boots and infect feet with fecal matter. Pungis planted by communist Viet Cong fighters caused half of all US casualties during the 1964–1973 Vietnam War. And across Southeast Asia, pungis are a favorite weapon of poorly funded guerilla movements: They're easily concealed in lush vegetation, and the tropical climate increases the chances that the infected foot will require amputation. Costing less than a barbed wire fence, pungis are now gaining popularity as low-tech security devices. According to weapons expert Charles Heyman of the UK-based Jane's Information Group, perimeters of excrement-dipped pungi now protect everything from heroin laboratories to vegetable gardens in Southeast Asia and sub-Saharan Africa.*

Une arme biologique La merde tue. Riche d'un milliard de virus et de bactéries par gramme, la matière fécale humaine est la moins chère des armes biologiques en circulation. Ainsi, les *pungis* – des piques de bambou affûtées recouvertes d'une croûte d'excréments et fichées dans le sol – sont conçus pour percer les semelles et infecter les pieds en déposant des déjections dans les plaies. On attribue aux pungis plantés par les combattants communistes viêt-cong la moitié des morts dans le camp américain durant la guerre du Viêtnam de 1964–1973. Ils restent d'ailleurs l'une des armes les plus prisées dans le Sud-Est asiatique, chez les mouvements de guérilla disposant de faibles moyens. Faciles à dissimuler dans la végétation luxuriante, ils sont d'autant plus efficaces que le climat tropical accroît les chances d'une infection grave menant à l'amputation du pied. En raison de leur faible coût – inférieur à celui du fil de fer barbelé – leur usage se répand en tant que systèmes de sécurité minimalistes. Selon Charles Heyman, expert en armement au sein du Jane's Information Group, basé en Grande-Bretagne, des périmètres de pungis enduits d'excréments protègent désormais les lieux les plus variés, depuis les laboratoires de fabrication d'héroïne jusqu'aux potagers d'Asie du Sud-Est et d'Afrique subsaharienne.

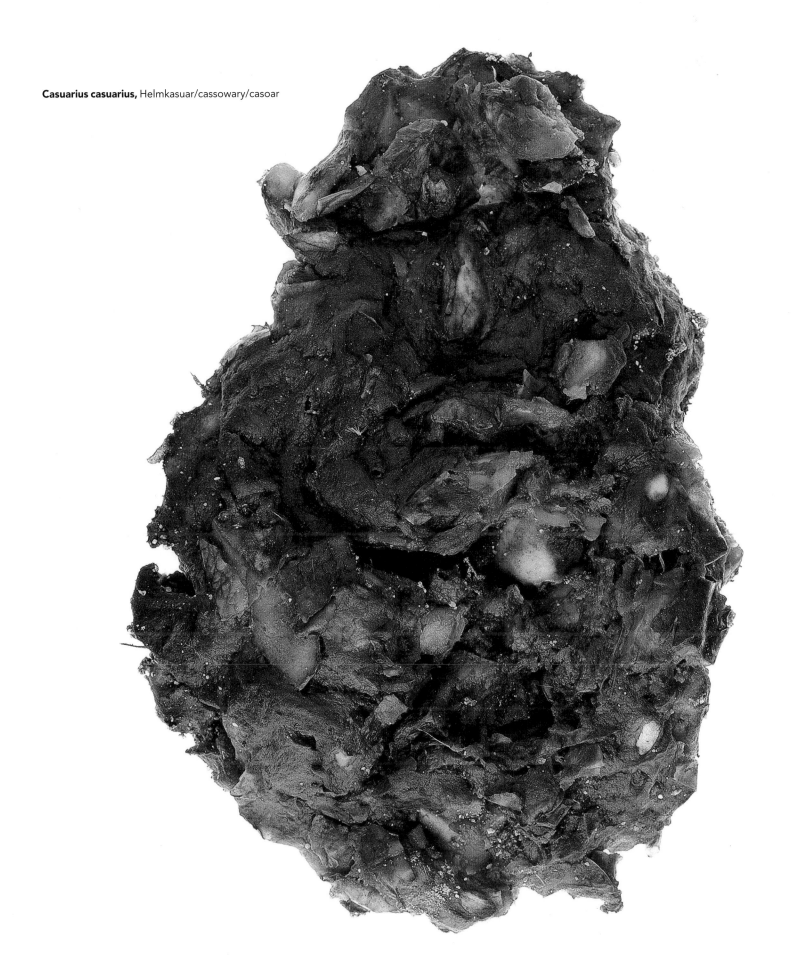

Casuarius casuarius, Helmkasuar/cassowary/casoar

Mustela vison, Nerz/mink/vison

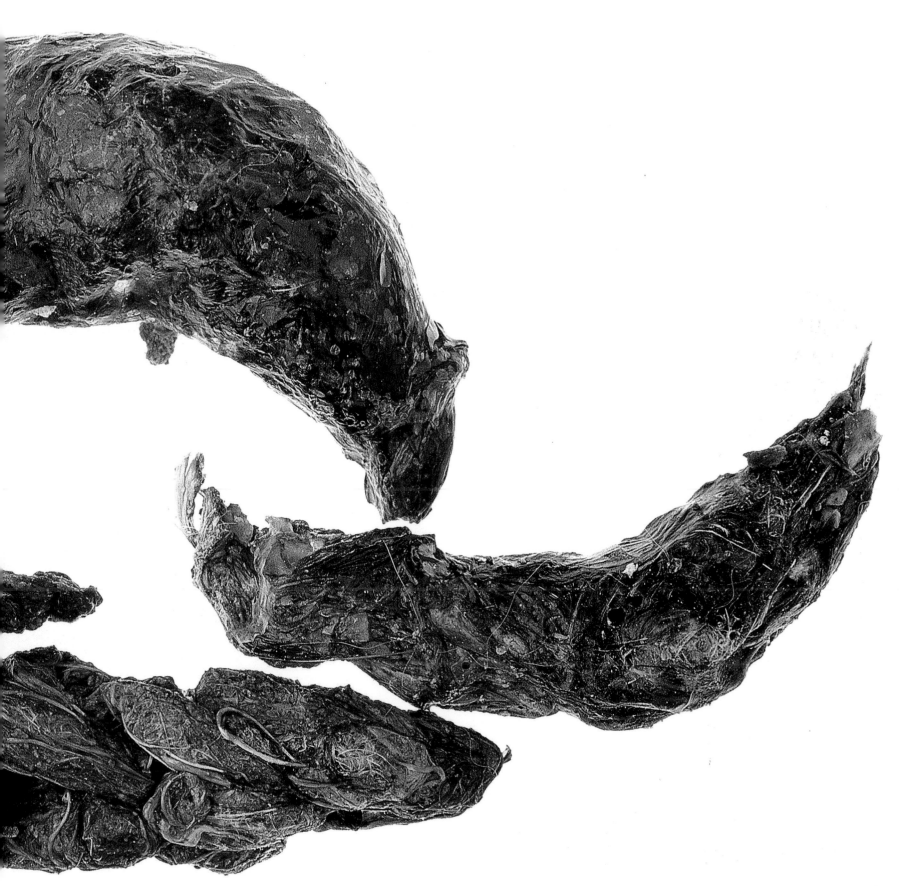

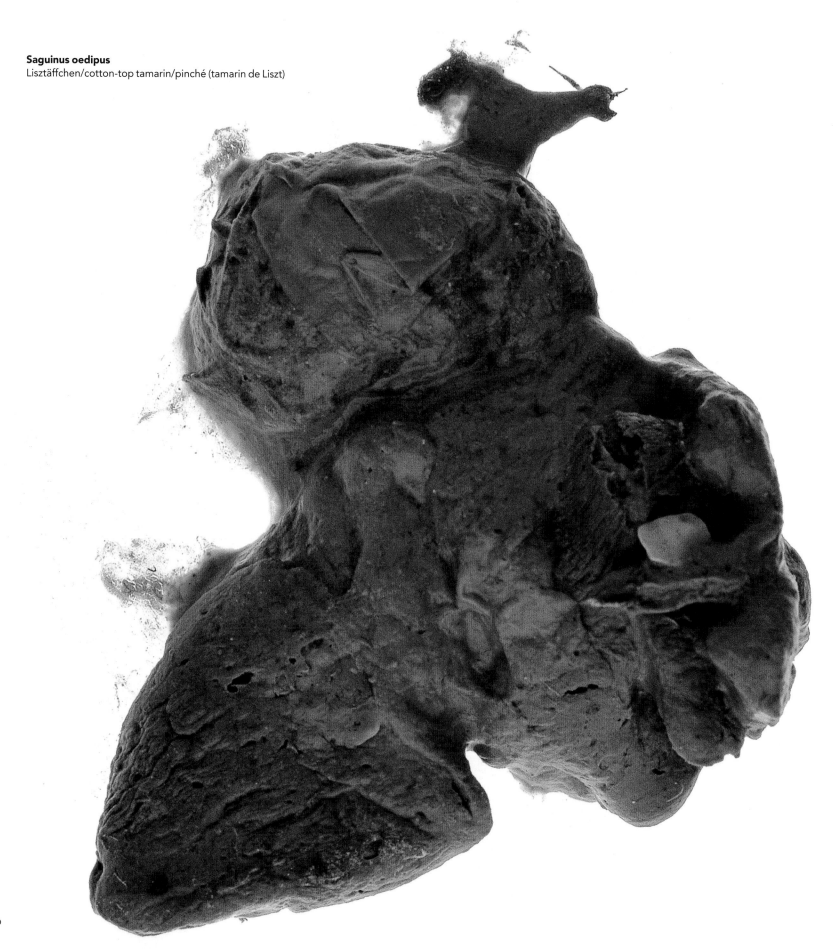

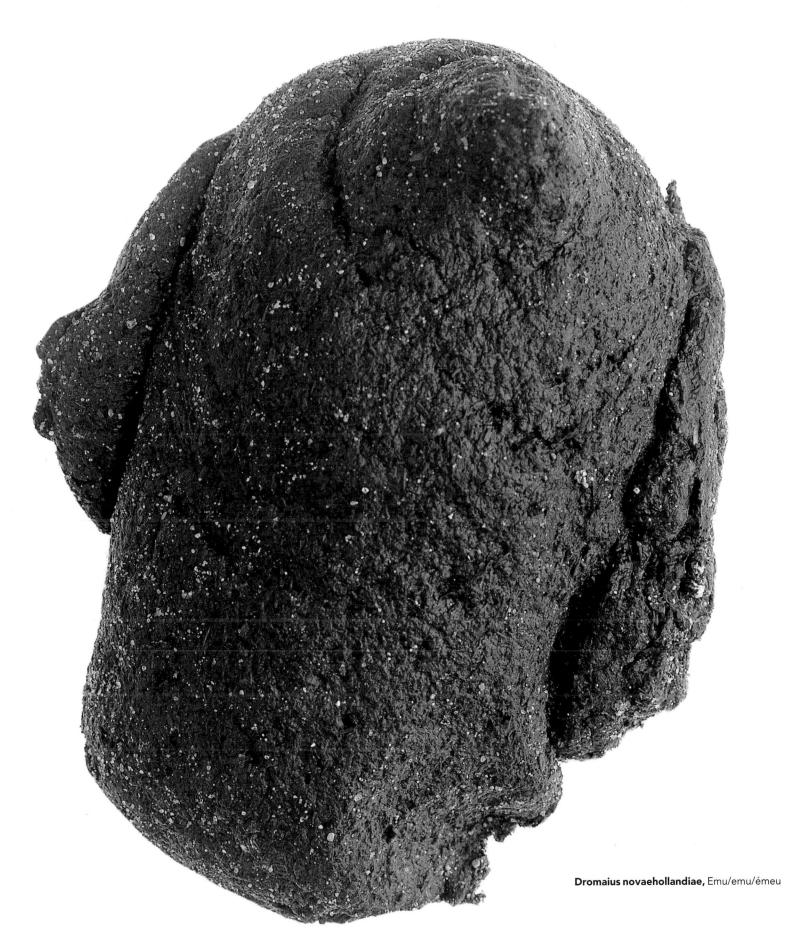

Dromaius novaehollandiae, Emu/emu/émeu

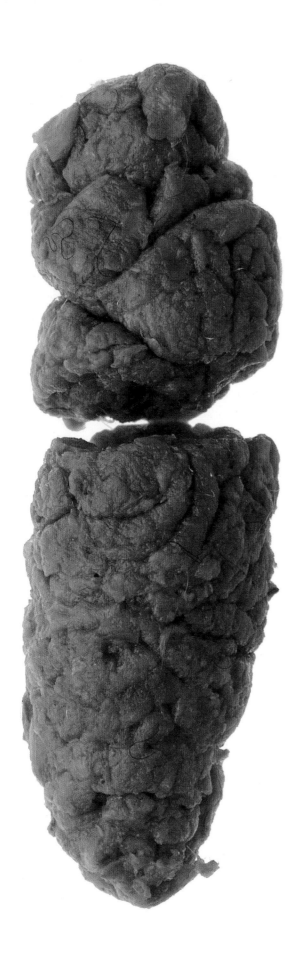

Lemur macaco, Mohrenmaki/lemur/lémur

Wie hätten Sie's denn gern? Der Kot, der sich in den Eingeweiden sammelt, ist zunächst noch eine gelbbraune Masse. Erst nachdem Bakterien sich über das Bilirubin (ein Abbauprodukt des Hämoglobins) hergemacht haben und der Kot im unteren Darmbereich trockener und fester geworden ist, nimmt er die bekannte braune Farbe an. Durch eine entsprechende Ernährung können Sie den Farbton Ihrer Exkremente beeinflussen. Ziehen Sie einen dunkleren Farbton vor, sollten Sie große Mengen Rind- oder Lammfleisch essen. Milch verleiht Ihrem Stuhl einen Stich ins Gelbe, Brombeeren geben ihm einen ins Grüne. Was Größe und Konsistenz betrifft, führen schwere, fettreiche Nahrungsmittel wie Eier und Käse zu kleinen Haufen, die sich nur langsam fortbewegen wollen. Je mehr Wasser ihre Nahrung enthält, desto umfangreicher der Kot: Um stattliche Haufen zu erreichen, sollten Sie wasserspeichernde Fasern enthaltende Nahrungsmittel wie Gemüse oder Kleie zu sich nehmen. Vollkornbrot und samenreiche Nahrungsmittel wie Tomaten, Paprikaschoten oder Wassermelonen bewirken eine ansprechende Textur: Die Körner und Samen bleiben oft unverdaut und kommen auf der Oberfläche des Kots zur Geltung.

How D'Ya Like It? *Feces actually start off yellow-brown in your intestine. Only after bacteria start munching on bilirubin (an end product of red blood cells) and the feces are dried and solidified in the lower intestine does the familiar brown color develop. (The lower intestines of newborn babies are still bacteria-free, so their poop is yellow.) You can color-code your feces by adjusting your diet. For a darker hue, eat large quantities of red meat. Milk will give stools a yellow tinge, while blackberries turn them slightly green. As for size and consistency, rich, fatty foods like eggs and cheese generate small, slow-moving turds. The more water in your food, the bigger the feces: For a larger stool, eat foods containing water-retaining fiber like vegetables and bran. Texture can be gained by eating more corn and seed foods like tomatoes, pepper or watermelon: The kernels and seeds often remain undigested and come out whole the other end.*

Du sur mesure Lorsque vos selles se forment dans votre intestin, elles sont de couleur ocre. Ce n'est que plus tard, quand les bactéries commencent à dévorer de la bilirubine (un dérivé final des globules rouges) et que vos déjections sèchent et se solidifient dans le gros intestin, qu'apparaît la traditionnelle couleur marron (le côlon des nouveau-nés étant encore vierge de toutes bactéries, ces petits font donc de beaux cacas jaunes). Il est possible de programmer la couleur de ses selles en ajustant son alimentation. Pour obtenir une teinte plus sombre, mangez de la viande rouge en quantité. Le lait jaunit, la mûre verdit. Au chapitre de la taille et de la consistance, les aliments gras, tels les œufs et le fromage, génèrent de petites crottes à transit lent. Plus votre nourriture contiendra d'eau, plus vous augmenterez le volume de vos selles : pour faire de gros boudins, optez pour des aliments riches en fibres comme les légumes ou le son. On peut également gagner en texture en consommant plus de maïs et de légumes à pépins, tomates, poivrons ou pastèque. En effet, grains et graines sont rarement assimilés par l'organisme et ressortent intacts à l'autre bout.

Das Toilettenmuseum »Der Geschichte der Evolution der Toiletten ausgerechnet in Indien nachzuspüren, hat schon etwas Ironisches«, sagt Dr. Bindeshwar Pathak, der Gründer des Toilettenmuseums in Delhi. »In diesem Land entleeren sich die meisten Menschen noch im Freien.« Trotzdem hat Dr. Pathak den ganzen Planeten jahrelang nach Informationen über Klosetts abgesucht, und heute dokumentiert sein Museum den glorreichen Aufstieg der Toilette von 2.500 v. Chr. bis zur Gegenwart. Unter den Exponaten findet sich neben Dutzenden von Abtritten und Nachttöpfen auch eine Kopie des Throns Ludwigs XII. mit eingebautem Nachtstuhl (der französische Monarch pflegte sich vor Publikum zu entleeren und in privater Umgebung zu speisen). Und die von Dr. Pathak gegründete Organisation für Sozialreformen, Sulabh International, hat sich ihren eigenen Platz in der Geschichte der Toiletten gesichert: In Indien, wo 70 Prozent der Bevölkerung keinen Zugang zu angemessenen sanitären Anlagen haben, hat sie 650.000 Toiletten eingerichtet, die täglich von 10 Millionen Menschen benutzt werden. Männer zahlen eine Rupie (ca. 5 Pfennig), für Frauen und Kinder ist die Benutzung kostenlos.

Excrement in History (the Toilet-Museum) *"Tracing the history of the evolution of toilets seems a bit ironic in India," says the founder of India's Museum of Toilets, Dr. Bindeshwar Pathak. "Most people here still defecate in the open." Nonetheless, Dr. Pathak spent years scouring the planet for information on lavatories, and his museum now chronicles the glorious rise of the toilet from 2,500 BC to the present day. Exhibits include dozens of privies, chamber pots, and a copy of King Louis XII's throne, complete with built-in commode (the French monarch would defecate in public and eat in private). And Dr. Pathak's social reform organization, Sulabh International, has earned its own place in toilet history: In India, where 70 percent of the population has no adequate sanitation, the organization has set up 650,000 toilets that are used by 10 million people daily. Men pay one rupee (US$0.02), women and children go for free.*

La glorieuse ascension des lieux d'aisance « Retracer l'histoire de l'évolution des toilettes, cela semble un peu paradoxal en Inde, concède le Dr Bindeshwar Pathak, qui a fondé à New Delhi un musée indien des Toilettes. Ici, la plupart des gens défèquent encore à l'air libre. » Cela n'a pas arrêté le Dr Pathak, qui a écumé la planète des années durant pour rassembler des informations sur les cabinets. Son musée raconte aujourd'hui la glorieuse ascension des lieux d'aisances, de 2 500 avant notre ère jusqu'à nos jours. Les collections recèlent moult cabinets d'aisance et pots de chambre, sans oublier une reproduction du trône de Louis XII, avec chaise percée intégrée (le monarque français déféquait en public et dînait en privé). En outre, le mouvement de réforme sociale que dirige le Dr Pathak, Sulabh International, a dignement gagné sa place dans l'histoire des toilettes. En Inde, où 70 % de la population ne dispose d'aucun équipement sanitaire, l'organisation a installé 650 000 toilettes, que visitent quotidiennement 10 millions de personnes. Les hommes paient une roupie, les femmes et les enfants bénéficient d'un accès gratuit.

Kot als Baumaterial Termiten (nahe Verwandte der Küchenschaben) bauen riesige Türme aus zerkautem Holz, Speichel und ihren eigenen Exkrementen. Auf den menschlichen Maßstab übertragen wären die Türme 2 km hoch. Doch ungewöhnliche Baumaterialien sind kein Monopol der Termiten: Auch der Mensch baut seit Jahrhunderten mit Dung. Die Japaner setzen, wie berichtet wird, menschliche Exkremente hohen Temperaturen aus, um sie fest werden zu lassen, und setzen sie dann im Straßenbau ein, während die Afghanen Mauern aus mit Schlamm und Stroh gemischtem Kameldung errichten. Die Massai in Kenia bauen ganze Hütten aus Kuhdung: Die Frauen (denen der Bau der Hütten obliegt) setzen aus dünnen Stöcken ein Rahmenwerk zusammen, mischen frischen Mist mit Asche und bestreichen das Gerüst mit der bloßen Hand mit diesem Material. »Diese Hütten sind wirklich einfach zu bauen«, sagt Nosiabai Simei. »In der Hitze sind sie kühl, und wenn es kalt ist, sind sie warm. Außerdem riechen sie gut.«

Crap Buildings *Termites (close cousins of cockroaches) build huge towers from regurgitated wood, saliva and their own excrement. If built to a human scale, the towers would be 2 km high. But termites don't have a monopoly on unusual building materials: Dung has been used for centuries in the human construction industry, too. The Japanese reportedly solidify human excrement by subjecting it to high temperatures, then use it in road construction, while Afghans build walls with camel dung mixed with mud and straw. The Maasai of Kenya build entire huts out of cow dung: Women (who are responsible for home building) fashion a frame with thin sticks, then mix fresh manure with ash, and plaster it on the frames with their bare hands. "These houses are really easy to make," says Nosiabai Simei. "They are cool in the heat and warm when it's cold. And they smell nice."*

Un matériau de construction insolite Les termites (proches cousines des blattes) bâtissent de gigantesques tours à partir de bois régurgité, de salive et de leurs propres excréments. Transposés à échelle humaine, ces édifices atteindraient 2 km de haut. Cependant, les termites n'ont pas le monopole du matériau de construction insolite : les hommes aussi utilisent la matière fécale depuis des siècles pour leurs travaux de maçonnerie. Il paraîtrait ainsi que les Japonais solidifient des excréments humains en les soumettant à de hautes températures, pour les utiliser dans la construction routière. Si les Afghans bâtissent leurs murs dans un mélange de bouse de chameau, de boue et de paille, les Massaïs du Kenya élèvent des huttes entièrement composées de bouse de vache : les femmes (préposées à la construction des habitations) façonnent tout d'abord une armature à l'aide de fines tiges de bois, puis amalgament du fumier frais à de la cendre et en colmatent les bâtis à la main. « Ce sont des maisons vraiment faciles à faire, assure Nosiabai Simei. Elles restent fraîches quand il fait chaud, et elles gardent la chaleur quand il fait froid. Et puis, elles sentent bon. »

Der Abschied von der Windel Wenn ein Kind an den Topf gewöhnt werden soll, kommt es zum ersten größeren Konflikt mit seinen Eltern. Auf der einen Seite stehen die Eltern, die es leid sind, ihrem Kind die Windeln wechseln zu müssen, und auf der anderen das Kind, das sich nicht sagen lassen will, wann es sich zu entleeren hat. Nein zu sagen dürfte, so Psychologen, für das Kind die erste Gelegenheit sein, seine Individualität zu behaupten. Frustrierte Eltern sollten in sich gehen, bevor sie aus der Haut fahren. Erst wenn ein Kind etwa zwei Jahre alt ist, ist sein Nervensystem in der Lage, den Sphinkter zu kontrollieren, und Psychoanalytikern zufolge kann eine verfehlte Erziehung zur Reinlichkeit Folgen für das ganze weitere Leben haben. Werden Kinder dafür bestraft, daß sie ihre Windeln beschmutzen, kann es später schwierig für sie werden, Dinge wegzuwerfen oder Entscheidungen zu treffen. Und die Eltern können ihren Kindern seelische Wunden zufügen, ohne sich dessen bewußt zu sein: Babys betrachten ihre ersten Häufchen im Töpfchen als ein Geschenk für Mama oder Papa und sind verletzt, wenn das Geschenk unverzüglich beseitigt wird.

Pretty Potty *Toilet training is a child's first major conflict. On one hand, parents sick of changing diapers want their children to use a toilet as soon as possible. On the other, toddlers object to being told when to let loose. Saying no, say psychologists, is probably the first chance toddlers have to assert their individuality. Frustrated parents should think twice before getting mad, though. A child's nervous system is not developed enough to control the sphincter until the age of about two anyway, and according to Freudian psychologists, toilet training carries lifelong consequences if not done correctly. Children punished for soiling their diapers can become afraid to throw things away or make decisions. And parents can scar their children without saying a word: Babies consider their first bowel movement in the potty as a gift to mom or dad and are wounded when parents immediately dispose of it.*

Les offrandes de bébé L'apprentissage de la propreté est l'une des premières crises majeures que traverse le jeune enfant. D'un côté, les parents las de changer les couches tiennent à ce que leur rejeton utilise les toilettes le plus prestement possible ; de l'autre, bébé ne voit pas pourquoi il ferait seulement quand on le lui dit. Selon les psychologues, le refus du pot est probablement la première occasion dont peuvent se saisir les tout-petits pour affirmer leur individualité. Cependant, parents contrariés, réfléchissez bien avant de vous fâcher tout rouge. Quoi que vous tentiez, le système nerveux d'un petit enfant n'est pas suffisamment développé pour lui permettre de maîtriser ses sphincters avant l'âge de 2 ans environ. De surcroît – renchérit l'école freudienne – un apprentissage de la propreté mené à tort et à travers risque de traumatiser un individu à vie. Les punitions reçues parce que l'enfant a souillé sa couche peuvent par exemple induire chez lui la phobie de jeter ou celle de prendre des décisions. Ajoutons que les parents marquent parfois leurs enfants pour la vie entière sans même dire un mot : en effet, les bébés considèrent leur caca-popo comme un cadeau à papa ou maman, et s'offusquent de les voir jeter l'offrande sitôt faite.

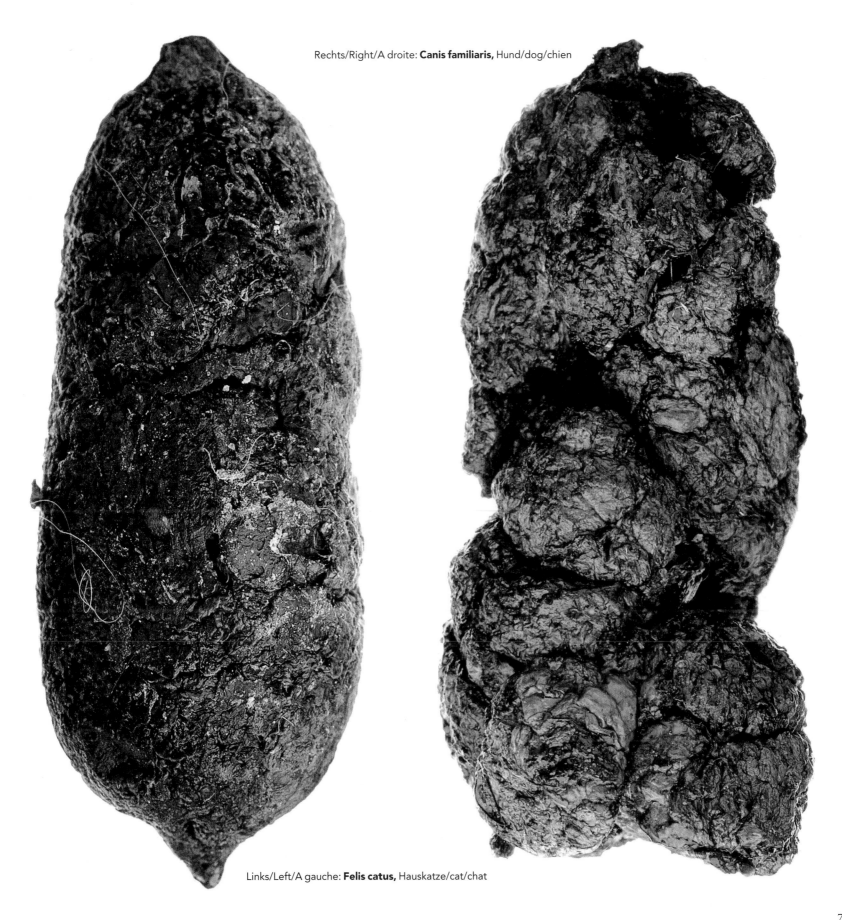

Rechts/Right/A droite: **Canis familiaris,** Hund/dog/chien

Links/Left/A gauche: **Felis catus,** Hauskatze/cat/chat

Ara ararauna, Ara/parrot/perroquet

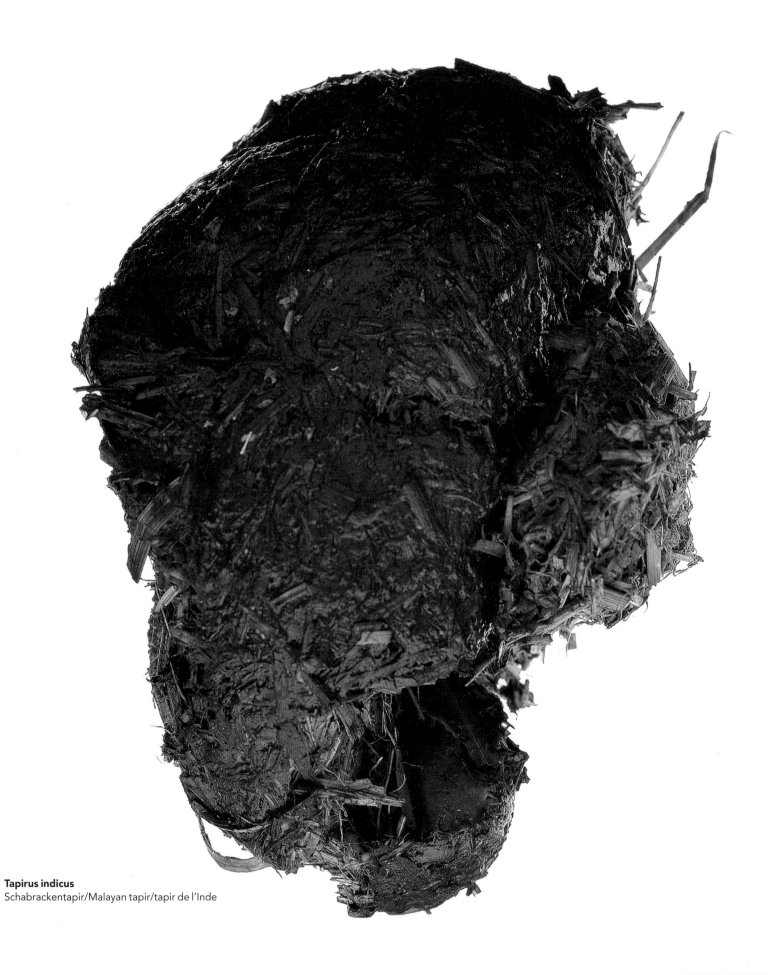

Tapirus indicus
Schabrackentapir/Malayan tapir/tapir de l'Inde

Nottoilette Im Katastrophenfall können die Wasserversorgungs- und Kanalisationssysteme lahmgelegt werden. Für Ihre eigene Nottoilette brauchen Sie: einen Plastikeimer mittlerer Größe mit genau passendem Deckel, zwei kurze Bretter, strapazierfähige, verschließbare Müllbeutel, ein Desinfektionsmittel (zum Beispiel einen Toilettenreiniger auf Chlorbasis) und Toilettenpapier oder Papierküchentücher. Kleiden sie den Eimer mit einem Müllbeutel aus und legen Sie als Sitz die beiden Bretter parallel zueinander auf den Eimer (Sollten Sie einen alten Toilettensitz haben, nehmen Sie statt dessen den). Gießen Sie etwas Desinfektionsmittel in den Eimer, um die Fäkalien keimfrei zu machen. Wenn er nicht benutzt wird, sollte der Eimer sorgfältig mit dem Deckel verschlossen werden. Um die Verbreitung von Krankheitskeimen durch Ratten oder Insekten zu vermeiden, sollten die Müllbeutel mit den Exkrementen in einem Mindestabstand von 15 m zur nächsten Wasserquelle in einer 1 m tiefen Grube vergraben werden.

When Disaster Strikes *Major disasters may cause havoc with water and sewage systems. To make your own emergency toilet, you'll need: One medium-size plastic bucket with a tight lid, two boards, heavy-duty plastic garbage bags and ties, a disinfectant like chlorine bleach, and toilet paper or towelettes. Line the bucket with a garbage bag and make a seat by placing two boards parallel to each other across the bucket. (If you have an old toilet seat, use that). To sanitize the waste, pour some disinfectant into the container. Cover the container tightly when not in use. Bury garbage and human waste to avoid the spread of disease by rats or insects: Dig a pit 1m deep and at least 15m downhill of or away from any well, spring or water supply.*

A toutes fins utiles Naturelles ou non, les grandes catastrophes causent parfois de terribles dommages dans les canalisations d'eau et les réseaux d'évacuation. Il est donc avisé de fabriquer soi-même ses toilettes de secours. Pour ce faire, il vous faut : un seau en plastique de taille moyenne muni d'un couvercle fermant bien, deux planches de bois, des sacs poubelle robustes avec rubans de fermeture, un désinfectant tel que l'eau de javel, et du papier toilette ou des lingettes. Protégez l'intérieur du seau à l'aide d'un sac poubelle, puis formez un siège en fixant les deux planches parallèlement en travers du seau, avec l'écartement voulu (si vous disposez d'une vieille lunette de toilettes, utilisez-la). Pour désinfecter, versez de l'eau de javel dans le récipient, que vous penserez aussi à bien refermer entre chaque utilisation. Enterrez le contenu des sacs pour éviter que les rats ou les insectes ne répandent les germes : à cette fin, creusez un trou de 1 m de profondeur, que vous aurez soin de placer à 15 m au moins de dénivelé ou de distance de tout puits, source ou arrivée d'eau environnants.

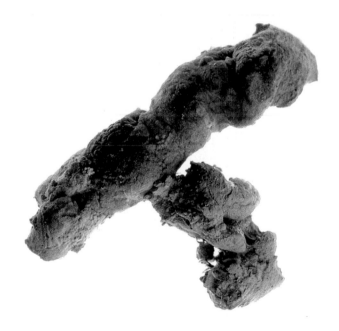

Thamnophis sirtalis
Strumpfbandnatter/garter snake/serpent-jarretière

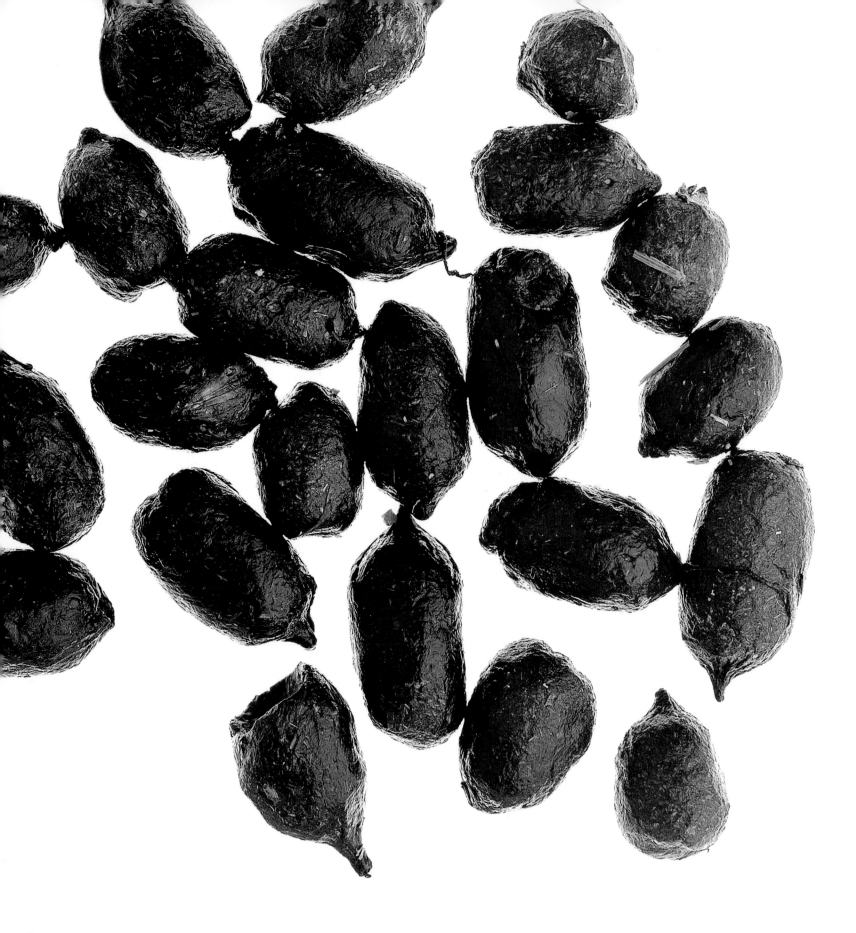

Vorsicht, Lebensgefahr! Schweine scheißen viermal soviel wie Menschen. Und ihre Exkremente sind eine nicht zu unterschätzende Gefahrenquelle: Die etwa 150 verschiedenen Gase im Schweinemist können Metall zerfressen und elektrische Leitungen zerstören. Der Schwefelwasserstoff (das nach faulen Eiern riechende Gas), der bei extremer Hitze in Jauche freigesetzt wird, kann Schweine auf der Stelle töten. Bei Menschen kann er in hoher Konzentration zu Bewußtlosigkeit und Tod durch Atemlähmung führen – noch dazu ohne Vorwarnung, da das Gas in höheren Konzentrationen den Geruchssinn außer Kraft setzt. Auch menschliche Exkremente sind keineswegs harmlos: »In China hört man immer wieder von Toiletten, die am frühen Morgen in die Luft gegangen sein sollen«, wie uns ein Latrinenexperte wissen läßt. »Der erste, der hereinkommt, setzt die gefährlichen Gase frei, die über Nacht entstanden sind, zündet sich eine Zigarette an und wirft das brennende Streichholz zwischen seine Beine. Genaues aber erfährt man nicht – über so etwas schweigt die hiesige Presse sich aus.«

Exploding Cesspits *Pigs defecate four times as much as humans. Their excrement is potent stuff: Some 150 gases found in pig manure can eat through metal and corrode electrical wiring. The hydrogen sulfide (which smells like rotten eggs) released from liquid manure in extreme heat can kill pigs on the spot. Inhaling it can paralyze and cause total collapse in humans – and the gas actually disables your sense of smell, so there's no forewarning of danger. Human feces aren't harmless, either: "In China there are rumors of toilets blowing up in the mornings," divulges one latrine expert. "The first visitor comes in, slightly stirs up the noxious gases generated overnight, lights a cigarette and throws the burning match between his legs. But it's hard to verify – it's not the sort of thing the press covers over here."*

Attention ! Danger de mort ! Un porc produit quatre fois plus d'excréments qu'un homme – et non des plus inoffensifs : on y trouve rien moins que 150 gaz capables de ronger les métaux et de corroder des fils électriques. Pour ne citer que lui, le sulfure d'hydrogène (à l'odeur d'œuf pourri) qui se dégage du lisier liquide exposé à une forte chaleur peut tuer sur place les porcs eux-mêmes. Chez l'homme, il peut provoquer une paralysie, voire une perte totale de conscience – d'autant que ce gaz perturbe l'odorat, si bien qu'aucun signe n'avertit plus du danger. Cependant, les excréments humains n'ont pas non plus la palme de l'innocuité. « Le bruit court qu'en Chine, il arrive que des toilettes explosent le matin, révèle un expert en latrines. Le premier qui y passe déplace légèrement les nappes de gaz toxique formées pendant la nuit, il allume une cigarette, il jette l'allumette enflammée entre ses jambes, et boum. Mais tout cela est difficile à vérifier. Ce n'est pas le genre de choses que la presse d'ici songe à couvrir. »

Lama guanicoë
Guanako/guanaco/guanaco

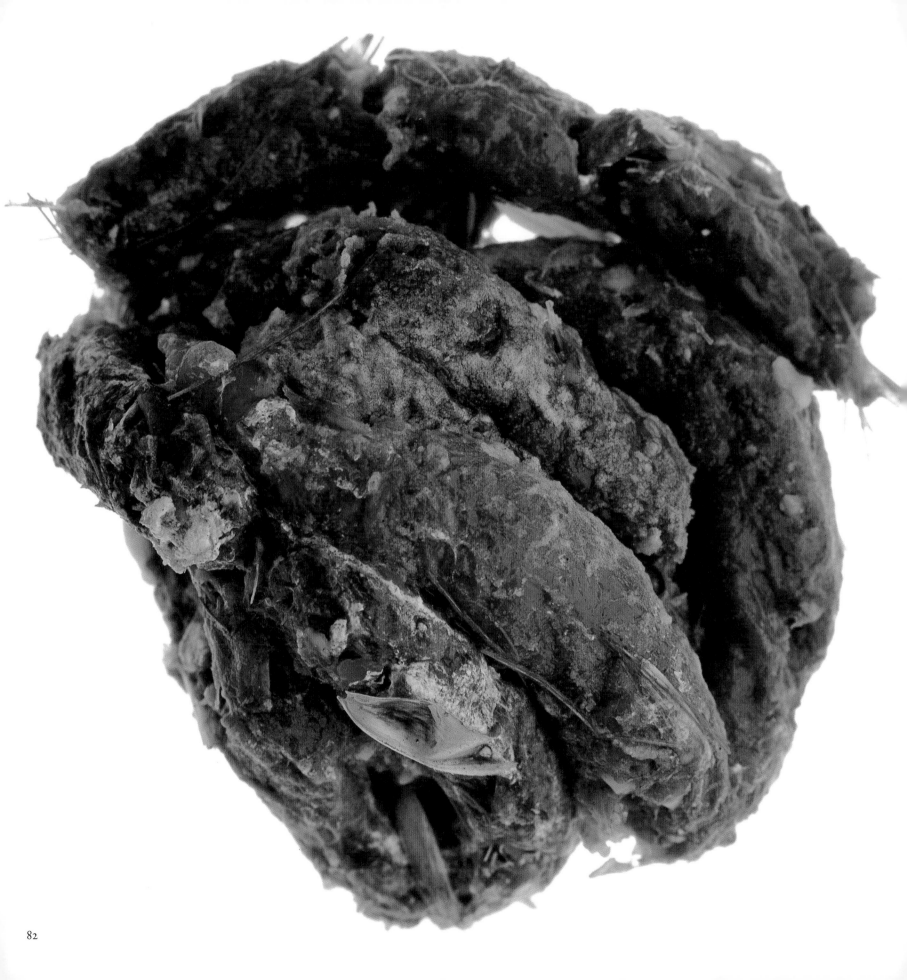

Tremarctos ornatus, Brillenbär/spectacled bear/ours à lunettes
Gegenüberliegende Seite/Opposite/Page de gauche: **Gallus domesticus,** Hahn/cock/coq

Koprophilie Für Liebhaber des Analverkehrs mit einer Abneigung gegen Exkremente empfiehlt sich die Benutzung eines Kondoms: Andernfalls können sich Kot und unverdaute Speisereste wie Körner auf dem Penis ansammeln. Falls Sie dagegen gerne Exkremente in Ihre sexuellen Handlungen einbeziehen, sind Sie gewiß nicht allein auf der Welt. Über 20 Prozent der Sadomasochisten spielen beim Sex mit Urin oder Kot, und Koprophile schauen einander genußvoll beim Scheißen zu, integrieren Exkremente in ihr Sexualleben und entleeren sich mit Vorliebe parallel zum Orgasmus. Für Psychologen hängt die Faszination, die Exkremente auf manche Menschen ausüben, mit dem Reiz des Tabubruchs zusammen. Aber auch der Geruch könnte durchaus eine Rolle spielen: Stechende Gerüche werden im limbischen System registriert, dem Randgebiet zwischen Hirnstamm und Großhirn, das auch für den Sexualtrieb zuständig ist. Falls Sie auf Exkremente abfahren, kann Ihr Fetischismus teuer für Sie werden. In Frankreich kostet eine Stunde mit einer Domina, die sich bereit erklärt, auf Ihr Gesicht zu scheißen, etwa 3.000 Franc (ca. 900 DM).

Coprophilia *For aficionados of anal sex with an aversion to feces, the use of a condom is advisable: Otherwise, the penis may collect feces and bits of undigested food, like corn. If you do like to include excrement in your sexual activity, though, you're certainly not alone. About 20 percent of sadomasochists play with urine or feces during sex, and coprophiliacs enjoy watching each other defecate, using excrement during sex, and synchronizing orgasms with bowel movements. In Japan, sex shops sell schoolgirls' panties streaked with excrement for ¥5,000 (US$35). Psychologists attribute a fascination with excrement to the thrill of breaking taboos. But the smell may be relevant: The brain registers pungent odors in the limbic region, which is also responsible for erotic urges. If your tastes run to excrement, your fetish could be pricey. In France, one hour with dominatrixes willing to defecate on their clients' faces costs about FF3,000 ($450).*

Comment pimenter vos ébats Pour les sodomites enthousiastes souffrant néanmoins d'une aversion pour la matière fécale, l'usage d'un préservatif est hautement recommandé. A défaut, ils risquent de se retrouver le pénis enduit de selles et autres bribes d'aliments non digérées, des grains de maïs par exemple. En revanche, si vous aimez assez relever vos ébats d'un zeste de caca, sachez bien que vous n'êtes pas seul. Près de 20 % des sadomasochistes jouent avec l'urine et les excréments durant les rapports sexuels ; quant aux coprophiles, ils n'apprécient rien tant que de regarder le partenaire déféquer, d'utiliser les déjections pendant l'amour et de synchroniser leurs orgasmes avec leurs vidanges intestinales. Au Japon, les sex-shops vendent des culottes de fillettes tachées de caca, au prix de 5 000 yens. Les psychologues attribuent cette fascination pour la matière fécale au plaisir d'enfreindre les tabous. L'odeur y contribue sans doute, elle aussi. En effet, le cerveau enregistre les relents âcres et puissants au niveau du système limbique, région cérébrale également responsable des pulsions érotiques.

Im Dienst der Wissenschaft »Für auf Fleischfresser spezialisierte Zoologen sind die Exkremente dieser Tiere unentbehrlich«, sagt Dr. Nigel Dunstone von der Durham University in Großbritannien. Anhand der »Losungen« untersuchen sie den Speiseplan aller erdenklichen Raubtiere. Den Jaguaren gilt ihr Interesse ebenso wie Nerzen oder Bären. »Mit Hilfe genetischer Techniken kann man das Tier identifizieren, das die Fäkalien ausgeschieden hat, auf die Größe der Population schließen, und sogar auf den Weg, den das einzelne Tier zurückgelegt hat.« Die Exkremente werden in Plastiktüten gesammelt, getrocknet und dann untersucht. Die größeren Haufen – der eines Bären kann 1 kg wiegen – werden in einen Kolben gesteckt und mit einem Bleichmittel versetzt, um Knochen und Haare von den eigentlichen Fäkalien unterscheiden zu können. Dr. Dunstone: »Ohne diese Kotanalyse müßte man die Tiere töten und ihnen den Mageninhalt entnehmen, was sich bei gefährdeten Arten von selbst verbietet. Sind die Exkremente frisch, können sie einen strengen Geruch verbreiten, und wir müssen dann im Freien arbeiten. Wir tragen Handschuhe, einen Mundschutz – und brauchen jede Menge Kölnisch Wasser.«

Dedicated to Science *Feces "are the major tool in carnivore biology," says Dr. Nigel Dunstone of the UK's Durham University. Carnivore biologists use "scats" (feces) to investigate the diet of almost every species of carnivore, including jaguars, mink and bears. "Using genetic techniques, you can identify which animal a scat came from, its population size, even how far the individual animal has traveled." The scats are collected in polythene bags, dried, and then teased apart. Larger droppings – a bear scat can weigh 1kg – are placed in a tube and mixed with bleach so that bones and hairs can be distinguished from the excrement. "Without this analysis," Dr. Dunstone continues, "you'd have to kill the animals and extract their stomach contents, which in terms of conservation is a no-no. If the scats are fresh, it can get a bit whiffy, and we have to do it outside. We wear gloves, a disposable mouth mask – and lots of cologne."*

Pour les besoins de la science Les selles « constituent l'outil majeur de l'étude biologique des carnivores », indique le Dr Nigel Dunstone, de l'université britannique de Durham. Les spécialistes du domaine utilisent des « largages » (selles) pour déterminer les régimes alimentaires de toutes les espèces carnivores ou peu s'en faut, du jaguar au vison en passant par l'ours. « Par le biais des techniques d'identification génétique, on peut déterminer l'espèce dont provient un largage, la taille de sa population, et même la distance éventuelle parcourue par l'animal individuel. » Les largages sont stockés dans des sacs en polyéthylène, séchés, puis décortiqués et analysés en détail. Les déjections les plus grosses (le largage d'un ours peut atteindre 1 kg) sont insérées dans un tube et additionnées de chlore, afin que les os et les poils parviennent à se distinguer de la matière fécale elle-même. « La seule autre solution serait de tuer les animaux pour prélever le contenu de leurs estomacs, ce qui, en termes de préservation des espèces, est un interdit absolu. Si les largages sont frais, l'air peut devenir un peu chargé, et en ce cas nous devons opérer en extérieur. »

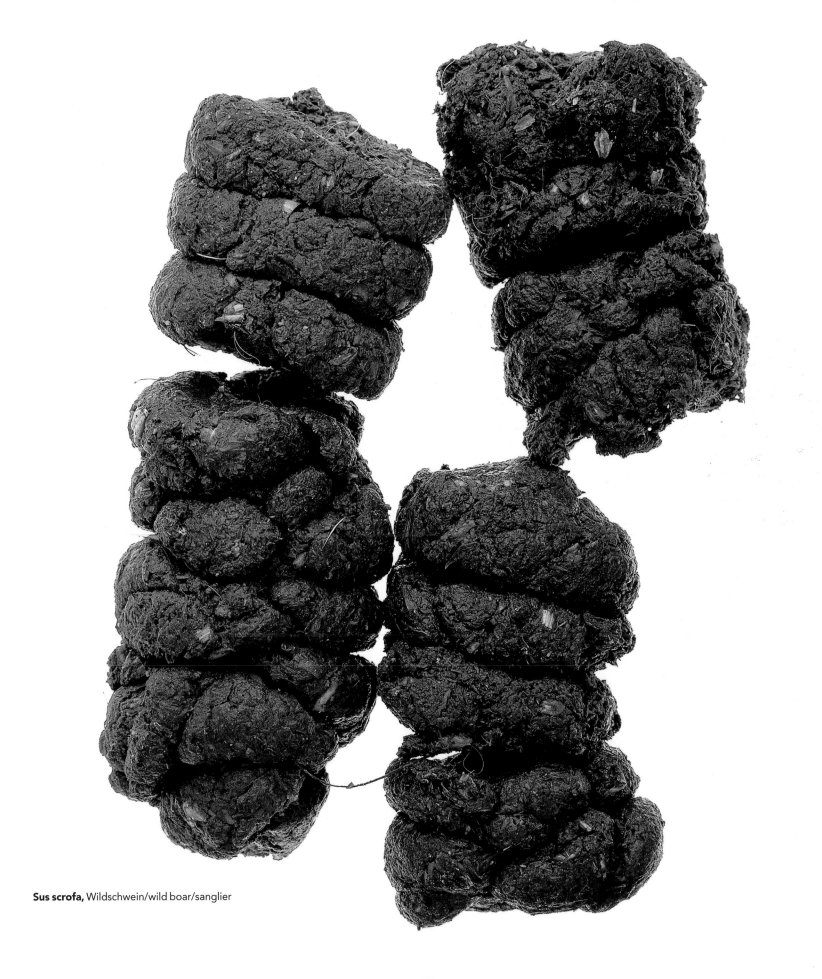

Sus scrofa, Wildschwein/wild boar/sanglier

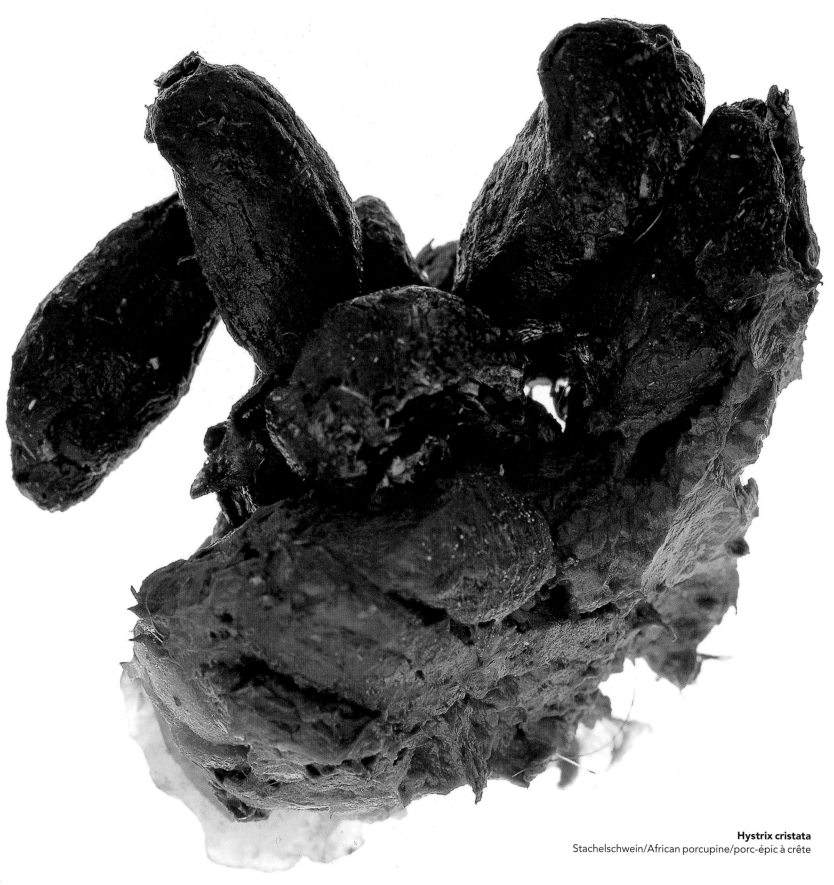

Hystrix cristata
Stachelschwein/African porcupine/porc-épic à crête

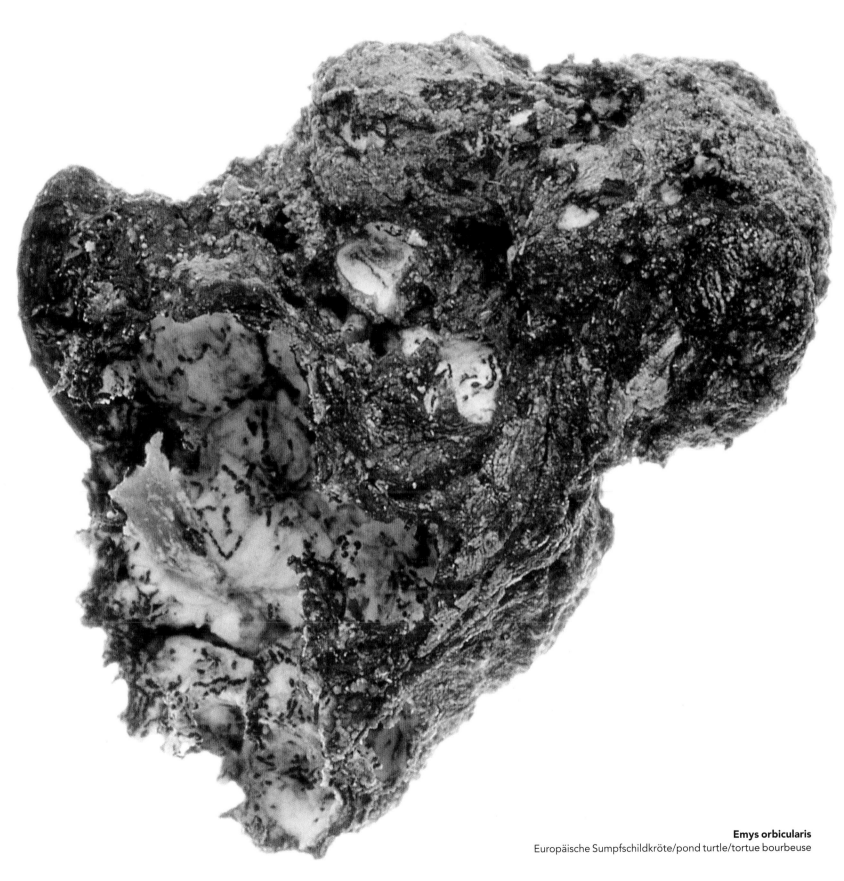

Emys orbicularis
Europäische Sumpfschildkröte/pond turtle/tortue bourbeuse

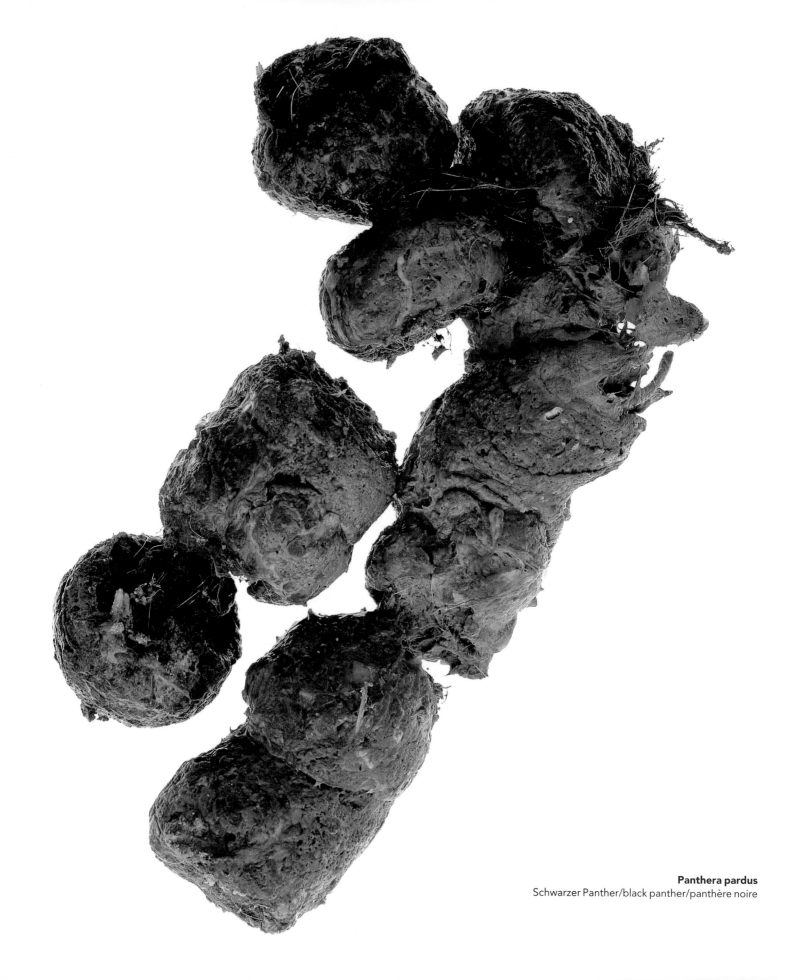

Panthera pardus
Schwarzer Panther/black panther/panthère noire

Big Brother is Watching You! Wir leben in einer Zeit der um sich greifenden Überwachung, und selbst Toiletten sind vor Kameras nicht sicher. Einer neueren Studie zufolge werden 63 Prozent der amerikanischen Arbeiter ständig an ihrem Arbeitsplatz beobachtet, 40 Prozent der Arbeitgeber lassen Telefongespräche aufzeichnen und 16 Prozent die Büros mit Videokameras überwachen. Und einige Unternehmen gehen noch weiter. Gegen britische und amerikanische Firmen sind in jüngster Zeit Verfahren angestrengt worden, weil sie Videokameras in den Arbeitnehmertoiletten installiert haben. Juristisch wird man jedoch kaum gegen sie vorgehen können – Firmengelände gelten als Privateigentum, und für gewöhnlich stellt die angelsächsische Rechtsprechung den Schutz des Privateigentums durch elektronische Überwachungsmaßnahmen über den der Privatsphäre. Die elektronische Beschnüffelung ist jedoch nicht auf den Arbeitsplatz beschränkt: Auch Koprophile (Menschen, die durch Exkremente sexuell erregt werden) und Voyeure installieren manchmal Kameras in Toiletten. Der amerikanische Sänger Chuck Berry wurde 1991 verurteilt, weil er in der Damentoilette seines Restaurants in Missouri 200 Frauen auf Videoband aufgezeichnet hatte, und das Internet bietet kinderleichten Zugriff auf Videoaufnahmen von Frauen, die ahnungslos auf die Toilette gegangen sind. Gibt es denn keine Möglichkeit, den Menschen wenigstens auf der Toilette vor Eingriffen in seine Intimsphäre zu schützen? »Bis jetzt noch nicht«, so die britische Bürgerrechtsorganisation Liberty. »In diesem Bereich hat sich die Technologie viel schneller entwickelt als die Rechtsprechung.«

Big Brother is Watching You! *In these days of advanced surveillance, even bowel movements aren't safe from scrutiny. According to a recent study, American workers are being watched 63 percent of the time: 40 percent of employers record telephone calls, 16 percent videotape offices – and some companies take it even further. Firms in the UK and USA are currently under investigation for installing video cameras in employee toilets. But according to most privacy laws, they're perfectly entitled to – it's usually legal to videotape on private property. Electronic snooping isn't confined to the workplace, though: Coprophiliacs (who get sexual pleasure from excrement) and voyeurs sometimes install cameras in toilets. American singer Chuck Berry was convicted in 1991 for videotaping 200 women in the rest room of his Missouri restaurant, and videos of unsuspecting women in lavatories are readily available on the Internet. Can nothing protect the sanctity of the toilet? Not yet, says UK-based civil rights group Liberty. "This is an area where technology has developed much faster than the law."*

Big Brother is Watching You ! En ces jours de surveillance exacerbée, même la vie de votre intestin n'est pas à l'abri de l'œil indiscret d'une caméra. Selon une étude récente, les travailleurs américains sont exposés à la haute vigilance patronale sur 63 % de leur temps de travail : 40 % des employeurs enregistrent les communications téléphoniques, 16 % truffent les bureaux de caméras vidéo – et certaines entreprises vont même un peu plus loin. Quelques firmes britanniques et américaines ont ainsi été mises en examen pour installation de caméras vidéo dans les toilettes des employés. Le problème est qu'au regard de la plupart des lois sur la protection de la vie privée, c'est là leur droit le plus strict – le filmage vidéo est généralement autorisé dans le cadre d'une propriété privée. L'indiscrétion électronique ne se limite pourtant pas aux lieux de travail : certains coprophiles (personnes tirant leur plaisir sexuel des excréments) et autres voyeurs ne répugnent pas à équiper les toilettes de caméras. Citons le chanteur américain Chuck Berry, condamné en 1991 pour avoir filmé 200 femmes dans les toilettes de son restaurant du Missouri, ainsi que multiples séquences vidéo de femmes espionnées à leur insu dans les lieux d'aisances déjà disponibles sur Internet. N'y a-t-il donc aucun moyen de protéger l'inviolabilité de nos cabinets ? Pas encore, déplore le mouvement de défense des droits du citoyen Liberté, basé au Royaume-Uni. « Nous avons là un domaine où la technologie a évolué bien plus vite que la loi. »

Bedürfnisanstalten Der Stuhlgang – ein Recht oder ein Privileg? Überall in der Welt sind die Behörden noch immer auf der Suche nach angemessenen Regelungen für öffentliche Bedürfnisanstalten. In Vietnam kann es Stunden dauern, bis man eine findet (es gibt keine Hinweisschilder). In den großen Städten Chinas zahlen Ortsansässige im Schnitt 0,3 Yuan (ca. 8 Pfennig) für einen Toilettenbesuch – Ausländern wird das Doppelte abverlangt. Im ländlichen China hockt man sich über einen Trog – der hat zwar keine Türen, ist dafür aber kostenlos. (Normalerweise sind die Latrinen allerdings dermaßen verdreckt, daß die Leute lieber Müllhalden aufsuchen.) Konkurrenzlos billig ist der Toilettenbesuch in der kanadischen Provinz British Columbia, wo der Public Toilet Act Benutzungsgebühren untersagt, und in der indonesischen Hauptstadt Jakarta stehen Studenten 60 Prozent Ermäßigung zu. Wer dagegen in Singapur ein dringendes Bedürfnis verspürt, sollte seine Brieftasche zur Hand haben: Die Spülung nicht zu betätigen, ist ein Vergehen, und wer von den Undercover-Agenten der Gesundheitsbehörde ertappt wird, hat an Ort und Stelle 29 Singapurdollar (ca. 34 DM) zu entrichten.

Public Convenience *Defecation – a right or a privilege? Worldwide, states are still working on a consistent public toilet policy. In Vietnam, it can take hours to find one (there are no signs to indicate their presence). In China's big cities, locals may pay Yo.3 or so per toilet visit – foreigners are charged double. In rural China you'll be squatting over a trough, with no doors, but it's free. (Latrines are usually so dirty, though, that people prefer to defecate in garbage dumps, reports a resident). For cheaper toilet options, move to British Columbia, Canada, where the Public Toilet Act makes it illegal to charge; or become a student in Jakarta, Indonesia, where you're entitled to a 60 percent discount. If you're caught short in Singapore, though, keep your wallet handy: Not flushing is an offense, and undercover health officials lurk in rest rooms to issue on-the-spot fines of S$29(US$17). Repeat offenders can be charged S$925 ($530).*

Les toilettes publiques Déféquer – droit ou privilège ? Aux quatre coins du monde, les Etats travaillent encore à se doter d'une politique cohérente en matière de toilettes publiques. Au Viêt-nam, on peut mettre des heures à en dénicher (aucun panneau n'indique leur présence). Dans les grandes agglomérations chinoises, on demande parfois quelque 0,3 yen aux résidents pour une visite au petit coin – et le double aux étrangers. En Chine rurale, il faudra certes vous accroupir au-dessus d'un trou, dans une cabine sans porte, mais cela ne vous coûtera pas un sou (cependant, les latrines sont généralement si sales que les gens préfèrent déféquer dans les décharges publiques, rapporte un résident). Pour de vraies économies, émigrez en Colombie-Britannique, au Canada, où la loi régissant les toilettes publiques prohibe toute tarification ; ou prenez le statut d'étudiant à Jakarta, en Indonésie : il vous donnera droit à une remise de 60 %. Pris d'une urgence naturelle à Singapour ? Gardez votre portefeuille à portée de main. En effet, oublier de tirer la chasse y est considéré comme une infraction, et des fonctionnaires de l'Inspection sanitaire rôdent …

Kosmetik und Geschmeide Kosmetikprodukte auf der Basis von Exkrementen sind in Japan nichts Neues. Die Feuchtigkeitscreme Nightingale Droppings (Nachtigallenhäufchen) ist dort sehr gefragt, und selbst für Modeschmuck wird in Japan Kot verwendet. Die für Kläranlagen zuständige Behörde in Tokio gibt gern entsprechende Auskünfte. Die braunen, marmorartigen Stücke werden aus Klärschlamm gefertigt, der hohem Druck und hohen Temperaturen ausgesetzt wird, und für Halsketten, Ohrringe, Krawattennadeln und Manschettenknöpfe verwendet. »Die Japaner nennen es Metro-Marmor«, sagt Graham Amy von der britischen Wasserversorgungsgesellschaft Southern Water, »aber in Wirklichkeit ist es das, was aus dem Hintern herauskommt.«

Ornaments and Shit *Excrement beauty products are nothing new in Japan, where Nightingale Droppings moisturizer is a popular skin treatment, and feces are even used to make stylish jewelry. Tokyo's Sewerage Bureau offers advice on how to make jewelry from sewage. The brown, marblelike pieces – formed by exposing sewage to high temperatures and pressure – are used in necklaces, earrings, tiepins and cuff links. "The Japanese call it metro-marble," says Graham Amy of the UK's Southern Water company. "But in real terms it's what comes out of your bottom."*

Onguents et bijoux fantaisie Les produits de beauté à base d'excréments ne sont pas chose nouvelle au Japon, où la crème hydratante aux fientes de rossignol connaît une grande popularité. On y recycle même la matière fécale pour fabriquer des bijoux du plus grand chic. L'Office de gestion des égouts de Tokyo dispense sur demande quelques bons conseils pour confectionner des bijoux en provenance directe du cloaque. En guise de perles, on utilise de petites billes brunes, formées en exposant les résidus d'eaux usées à de hautes températures et à des pressions élevées. On les porte d'ordinaire en collier, en boucles d'oreilles, en épingle à cravate ou en boutons de manchettes. « Les Japonais les appellent ‹ métro-billes ›, précise Graham Amy, de la compagnie des eaux britannique Southern Water. Mais concrètement, ce n'est rien d'autre que ce qui sort de votre derrière. »

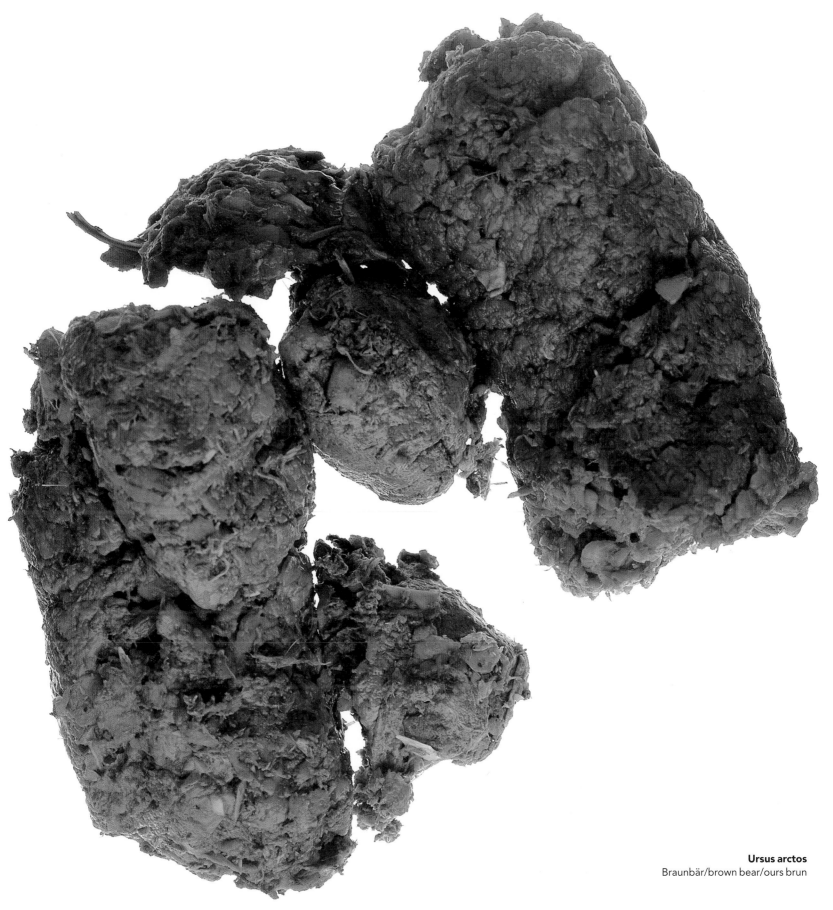

Ursus arctos
Braunbär/brown bear/ours brun

Dama dama, Damwild/fallow deer/daim

In der Kanalisation Es ist gar nicht so leicht, die 160.000 kg Scheiße, die Marseille täglich produziert, in Fluß zu halten. Die südfranzösische Stadt beschäftigt 420 Vollzeitarbeitskräfte, um ihre Abwasserkanäle vor Verstopfungen zu bewahren. Die Kanalarbeiter müssen täglich durch Fäkalienströme hindurchwaten. Um vor Infektionen geschützt zu sein, sind sie mit brusthohen Gummiwatstiefeln, einer Schutzbrille, einem Regenmantel, Gummihandschuhen, einer Gasmaske und einer Notsauerstoffflasche ausgerüstet. Impfungen (Tetanus, Hepatitis B) sind ebenso obligatorisch wie das tägliche Duschen mit einem Bakterizid und eine schnittwundenfreie Haut (bei der Rasur ist also größte Vorsicht geboten). Wie aber wird man mit dem Gestank fertig? »Nach etwa fünf Minuten hat man sich daran gewöhnt«, sagt Pierre Faure, der dreißig Jahre in den Abwasserkanälen von Marseille verbracht hat. Trotzdem kann's gefährlich werden: Die Kanalarbeiter sind über eine Leine mit Kollegen auf der Straße verbunden, die sie aus dem Schlamm ziehen, wenn sie von den aus den gärenden Fäkalien aufsteigenden Dämpfen umgehauen werden, bevor sie zur Gasmaske greifen können. Sollte das alles nicht sonderlich verlockend klingen, muß man sich nur die Vorteile vor Augen führen: 8.416 Franc (ca. 2.500 DM) im Monat und jährlich ein Handtuch und eine Ration Seife und Shampoo.

Below the Manhole-Cover *Keeping Marseille's 160,000kg of shit flowing smoothly isn't easy. The southern French town employs 420 full-time workers to unclog its sewers. To avoid infections (wading through rivers of soupy feces is inevitable) workers are supplied with chest-high rubber waders, antisplash goggles, a raincoat, rubber gloves and an emergency oxygen tank and gas mask. Vaccinations (tetanus, hepatitis B), daily showers with bactericide and uncut skin (that means no shaving nicks) are mandatory. But what about the smell? According to Pierre Faure – who has spent 30 years in Marseille's sewers – you get used to it after about five minutes. It can still be dangerous though: Workers are attached by a cord to surface teams. That way, if fumes from fermenting excrement knock them out before they can grab their gas masks, colleagues can drag them out of the sludge. If it all sounds a little daunting, consider the on-the-job benefits: FF8,416 (US$1,200) per month and a yearly soap, shampoo and towel allowance.*

Le dur métier d'égoutier Difficile de faire circuler sans accroc 160 000 tonnes de merde par jour, comme en produit Marseille. Cette ville du midi de la France emploie à plein temps une brigade de 420 égoutiers pour déboucher ses égouts. Afin d'éviter les infections (patauger dans des rivières d'excréments réduits en soupe fait partie des aléas du métier), ces travailleurs des sous-sols sont équipés de toute une panoplie : salopettes à cuissardes intégrées en caoutchouc, lunettes hermétiques anti-éclaboussures, imperméable et gants plastique, sans oublier les bouteilles à oxygène et le masque à gaz pour les urgences. Autres obligations absolues : les vaccins (tétanos et hépatite B), la douche quotidienne au bactéricide, et pas de coupures (ce qui exclue les égratignures de rasoir). Oui, mais l'odeur? Selon Pierre Faure – trente ans de carrière dans les égouts de Marseille – on ne sent plus rien au bout d'environ cinq minutes. Pour autant, tout danger n'est pas écarté. Les égoutiers sont reliés par des cordes à des équipes de surface. Ainsi, si les émanations toxiques que dégage la fermentation d'excréments les assomment avant qu'ils n'aient eu le temps de saisir leurs masques à gaz, leurs collègues parviennent à les extirper du cloaque. Tout cela vous paraît un brin décourageant? Songez aux avantages du métier : 8 416FF par mois, plus une provision annuelle de savon, shampooing et serviettes.

Mandrilus sphinx
Mandrill/mandrill/mandrill

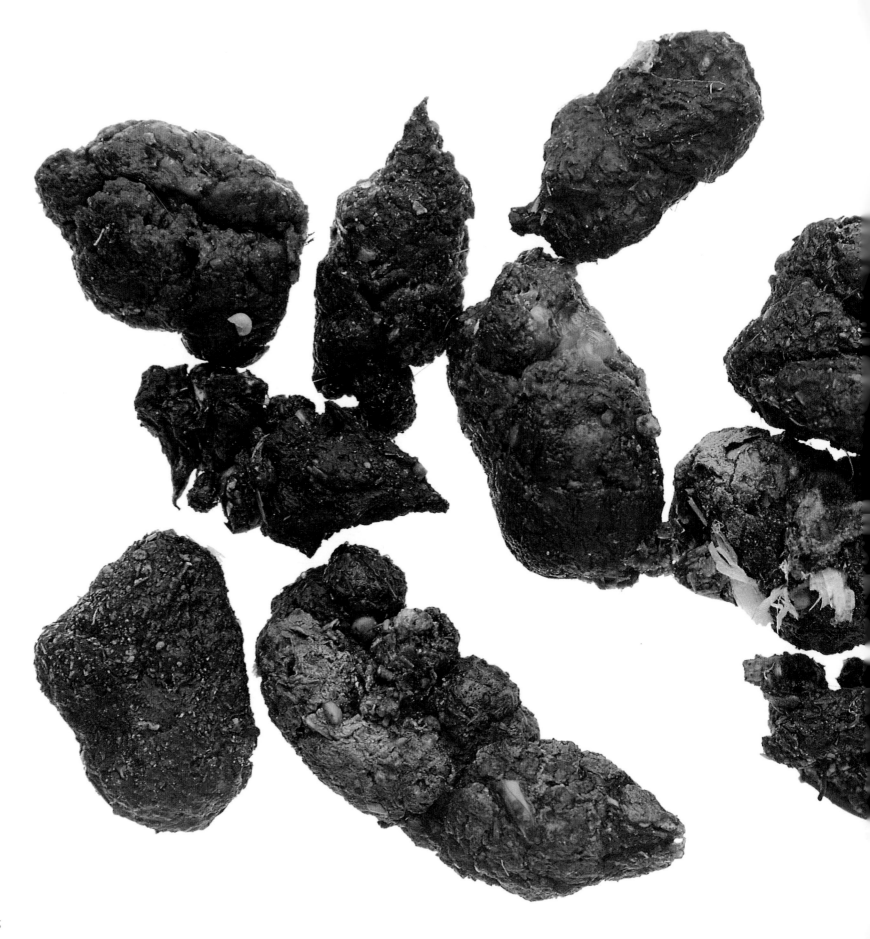

Biogas Für mehr als ein Zehntel der Weltbevölkerung sind gärende Fäkalien die wichtigste Energiequelle. Das Ergebnis – Biogas – kann zum Kochen oder zur Elektrizitätsgewinnung verwendet werden. In Nepal liefern die Ausscheidungen zweier Kühe genügend Brennmaterial für den Herd einer sechsköpfigen Familie. In den letzten 20 Jahren hat China mehr als fünf Millionen »Verdauer« installiert, Biogaserzeuger, die Fäkalien und Abfälle zersetzen und 60 Prozent des Energiebedarfs einer Familie decken können. In Indien, wo bislang mehr als zwei Millionen Biogasanlagen eingerichtet worden sind, erhält jeder, der eine solche Anlage installiert, eine Beihilfe von der Bundesregierung. Das Prinzip, das der Biogasnutzung zugrunde liegt, ist nicht neu: Die Tibeter kochen seit Jahrhunderten mit Dung (auf den baumlosen Plateaus dieses Landes ist Jak-Dung das einzige verfügbare Brennmaterial). Die Afghanen kochen mit Kameldung, die Mongolen mit Pferdeäpfeln.

Biogas *More than one in 10 people worldwide get their power from fermenting shit. Biogas – as the result is known – can be used as cooking fuel or to generate electricity. In Nepal, the excreta from two cows can provide cooking fuel for a family of six. Over the last 20 years, China has installed more than five million "digesters," devices that break down household waste and can supply 60 percent of a family's energy needs. In India, where more than two million biogas plants have been built so far, anyone who installs a plant is entitled to an allowance from the central government. The principle behind biogas isn't new: Tibetans have been cooking with dung for centuries (yak dung is the only fuel available on the country's treeless plateaus). Afghans cook with camel dung, while Mongolians prefer horse droppings.*

Le bio-gaz Plus d'une personne sur dix dans le monde tire son carburant de la fermentation fécale. Le bio-gaz – ainsi nomme-t-on le résultat du processus – peut être utilisé aussi bien pour cuire ses aliments que pour produire de l'électricité. Au Népal, les déjections de deux vaches suffisent pour assurer des repas chauds à une famille de six personnes. Au cours des vingt dernières années, la Chine a installé plus de 5 millions de «digesteurs», appareillages qui décomposent les déchets domestiques et couvrent 60% des besoins énergétiques d'un foyer. En Inde, où l'on a construit à ce jour plus de 2 millions de centrales à bio-gaz, toute personne qui bâtit ce genre d'installation se voit attribuer une allocation d'Etat. Le principe du bio-gaz n'a rien de nouveau : les Tibétains cuisent leur nourriture à la bouse depuis des siècles (les excréments de yak étant le seul combustible disponible dans cette contrée de hauts plateaux dénudés). Les Afghans utilisent de la bouse de chameau, les Mongols préfèrent le crottin de cheval.

Saguinus fuscicollis
Braunrückentamarin/brown-headed tamarin/tamarin à tête brune

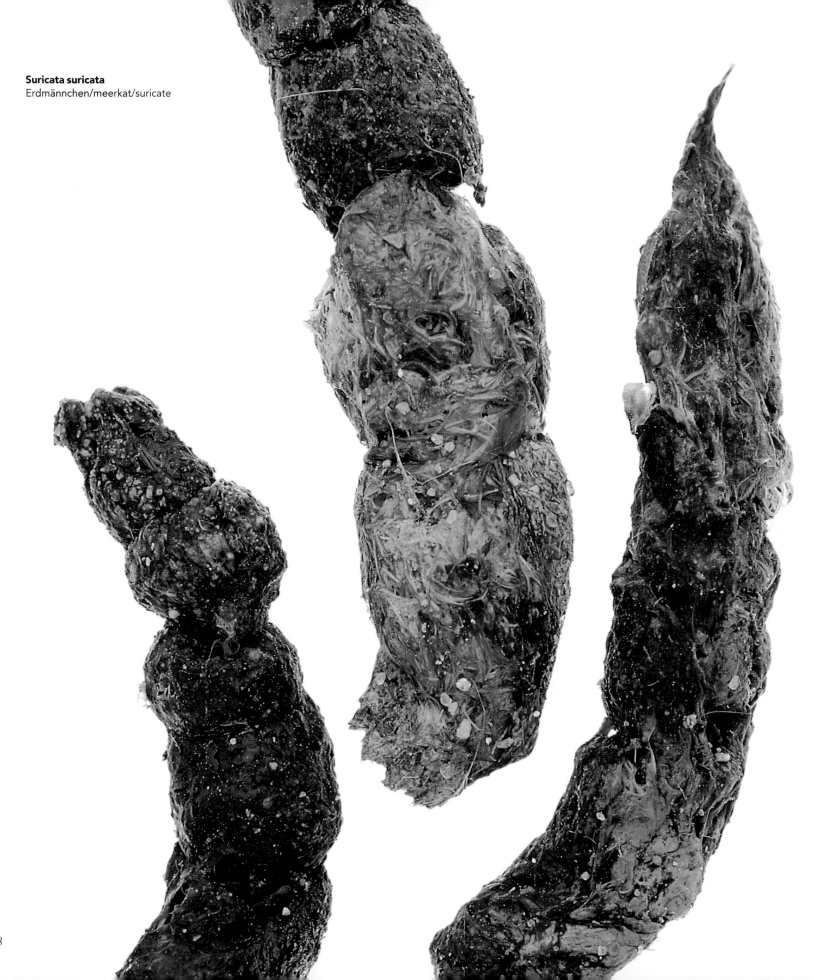

Drogenkuriere Wenn Sie sich das nächste Mal einen Schuß setzen, sollten Sie bedenken, daß das Heroin aus einem menschlichen Hintern gekommen sein könnte. Marihuana, Heroin und Kokain werden oft von als »Stopfern« oder »Schluckern« bekannten Schmugglern im Körper transportiert. »Schlucker« nehmen das Zeugs durch den Mund auf«, erklärt ein Sprecher der britischen Zollverwaltung, »Stopfer stecken es sich in den Hintern.« Schlucker – normalerweise arme Frauen aus Entwicklungsländern – nehmen vor ihrer Abreise in die Industrieländer etwa 70 traubengroße Drogenpäckchen auf. Für gewöhnlich wird der Stoff in mit Kreppband versiegelten und mit Honig beschichteten Kondomen transportiert. Trotz dieser Vorsichtsmaßnahmen reißen die Päckchen oft und versetzen dem Drogenkurier eine massive Überdosis, die zum Kollaps und manchmal auch zum Tod führt. Auf dem Londoner Flughafen Heathrow werden verdächtige Personen zur Frost Box geführt, einer Spezialtoilette mit einem durchsichtigen Plexiglasrohr, das die Sicht auf die Exkremente freigibt. Sobald die Natur ihren Lauf nimmt, desinfiziert die Frost Box den Kot und schwemmt ihn aus. Werden dabei Drogenpäckchen freigelegt, streift sich ein Beamter Gummihandschuhe über und nimmt sie heraus. »Nur ein ganz kleiner Anteil der eingeschmuggelten Drogenmengen wird auf diese Weise aufgespürt«, so der Sprecher der Zollverwaltung. »Als Frachtgut getarnt können kiloweise Drogen eingeführt werden, aber der Magen hat nun einmal nur eine beschränkte Kapazität.«

Drug-Runs *Next time you shoot up heroin, consider that it may have come out of someone's backside. Marijuana, heroin and cocaine can be smuggled inside human bodies by carriers known as "stuffers" or "swallowers." "Swallowing is taking it orally," explained a spokesperson at the UK's Customs and Excise Department. "Stuffing is putting it in the other end." Swallowers – who tend to be poor women from developing countries traveling to the West – ingest about 70 grape-size drug packages, usually wrapped in condoms, sealed with masking tape and coated with honey. Despite the precautions, the packages often leak, causing collapse and occasionally death from a massive overdose. At London's Heathrow Airport, suspected swallowers are taken to the Frost Box, a special toilet with a clear perspex pipe that allows officers to see what's excreted. When nature takes its course, the Frost Box sluices and disinfects the feces, before an officer picks out the drug packages using rubber gloves. "A very small percentage of drugs are seized this way," continues the spokesperson. "You can get kilos of drugs through cargo, but your stomach's only a certain size."*

Les dealers : avaleurs et farcis La prochaine fois que vous vous injectez de l'héroïne, prenez le temps de songer qu'elle peut provenir tout droit du derrière de quelqu'un. En effet, la marijuana, l'héroïne et la cocaïne traversent parfois les frontières cachées dans les intestins de passeurs connus sous le nom de « farcis » ou « avaleurs ». « Avaler signifie ingérer par voie orale, explique un porte-parole du ministère des Douanes et Taxations britannique. Se farcir, c'est par l'autre côté. » Les avaleurs – en majorité des femmes démunies en provenance des pays en voie de développement et transitant vers l'Ouest – gobent environ 70 sachets de drogue de la taille d'un grain de raisin, d'ordinaire confectionnés dans des préservatifs, scellés à l'aide de papier-cache adhésif, et enrobés de miel. Malgré ces précautions, il arrive souvent que les sachets fuient, provoquant des syncopes, voire la mort par surdose massive. A l'aéroport londonien de Heathrow, les voyageurs suspects sont conduits à la « boîte à gelée », des toilettes spéciales munies d'un tube d'évacuation en plexiglas transparent, qui permet à la police de voir ce qui a été excrété. Lorsque la nature fait son office, la boîte à gelée lave à grande eau et désinfecte les selles, puis un officier de police ganté de caoutchouc se dévoue pour récolter les sachets. « Ce n'est pas de cette manière que nous réalisons nos plus grosses prises, poursuit le porte-parole. On peut passer des kilos de drogues par cargo, mais un estomac n'a qu'une contenance limitée. »

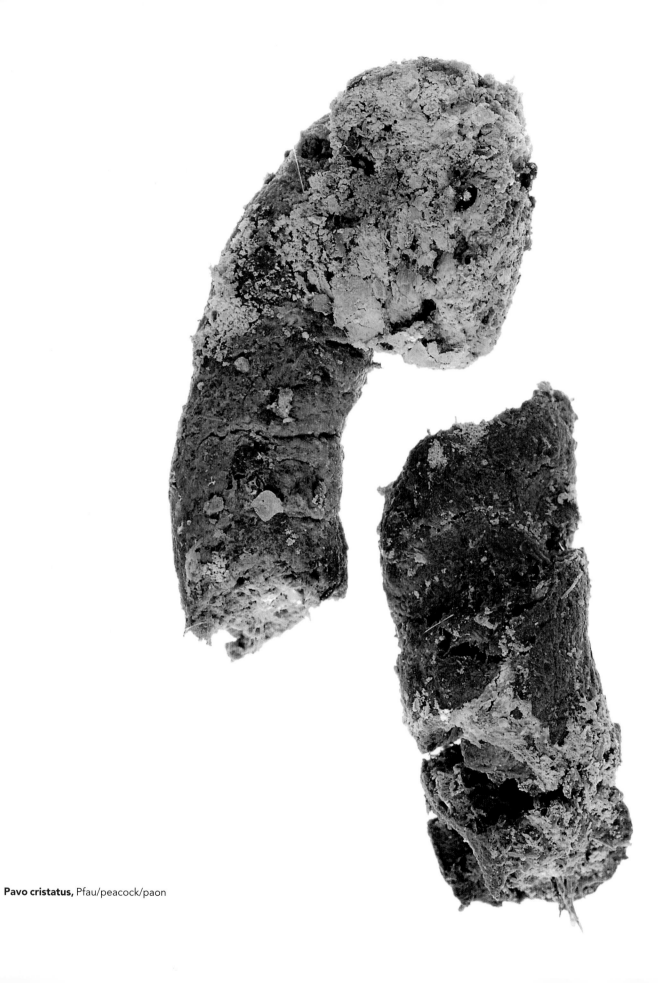

Pavo cristatus, Pfau/peacock/paon

Künstlerscheiße 1961 verwandelte der italienische Künstler Piero Manzoni Scheiße in Gold. Manzoni füllte 90 Dosen mit seinen eigenen Exkrementen und brachte sie als *Merda d'Artista* (Künstlerscheiße) auf den Kunstmarkt. Der Preis entsprach dem Goldwert des Gewichts der einzelnen Dosen. 1998 wurden einige Exemplare für ca. 80.000 DM das Stück verkauft. 37 Jahre später trat der britische Künstler Marc Quinn in Manzonis skatologische Fußstapfen. Er füllte einen Abguß seines Kopfes mit Scheiße und nannte das Ergebnis *Shithead*. »Ich habe drei Wochen lang meine Scheiße gesammelt und eingefroren«, erklärte Quinn. »Als ich genug beisammen hatte, habe ich sie in einen Abguß meines Kopfes gefüllt und trocknen lassen. Sie schrumpfte auf ein Drittel der ursprünglichen Masse zusammen. Ich arbeite gerne mit Scheiße. Es ist ein totes Material, das jedoch als Dünger verwendet wird und deshalb auch mit dem Leben zu tun hat. Ich werde wohl auch in Zukunft mit Scheiße arbeiten – Nachschubprobleme gibt es ja keine.«

Artshit *In 1961, Italian artist Piero Manzoni turned shit into gold. Manzoni's 90 cans of his own excrement (entitled Merda d'Artista, or Artist's Shit) were priced by weight according to the market value of gold. In 1998, some were sold for UK£25,000 (US$38,000) each. Thirty-seven years later, British artist Marc Quinn has followed in Manzoni's scatological footsteps, filling a mold of his own head with excrement and entitling it Shithead. "I stored my own shit for three weeks," explained Quinn. "I froze it until I had enough, then I poured it into a mold of my head and dried it. It shrank to a third of the size. I like working with shit: It's something dead, but it's also about life, because it fertilizes as well. I think I'll use shit again – it's a material that keeps on coming and there's never any shortage of it."*

Merda d'Artista En 1961, l'artiste italien Piero Manzoni changea de la merde en or. Il réunit 90 boîtes emplies de ses propres excréments (collection baptisée *Merda d'Artista*), qui furent mises à prix au poids … au cours de l'or sur le marché. En 1998, certaines se vendirent 260 000 francs l'unité. Trente-sept ans plus tard, le plasticien britannique Marc Quinn emprunte à nouveau la piste scatologique tracée par Manzoni, en remplissant de son propre caca un moulage de sa propre tête, et en intitulant le tout *Shithead* (face de merde). « J'ai stocké ma merde pendant trois semaines, explique-t-il. Je la congelais au fur et à mesure, jusqu'à ce que j'aie la quantité nécessaire. Ensuite, je l'ai coulée dans le moule de ma tête et j'ai fait sécher. Elle s'est réduite à un tiers de son volume. J'aime travailler la merde – c'est une matière morte, mais elle évoque aussi la vie, puisque c'est un engrais. Je pense que je vais continuer à en utiliser. On est constamment réapprovisionné – pas de risque de rupture de stock. »

Taubendreck Taubendreck hat eine starke Korrosionskraft und zersetzt Baudenkmäler, Holz und Autolack. Zum Leidwesen der Denkmalschützer lieben Tauben alte Städte mit ornament- und nischenreichen Gebäuden, die ideal für ihre Nester sind. »Die Säure im Kot greift das Kalziumkarbonat im Marmor oder Stein an«, erklärt die Restauratorin Cecilia Bernardini aus Rom, »und weil die Exkremente wäßrig sind, dringen sie in den Marmor ein und zersetzen ihn.« Je feuchter die Umgebung, desto höher der Schaden – deshalb gestaltet sich die Restaurierung der Baudenkmäler im wasserreichen Venedig mit seinen 100.000 Tauben so schwierig. Zu den Taubenbekämpfungsmaßnahmen gehören Verhütungspillen (Tauben brüten das ganze Jahr über), Netze und Schwachstromkabel. Alle diese Maßnahmen gehen ins Geld: Die britische Regierung gibt jährlich 100.000 Pfund (ca. 315.000 DM) aus, um den Trafalgar Square in London vor Taubendreck zu schützen.

Pigeonshit *Pigeon droppings are highly corrosive and damage monuments, wood and car paint. Unfortunately for urban conservationists, the domestic pigeon loves old cities, where ornate architecture provides plenty of nooks to nest in. "The acid in the droppings attacks the calcium carbonate in marble or stone," explains Rome-based restorer Cecilia Bernardini. "And the excrement's watery, so it penetrates into the marble and corrodes it." The more humid the environment, the deeper the damage – that's why it's so hard to restore monuments in Venice, Italy, home to 100,000 pigeons and a lot of water. Antipigeon measures include birth control pills (pigeons breed all year round), nets and low-voltage electrified cables, all of which are expensive: The UK government spends UK£100,000 (US$150,000) a year in an attempt to keep London's Trafalgar Square dropping-free.*

Outrages à notre patrimoine Hautement corrosives, les fientes de pigeons endommagent les monuments historiques, le bois et la peinture des carrosseries. Malheureusement pour les défenseurs du patrimoine, le pigeon domestique adore les cités historiques, où l'architecture ornementale lui procure quantité de recoins et cavités où nicher. «Les fientes sont chargées d'acide qui attaque le carbonate de calcium contenu dans le marbre et la pierre, explique la restauratrice Cecilia Bernardini, qui opère à Rome. Comme les excréments sont plutôt liquides, ils pénètrent le marbre et le corrodent.» Plus l'environnement est humide, plus le dommage est grand – d'où la terrible difficulté à restaurer les monuments de Venise, en Italie, qui cumule deux désavantages : 100 000 pigeons et beaucoup d'eau. Les mesures anti-pigeons vont des filets aux pilules contraceptives (ces volatiles se reproduisent à longueur d'année), en passant par les câbles électriques à basse tension, tous procédés fort coûteux. Le gouvernement britannique dépense ainsi 100 000 livres sterling par an dans l'espoir d'épargner les cataractes de fientes à Trafalgar Square.

Ein kunsthistorisches Thema Gabriel Weisberg lehrt Kunstgeschichte an der University of Minnesota in den USA. Er ist einer der wenigen Experten für »skatologische Kunst«. »Die Geschichte beginnt bei den Maya, die Exkremente für etwas Göttliches hielten, und sie zieht sich über die flämische Malerei des 16. und die französische des 19. Jahrhunderts bis in die heutige Kunst hinein, in der der Kot sehr präsent ist. Toulouse-Lautrec war zum Beispiel ein sehr analfixierter Künstler, und es gibt ein paar sehr komische Fotografien, die ihn auf der Toilette zeigen.« 1993 stellte Weisberg eine der skatologischen Kunst gewidmete Ausgabe des *Art Journal* zusammen. »Einige Mitarbeiter der Zeitschrift kündigten sogar, weil sie das Thema für unschicklich hielten. Aber die Ausgabe wurde restlos verkauft. Einige wunderbare Artikel waren dabei: ›Tief in der Scheiße: Die codierten Bilder von Traviès im Julikönigtum‹, ›Merde!‹ (Scheiße!), ›Ein anales Universum‹, ›Göttliche Exkremente: Die Bedeutung der »Heiligen Scheiße« im alten Mexiko‹. Hinter allen diesen Titeln verstecken sich sehr geistreiche Beiträge, die sehr ernsthafte Fragen behandeln.«

The Place of Excrement in Art History *Gabriel Weisberg teaches art history at the University of Minnesota, USA. He's one of the few "scatological art" experts in the world. "The history starts with the Mayans, who believed excrement was divine, going through the 16th century Flemish paintings to French 19th century, to today's art, in which shit is very present. Toulouse-Lautrec, for example, was a very anal artist, and there are some very funny photographs of him taking a poop." In 1993 Weisberg coordinated an issue of Art Journal dedicated to scatological art. "Some people even resigned from the magazine," reports Gabriel, "because they thought the subject was inappropriate. But the magazine sold out. There were some wonderful articles: 'In Deep Shit: The Coded Images of Traviès in the July Monarchy,' 'Merde!' (Shit!), 'An Anal Universe,' 'Divine Excrement: The Significance of "Holy Shit" in Ancient Mexico.' People laugh when they hear this, but these are very serious questions and these are very witty papers."*

L'art scatologique Gabriel Weisberg enseigne l'histoire de l'art à l'université du Minnesota, aux Etats-Unis. C'est aussi l'un des rares experts en «art scatologique» de la planète. «L'histoire commence chez les Mayas, qui prêtaient aux excréments un caractère divin. Elle se poursuit dans la peinture flamande du XVIe siècle, parcourt tout le XIXe siècle français, et trouve son prolongement dans l'art contemporain, où la merde est un élément très présent. Prenez Toulouse-Lautrec – voilà un peintre singulièrement anal, et nous disposons de photos assez désopilantes de l'artiste en train de faire caca.» En 1993, la revue *Art Journal* a consacré à l'art scatologique un numéro dont Weisberg a coordonné l'édition. «Certains sont allés jusqu'à démissionner de la rédaction, raconte Gabriel, parce qu'ils trouvaient le sujet déplacé. Pourtant, on s'est arraché le numéro. Il contenait des contributions formidables, par exemple ‹Dans la merde jusqu'au cou : les images codées de Traviès durant la monarchie de Juillet›, ou encore ‹Merde!›, ‹Un univers anal›, ‹Excréments divins : ce qu'on entendait par Merde-Dieu! dans l'Antiquité mexicaine›. »

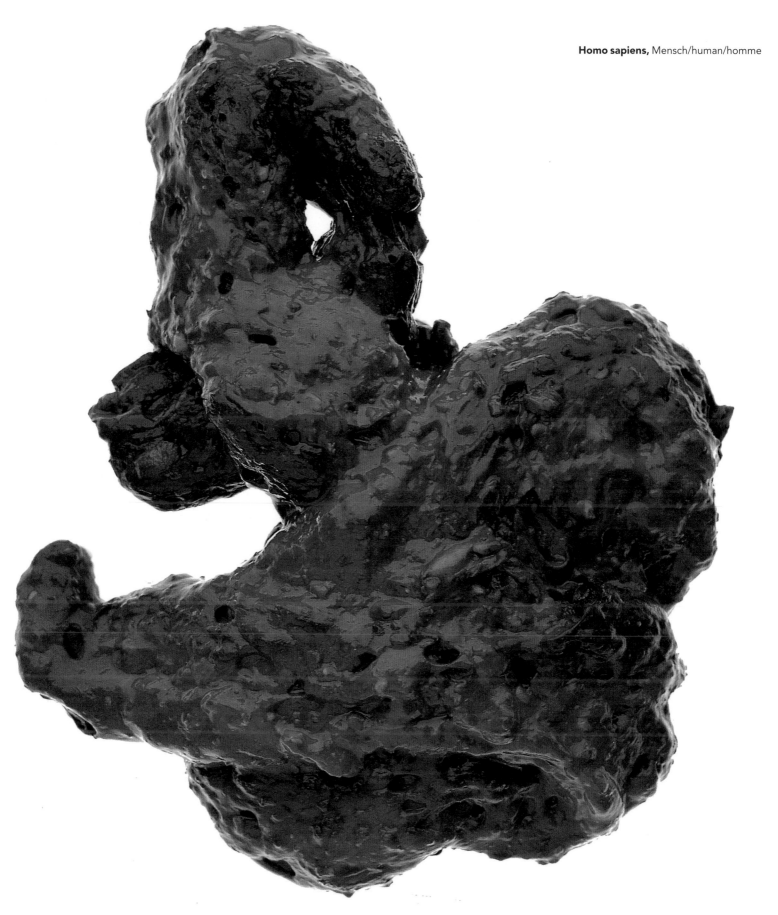

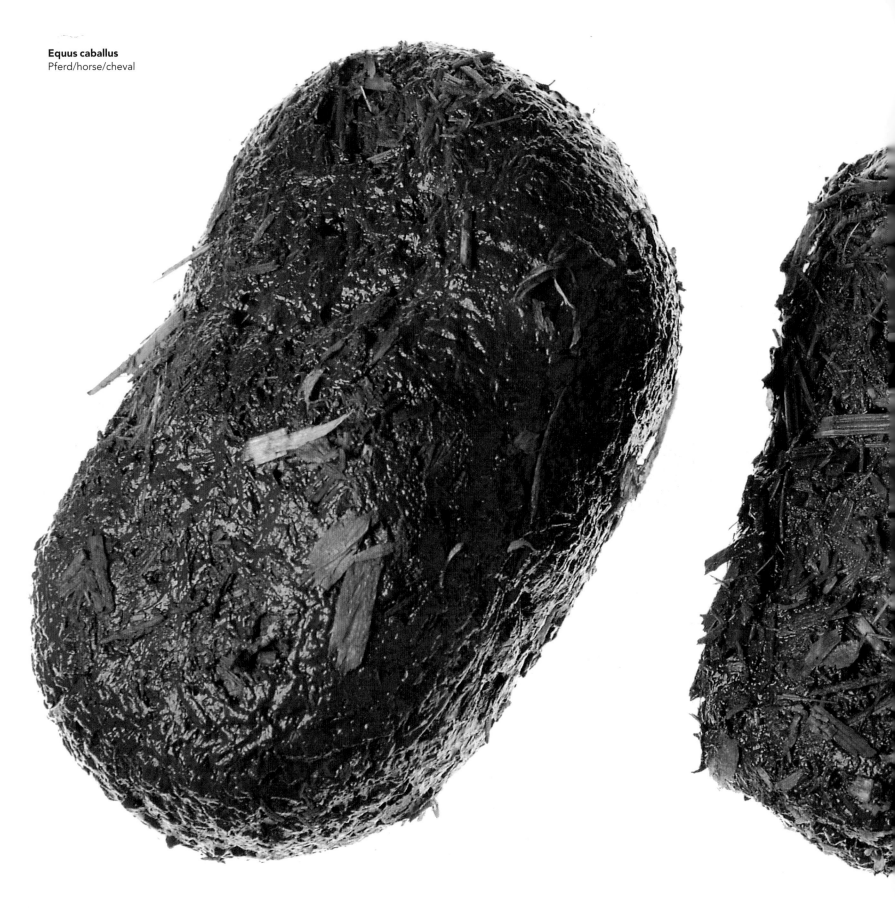

Equus caballus
Pferd/horse/cheval

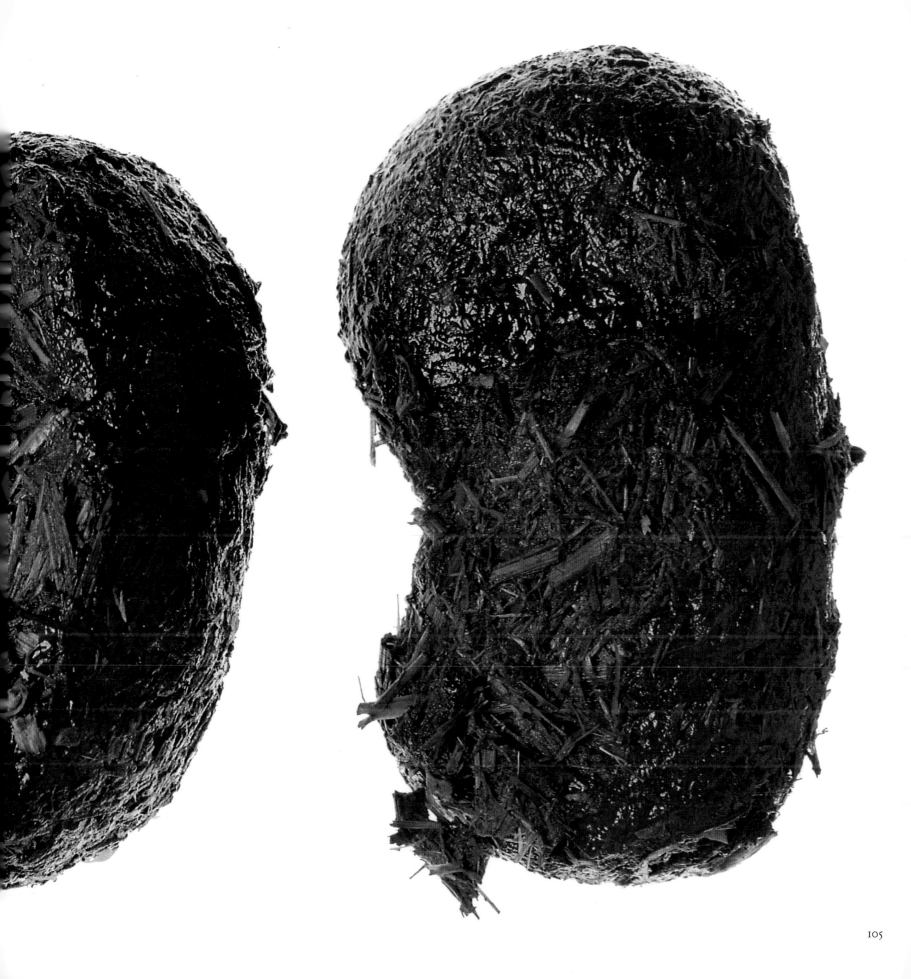

Hundescheiße Tagtäglich hinterlassen die 200.000 Pariser Hunde (auf zehn Einwohner kommt ein Hund) ungefähr zwei Tonnen Exkremente auf den Straßen der Stadt. Die Säuberung – für die 90 *caninettes* (Motorroller mit speziellen Saugvorrichtungen) eingesetzt werden – kostet die Stadt jährlich 52 Millionen Franc (ca. 20 Millionen DM). In anderen Städten bauen die Behörden im Kampf gegen die anwachsenden Kotberge auf die Mitarbeit der Hundehalter: In den öffentlichen Parkanlagen in Hongkong wurden Hundeklos (Sandkästen) eingerichtet, in niederländischen Parks Kotentsorgungsbeutelautomaten aufgestellt. Wer sich solcher Beutel in Singapur nicht bedient, kann mit 1.700 Singapurdollar (ca. 2.000 DM) zur Kasse gebeten werden, während die Argentinier den Hunden einen Mikrochip ins Ohr einpflanzen wollen, der den Halter identifiziert. Warum der ganze Aufwand? Jahr für Jahr landen 650 Pariser im Krankenhaus, weil sie auf Hundescheiße ausgerutscht sind. Außerdem kann Hundekot für Menschen gefährliche Parasiten enthalten. Rundwurmeier zum Beispiel können jahrelang im Boden verharren und stellen ein Risiko für alle dar, die zuerst den Boden und dann ihren Mund berühren (Kinder und Rollstuhlfahrer sind die häufigsten Opfer).

Dogshit *Every day, Paris's 200,000 dogs (one for every 10 people) dump about two tons of excrement on city streets. The cleanup operation – carried out using 90 caninettes (motorcycle poop-scoopers) – costs the city FF52 million (US$10 million) annually. To combat rising shit mountains, authorities in other cities encourage owners to clean up after their pets: Public parks in Hong Kong provide pet toilets (sandboxes), while Dutch parks have installed "doggy bag" dispensers. In Singapore, you can be fined up to S$1,700 ($1,000) for not scooping, while Argentinians want to insert microchips in dogs' ears containing the owner's identification. Why the fuss? Every year 650 Parisians end up in hospital after slipping on dog mess. And feces can contain parasites fatal for humans. Roundworm eggs, for example, can remain in the ground for years, posing a risk to anyone who touches the ground and then their mouth (children and people in wheelchairs are the most common victims).*

Les crottes de chien Chaque jour, les 200 000 chiens de Paris (soit un pour dix habitants) délestent dans ses rues environ deux tonnes d'excréments. Le nettoyage des trottoirs – effectué par une escouade de 90 caninettes, des aspi-crottes motorisés à deux roues – coûte annuellement à la ville la coquette somme de 52 millions de francs. Pour venir à bout de ces montagnes toujours plus hautes de merde, d'autres municipalités encouragent les propriétaires de chiens à nettoyer derrière eux. Les jardins publics de Hongkong ont installé des latrines pour chiens (de simples bacs à sable) ; de leur côté, les parcs hollandais se sont équipés de distributeurs de « sacs à crottes ». A Singapour, celui qui ne ramasse pas les crottes de son chien est passible d'une amende de 1 700 dollars Singapour. Quant aux Argentins, ils envisagent d'insérer dans les oreilles des chiens des puces électroniques permettant d'identifier les maîtres. Pourquoi tant de haine? Parce que, chaque année, 650 Parisiens finissent à l'hôpital, après une bonne glissade sur souillure canine. Qui plus est, les déjections de nos chers compagnons regorgent de parasites fatals pour l'homme. Les œufs de vers ronds, pour ne citer qu'eux, peuvent survivre enfouis sous la terre des années durant, d'où le risque encouru lorsqu'une personne touche la terre, puis porte la main à sa bouche (les enfants et les handicapés en chaise roulante y sont particulièrement exposés).

Theraphosidae, Vogelspinne/tarantula/tarentule

Das Abwasserproblem Bevor Sie das nächste Mal ein Bad in balsamischen Fluten nehmen, sollten Sie das folgende bedenken: 95 Prozent der Abwässer aus den Städten der Entwicklungsländer landen – meist unaufbereitet – im Meer. Viele der größten Flüsse der Welt – der Jangtse, der Mekong und der Ganges – sind heute kaum mehr als offene Abwasserkanäle, und jährlich sterben mehr als 10 Millionen Menschen an Krankheiten, die durch verseuchtes Wasser verursacht wurden. Die Industrieländer rühmen sich, das Abwasserproblem weitgehend in den Griff bekommen zu haben, da hier die meisten Abwässer geklärt werden und der Klärschlamm verbrannt und in Mülldeponien vergraben wird. Doch auch in Europa werden Abwässer immer noch in Küstengewässer eingeleitet und stellen für manche Strände eine Belastung dar. Und der Umweltschutzorganisation Greenpeace zufolge fördern Müllverbrennungsanlagen – in denen nicht nur Hausmüll, sondern auch Klärschlamm verbrannt wird – letzten Endes nur die Müllproduktion: Sie müssen ständig ausgelastet werden, und die Betreiber belangen die kommunalen und regionalen Behörden, wenn nicht genügend Nachschub geliefert wird. Greenpeace schlägt eine ökologisch sinnvollere Alternative vor: Klärschlamm macht nur 15 Prozent des in den Anlagen verbrannten Materials aus; diese Menge könnte problemlos vergraben oder als Dünger auf Felder und Wiesen verteilt werden. Der übrige Abfall – Papier, Metall, Holz, Textilien, Wolle und Glas – könnte genauso problemlos recycelt werden.

Swimming in Sewage *Next time you go swimming in balmy waters, consider this: 95 percent of urban sewage in the developing world ends up in the sea, mostly untreated. Many of the world's great rivers – the Yangtze, Mekong and Ganges – are now little more than open sewers, and more than 10 million people a year die from waterborne diseases caused by sewage pollution. In the developed world, where sewage is often incinerated and buried in landfills, waste disposal is officially more advanced. Yet raw sewage pumped into coastal waters still contaminates hundreds of European beaches. And incinerators – which burn all types of household waste, including sewage – actually encourage the production of waste, says environmental pressure group Greenpeace: They need to be fed constantly, and local governments are fined by incinerator companies if they don't deliver enough rubbish. Greenpeace suggests a more sustainable alternative. Only 15 percent of incinerated waste is sewage; this can be safely buried or sprayed on farmland, while the rest – paper, metal, wood, textiles, wool and glass – can easily be recycled.*

Comment recycler nos étrons La prochaine fois que vous vous baignerez dans des ondes embaumées, songez à ceci : 95 % des eaux usées urbaines produites dans les pays en voie de développement se déversent directement dans la mer, sans traitement préalable digne de ce nom. Nombre de grands fleuves du monde – le Yang-Tsê, le Mékong, le Gange – ne sont plus guère aujourd'hui que des égouts à ciel ouvert ; et les maladies d'origine hydrique, dues à la contamination des eaux potables, font chaque année plus de 10 millions de morts. Dans les régions industrialisées du globe, où les résidus d'égout sont bien souvent incinérés et ensevelis dans des centres d'enfouissement, la gestion des déchets est officiellement une affaire qui tourne. Pourtant, les déversements directs d'eaux usées dans la mer, sur les zones côtières, polluent encore des centaines de plages européennes. Et là n'est pas le seul problème, souligne le groupe de pression écologiste Greenpeace : les incinérateurs – qui brûlent tous les types de déchets domestiques, y compris les résidus d'égouts – ne font en réalité qu'encourager la production de détritus. En effet, il faut les nourrir constamment, au point que les municipalités doivent dédommager les entreprises d'incinération si elles ne leur livrent pas assez d'ordures. Greenpeace suggère une solution plus soutenable : 15 % seulement des déchets incinérés sont des résidus d'eaux usées. Une telle quantité peut être enterrée ou répandue sur les champs cultivés en toute sécurité. Le reste – papier, métal, bois, textiles, laine et verre – est aisément recyclable.

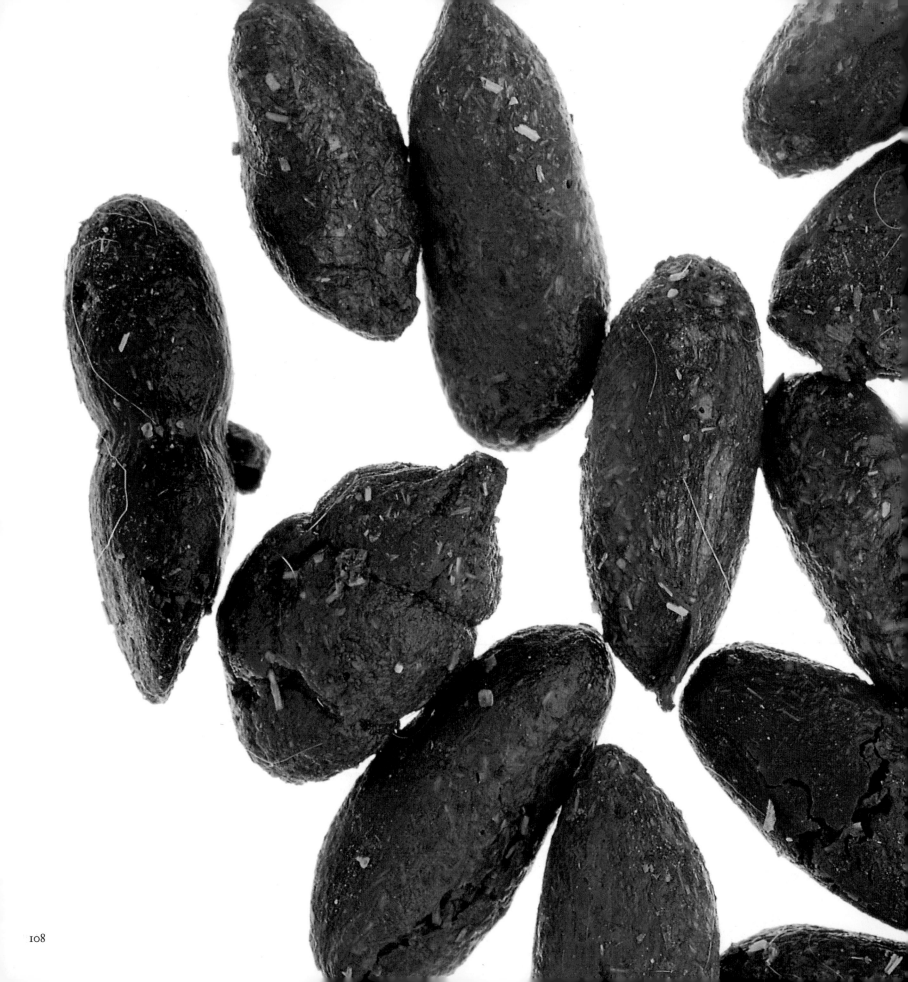

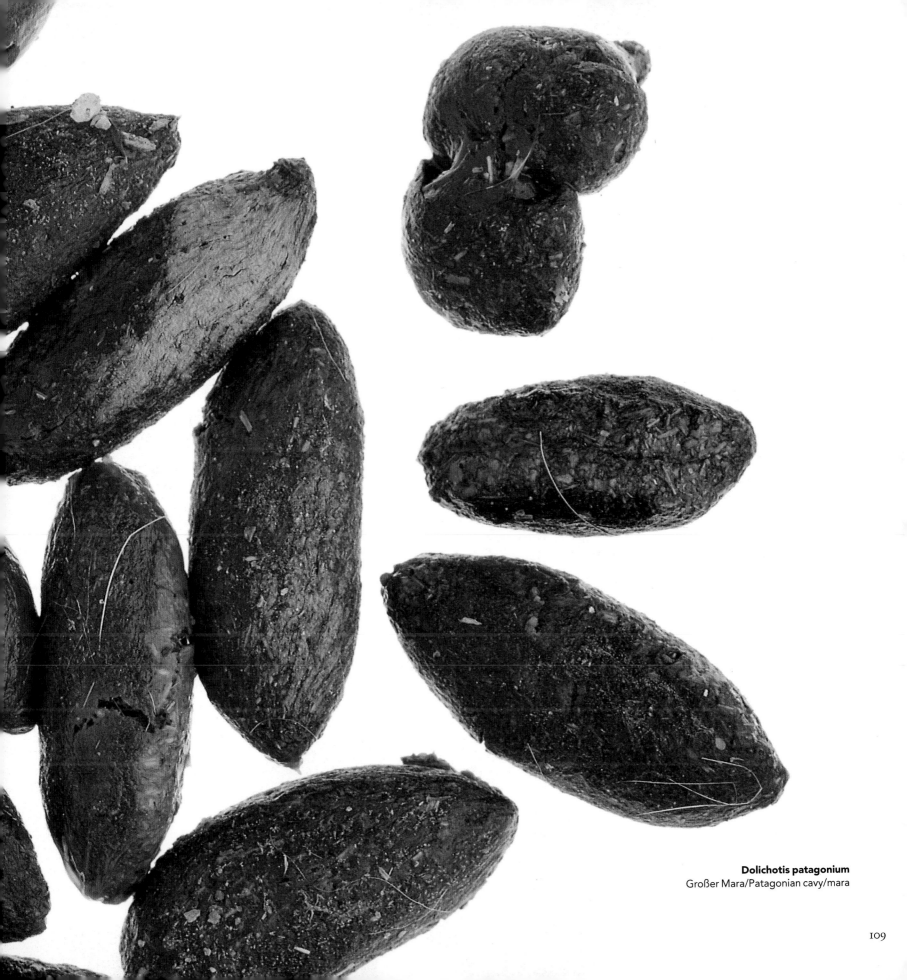

Dolichotis patagonium
Großer Mara/Patagonian cavy/mara

Papier aus Elefantendung »Solange wir aus Elefantendung Papier herstellen«, sagt Lindizga Buliani vom Paper Making Education Trust in Malawi, »und solange dieses Papier gekauft wird, können wir und unsere Kunden einen Beitrag zum Schutz der Elefanten leisten. In Malawi, wo die Elefantenpopulation von Wilderern dezimiert wurde, kann sich die National Parks and Wildlife Society mit Hilfe des Geldes, das wir ihnen für den Elefantendung zahlen, ein paar zusätzliche Wildhüter leisten«, so Lindizga. Um dieses strapazierfähige, faserige Papier (das auch in Kenia, Sambia, Südafrika und den USA produziert wird) herzustellen, wird der Dung in Wasser eingeweicht und dann mit einer Schöpfkelle auf ein auf einer Presse liegendes Tuch aufgetragen, eingehüllt und zu dünnen Lagen gepreßt: Für ein Blatt Schreibpapier braucht man 100 Lagen. Lindizga: »Die Pressen werden von ortsansässigen Handwerkern aus Altmetall hergestellt, und wir machen Papier aus Altpapier und Exkrementen. Wir nutzen also alle unsere Ressourcen.«

Under the Elephant *"As long as we're producing elephant dung paper," says Lindizga Buliani of Malawi's Paper Making Education Trust, "as long as people are paying for it, they'll be helping protect elephants. In Malawi, where poaching has decimated the native elephant population, buying elephant dung from the National Parks and Wildlife Society helps pay the salaries of a couple of anti-poaching rangers", says Lindizga. The tough, fibrous paper (also produced in Kenya, Zambia, South Africa and the USA) is made by soaking dung in water, then scooping it onto mortars and pressing it between cloth into layers: 100 layers are required for a sheet of writing paper. "Local artisans make scoop presses from discarded metal," continues Lindizga. "And we make paper from wastepaper and excrement. So we're using all the resources."*

Le papier-bouse « Tant que nous produirons du papier à partir de bouse d'éléphant, assure Lindizga Buliani, de la Délégation malawite pour l'éducation à la fabrication du papier, et tant que les gens paieront pour s'en procurer, ils contribueront à la protection des éléphants. » Et de souligner qu'au Malawi, la chasse illicite a décimé la population des pachydermes, et que tout achat de bouse d'éléphant à la Société des parcs nationaux et de la vie sauvage aide à payer les salaires de deux gardes mobiles affectés à la lutte contre le braconnage. Résistant et fibreux, le papier-bouse (également produit au Kenya, en Zambie, en Afrique du Sud et aux Etats-Unis) se fabrique en laissant tremper les excréments dans l'eau, puis en rassemblant les particules à la pelle sur des mortiers, où elles seront pressées entre des carrés de chiffon jusqu'à obtention d'une fine pellicule. Il faut 100 couches de ce type pour former une feuille de papier à écrire. « Les artisans locaux fabriquent des presses-pelleteuses à partir de métal de récupération, poursuit Lindizga. Et nous faisons du papier à partir de vieux papiers et d'excréments! Vous voyez que nous utilisons toutes les ressources disponibles. »

Lophognatus temporalis, Leguan/iguana/iguane

Mus musculus, Maus/mouse/souris
Gegenüberliegende Seite/Opposite/Page de droite: **Elephas maximus,** Elefant/elephant/éléphant

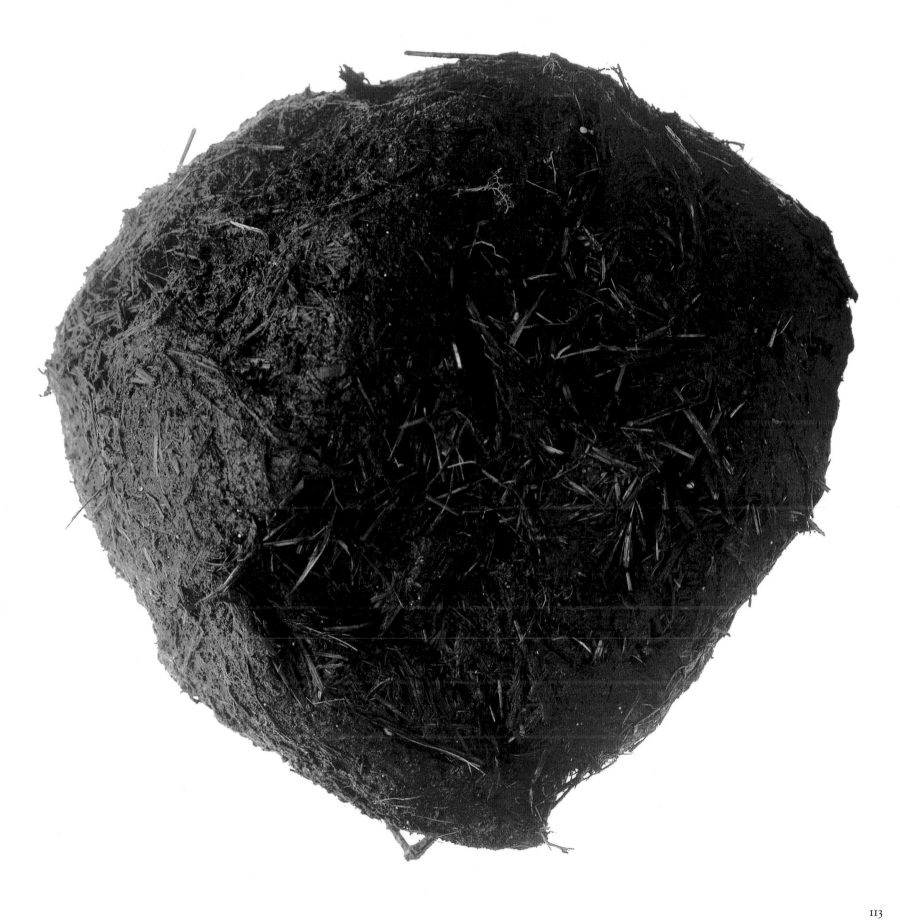

Contents

Inhalt

Table des matières

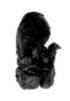

58
Selenarctos tibetanus
Kragenbär/Tibetan bear/
ours à collier

59
Ailuropoda melanoleuca
Großer Panda/giant panda/
grand panda

61
Capra hircus
Ziege/goat/chèvre

62
Hippopotamus amphibus
Flußpferd/hippopotamus/
hippopotame

65
Camelus dromedarius
Dromedar/dromedary/
dromadaire

67
Casuarius casuarius
Helmkasuar/cassowary/casoar

68
Mustela vison
Nerz/mink/vison

70
Saguinus oedipus
Lisztäffchen/cotton-top tamarin/
pinché (tamarin de Liszt)

71
Dromaius novaehollandiae
Emu/emu/émeu

72
Lemur macaco
Mohrenmaki/lemur/lémur

75
Felis catus
Hauskatze/cat/chat

75
Canis familiaris
Hund/dog/chien

76
Ara ararauna
Ara/parrot/perroquet

78
Tapirus indicus
Schabrackentapir/Malayan tapir/
tapir de l'Inde

79
Thamnophis sirtalis
Strumpfbandnatter/garter snake/
serpent-jarretière

80
Lama guanicoë
Guanako/guanaco/guanaco

82
Gallus domesticus
Hahn/cock/coq

83
Tremarctos ornatus
Brillenbär/spectacled bear/
ours à lunettes

85
Sus scrofa
Wildschwein/wild boar/
sanglier

86
Hystrix cristata
Stachelschwein/
African porcupine/
porc-épic à crête

87
Emys orbicularis
Europäische Sumpfschildkröte/
pond turtle/tortue bourbeuse

88
Panthera pardus
Schwarzer Panther/black panther/
panthère noire

91
Ursus arctos
Braunbär/brown bear/
ours brun

92
Dama dama
Damwild/fallow deer/
daim

94
Mandrilus sphinx
Mandrill/mandrill/mandrill

96
Saguinus fuscicollis
Braunrückentamarin/
brown-headed tamarin/
tamarin à tête brune

98
Suricata suricata
Erdmännchen/meerkat/
suricate

100
Pavo cristatus
Pfau/peacock/paon

103
Homo sapiens
Mensch/human/homme

104
Equus caballus
Pferd/horse/cheval

106
Theraphosidae
Vogelspinne/tarantula/tarentule

108
Dolichotis patagonium
Großer Mara/Patagonian cavy/mara

110
Lophognatus temporalis
Leguan/iguana/iguane

112
Mus musculus
Maus/mouse/souris

113
Elephas maximus
Elefant/elephant/éléphant

Dank an/Thanks to/Remerciements à

Parc Zoologique de Paris Vincennes
Zoo Aquarium de la Casa de Campo, Madrid
Arthur Binard
Claudine Boeglin
Steven Brimelow
Adam Broomberg
Prospero Cultrera
Alejandro Duque
Alberto Gandini
Paolo Landi
Max de Lotbinière
Fernando Haro
Parag Kapashi
Pierpaolo Micheletti
Maurizio Nardin
Anyango Odhiambo
Takao Oshima
Eleonora Parise
Sarah Rooney
Diego Rottman
Altin Sezer
Bijaya Lal Shrestha
Marcello Signorile
Esra Sirin
Martino Sorteni
Paulo de Sousa
Juliana Stein
Michael Sutherland
Valerie Williams
Chiara Zanoni

**Besonderer Dank an/Special thanks to/
Remerciements particuliers à**

Affitalia